1,000 BIKER TATTOOS

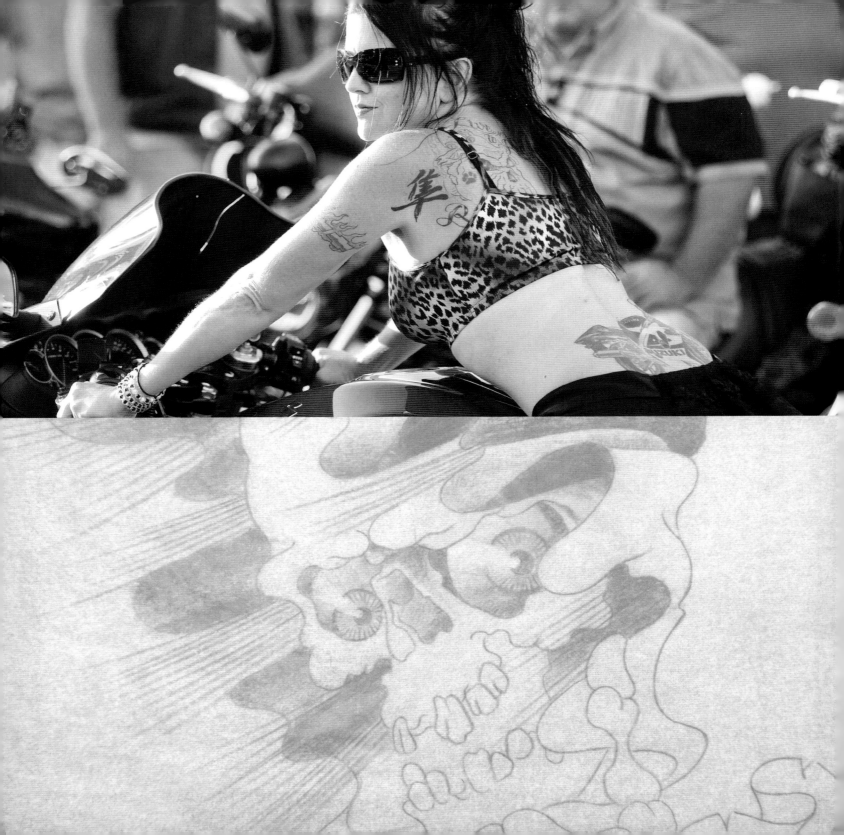

1000
BIKER
TATTOOS

First published in 2013 by Motorbooks, an imprint of MBI Publishing Company, 400 First Avenue North, Suite 400, Minneapolis, MN 55401 USA

The information in this book is true and complete to the best of our knowledge. All recommendations are made without any guarantee on the part of the author or Publisher, who also disclaims any liability incurred in connection with the use of this data or specific details.

We recognize, further, that some words, model names, and designations mentioned herein are the property of the trademark holder. We use them for identification purposes only. This is not an official publication.

Motorbooks titles are also available at discounts in bulk quantity for industrial or sales-promotional use. For details, write to Special Sales Manager at MBI Publishing Company, 400 First Avenue North, Suite 400, Minneapolis, MN 55401 USA.

To find out more about our books, visit us online at www.motorbooks.com.

Library of Congress
Cataloging-in-Publication Data

Liberte, Sara, author.
 1000 biker tattoos / by Sara Liberte.
 pages cm
 ISBN 978-0-7603-4435-4 (softcover)
 1. Tattooing--Social aspects--United States. 2. Motorcyclists--United States--Social life and customs. 3. Tattoo artists--United States. 4. Tattooing--Social aspects--United States--Pictorial works. 5. Motorcyclists--United States--Social life and customs--Pictorial works. I. Title.
 GT2346.U6L54 2013
 391.6'5--dc23
 2013014978

Editor: Jordan Wiklund
Design by: Diana Boger
Cover Design by: John Barnett/4Eyes Design
Cover Illustration by: Darren McKeag

Printed in China

10 9 8 7 6 5 4 3 2 1

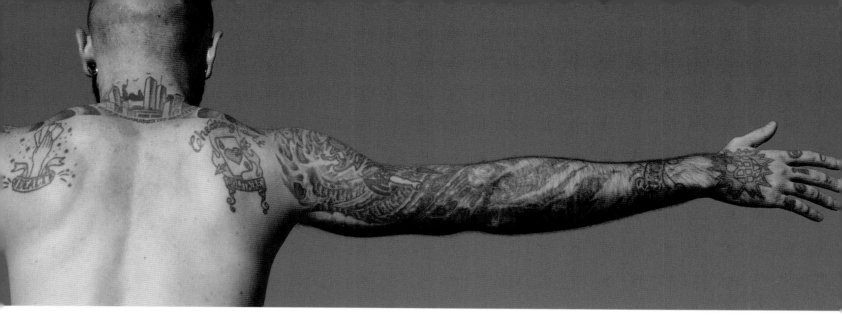

Acknowledgments

In the conservative stretch of nothingness west of the 100th meridian (minus California), I'm often asked, "Don't you think that you'll regret your tattoos one day?"

That's a question I've been asked as long as I've had tattoos. Will these images in my skin damn me to an eternity of torment and misery? Will they be cause for infinite despair?

I don't think so. But I always consider what people say, and I can confidently say that I will never regret a single one of them. Each tattoo, peaceful or violent, shocking or alluring, exists because that's where I was at that time in my life. I won't even regret the bad ones.

Tattoos exist to remind us to think about our past, to learn something in the present, and to be smarter in the future. Tattoos are statements, and tattooed bodies are merely timelines of life events you either loved or hated.

—Chad Lemme

The journey of *1,000 Biker Tattoos* was a whole new adventure for me. I felt like Lewis and Clark searching for the Northwest Passage—tearing through different scenery, visiting with good friends, and meeting an odd array of people fulfilled me visually, artistically, philosophically, and emotionally. Just as their stories were permanently inked on their skin, this journey is permanently inked in my memory.

I simply cannot go any further without sharing some of the people who were instrumental in the completion of this book, or without thanking them endlessly. First and foremost is Darren McKeag of Slingin' Ink Tattoo in Grinnell, Iowa. I'd also like to mention those who helped us immensely on compiling this book, everyone from tattoo artists, photographers, writers, artists, and even just ordinary enthusiasts like you and me.

In no particular order, many heartfelt thanks from the bottom of both of our hearts to Darren McKeag, Paul Wideman, Terry Meyer, Long Jon and Pinky, George the Painter, Iliya Hamovic, Kevin "Teach" Bass, Noah, Scottie B and Dan of Slingin' Ink, Chad and Tim at Ink & Iron Tattoo, Billy Tinney, Rogue, Willie of Willie's Tropical Tattoo, Richie Pan, Jason Kangas, Kai Morrison, Robert Pradke, Jason Grimes, Goth Girl, Bart Mitchel, and Tom Tobin. Many thanks are also due our parents for putting up with our hectic schedules, incessant traveling, and for always welcoming us in from the road with good food and the comfort of home.

—Sara Liberte

Introduction

"And behold a pale horse: And his name that sat upon him was Death, and Hell followed with him.
And power was given unto them ... to kill with sword, and with death, and with the beasts of the Earth."
—Revelation 6:8

he peaceful and still summer air is shattered by the guttural, reverberating waves of a familiar sound. A nameless dread ripples across the hearts and minds of the squares as the sound continues its ominous crescendo, cascading into a rumbling, resounding thunder so heavy it makes breathing difficult. It vibrates the ground, throwing you off balance. And you know there's only one thing it can be—the unmistakable sound of an American V-Twin motorcycle. And there, perched atop the terrible beast, the horrid dirtbag your mother warned you about. These tattooed mutants, dirtier than the dust-soaked oil leaks streaming backwards from the warped mating surfaces of a motor that can't hold back seventy-weight anymore, descend upon your once-peaceful purview of this crazy world.

You've heard it all before, and they'll say it 'til the bitter end: these external combustion bastards riding internal combustion bikes care not for society and less for its rules. And they will swipe your innocence faster than a mongoose on speed, and ruin you for life, if your life is even spared.

Stereotypes aside, the uninformed perception of anything outside the nine-to-five straight and narrow is all too often erroneous and just plain wrong. Hell, even the label "biker" has been bastardized into a meaningless title—someone who spends 96 percent of their life concerned with retirement funds, name-brand home furnishings, expensive business attire, and low golf scores shouldn't be labeled a biker. The dude who can fully disassemble and correctly reassemble his entire motorbike on the side of the road; the hellion who rides through wind and rain and snow and hell because he loves it; the man who would rather sleep under the stars with his bike, a change of socks, and a half-empty pack of cigarettes as his only companions than in a plush bed inside of five thousand square feet of prime real estate ... this road warrior has earned the title of Biker. Not because he looks the part, but because it's his life.

And many of the masses—those who think men who are married to their motorcycles are dirt-heads and disgusting vagrants—come out in swarms, flaunting their sleeveless and, no doubt, preworn rally shirts to feign, if for only one weekend, the look of a real biker. The sheep might also flaunt their single tattoo, some bullshit henna or Chinese symbol or their pet's

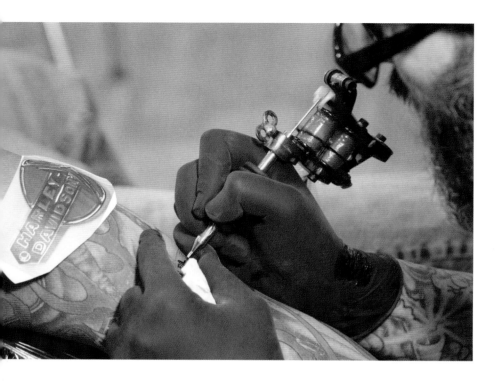

end of your life But when the ride is over, you're still standing—you've cheated death yet again.

Some are very familiar with this strange feeling; soldiers often describe something similar when recounting the heightened senses, the blood-rage they endure in combat. Nobody can explain such a feeling unless they've stood with their toes hanging over a mighty precipice, with only their ability to put fear on the back burner to keep them alive. It feels as though life is suddenly running in slow motion. It feels like your basic motor instincts and emotions are on different planets.

It feels peaceful, oddly enough.

But a soldier in the theatre of war is reminded on a daily basis exactly where that tipping point between life and death lies, and as a result becomes accustomed to it, if not entirely numb. If you're lucky enough to return to a life on easy street, it can be very difficult to handle. In some cases, dangerous decisions ensue: drugs, drinking, violence, using women … all the really fun stuff in life. But one thing that allows many to cope—other than the aforementioned escapades or any combination thereof—is the motorcycle. It is a whole other drug in and of itself.

But, for the sake of sticking the horse in *front* of that proverbial carriage, allow me to back up a ways and recite some history that I've strung together like a first-grade macaroni art project over the years. Readers beware: I cannot be held accountable for any permanent brain damage you might suffer from this (my editor regrets the whole thing in its entirety, I assure you). And with that, we're off!

Amid the plethora of misinformation on the intertubes these days, there are about a thousand false accounts of the history of motorcycles and tattoos. When it comes

nickname, also probably located somewhere on their flabby, underused deltoid.

But whether you're a hardcore biker badass or weekend wannabe, one thing remains true: the need for escape. Escape from the mundane office job and the daily perils of this shitty world. One solution involves sitting on top of a high-test series of controlled explosions of vaporized fuel at breakneck speeds; somehow, it seems to make the minutiae of daily life disappear, makes them flit by like another stripe on the highway.

A peculiar sort of liberation envelops you when you're piloting one of these death machines down the dotted line at a hundred-plus miles an hour, weaving in and out of traffic while your eyeballs bleed and your teeth rattle loose from your gums. It's like standing toe to toe with Death, looking him long in his evil eye, preparing yourself for the

down to it, motorcycles and tattoos have about as much in common as basket weaving and monster trucks. It just so happened that these two very different worlds on their predestined paths would collide in the early half of the twentieth century, right here in America. But let's back up even farther.

Imagine this: an adventurous boatload of Spaniards explores the oceans of the world in search of the edge of the earth. They face many seagoing perils: starvation, bands of deadly pirates, high winds, low morale, even the mythical Kraken! Now, imagine the Spanish explorers reach the shores of the faraway tropical island of Polynesia, where they encounter the indigenous population. The natives behold foreign visitors in strange clothes, all speaking an unrecognizable language. The lifestyles of the islanders seem just as foreign to the Spanish conquistadors. Yet both sides had something to gain from each other—the native Polynesians might have seen and imagined advanced weaponry or ship-building. From the natives, the Spanish picked up one important practice integral to our story: the practice of tattooing (not to mention all the natives' gold).

At the time, tattooing seemed quite odd— why permanently alter your body in such a painful way? The novelty of tattooing was so strange, so new and bizarre and unheard of, that many native people from island cultures were put on public display like some sort of prehistoric saber-toothed unicorn freakshow or something. Beside the visual mindfuck of seeing tattooed people for the first time, these displays caused the equally mind-bending realization of the grueling, self-destructive process of using a single needle to poke hundreds of thousands of ink-laden holes, one by one, for hours and days on end, to complete the permanent art under the skin.

Naturally enough, the affluent justified tattooing as a luxury that only they, the pre–Wall Street one percenters of society, could possibly afford. Ashore, the practice of tattooing was reserved for the richest seventeenth- and eighteenth-century monarchs and upper-crust elitist society hags, but on the sea, rollicking from wave to wave above the briny deep, tattooing was undertaken by the sailors themselves. And this practice is still seen today— before motorcycle jockeys, tattoos were most commonly found adorning the arms and chests of members of the navy, just like their seafaring forefathers.

Tattoos have been used by every culture in every corner of the world, throughout all of history. They've been used as signs of pride, as status symbols, and as religious markers.

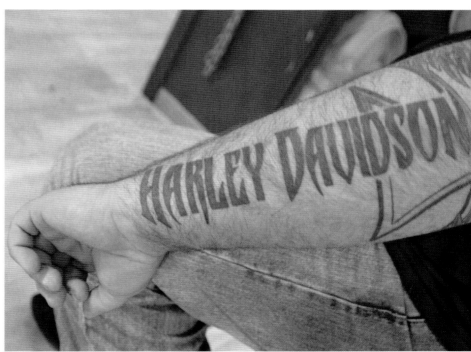

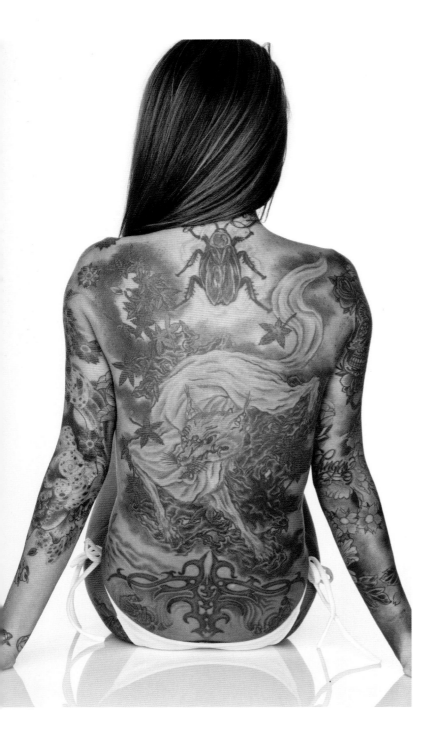

Tattoos have also been used as negative labeling tools, such as in the case of criminals, oppressed peoples, and slaves. The perception of tattoos and tattooing has varied wildly from good to bad, and in many cases, both at the same time. But for us, tattoos have mainly devolved from high-society emblems to markings that carry (often unfairly) certain lifestyle connotations.

The reason for this is due in part to the Industrial Revolution, when the modern, steam-belching machines of the 1800s turned many a skilled craftsman's difficult art and livelihood into a simple, mechanized, and mindless routine that could now be executed by anyone capable of pulling a lever or pushing a button. In this case, the tattooing machine was invented; tattoos no longer required vast amounts of wealth to acquire. Instead, an artist could now do in a matter of minutes or hours what would have taken days and weeks to accomplish before, and for a much, *much* lower cost. For the first time, those with a few extra dollars could now appear to be extremely wealthy.

Once tattoos became more mainstream, the idea that someone would mutilate themselves permanently was considered self-destructive, rejected, and ultimately labeled taboo. Many naysayers regarded anyone who would do such a thing to themselves as banal and mentally inferior. But another order rose as well, an order of people who were entirely fine with permanently altering their bodies. Some were simply blessed with extremely high thresholds for pain. Others possessed the mindset that we are all going to die someday, and that our bodies, like certain philosophers of the time decreed, were just vessels for a short time. So who gives a shit what happens to them, right? So it was that tattooing became associated with death, and we all know that people who don't fear death are seen in an entirely

different light than everyone else, because death is so terrifying to many. The masses turned fearfully away from the "ritual death" of tattooing, the permanent mutilation of one's body. Religious institutions naturally shunned the practice, and many states in the burgeoning USA banned tattooing for quite some time. (Religion was, and still exists, for people who can't handle the thought of nothingness after life.)

In this atmosphere, tattoo aficionados and enthusiasts slowly evolved into socially persecuted, reckless youth, often seen as a horde of dangerous ne'er-do-wells incapable of responsibility, self-discipline, and respect—generally evil people all the way around. Some rode deadly motorcycles and were branded as social outcasts and lowlifes who couldn't afford a car and spurned "normal" lifestyles. And this couldn't be farther from the truth.

The truth is that many of the people tattooing themselves were the same ones who signed up for war, willingly putting themselves in harm's way in the defense of their country. As recently as 100 years ago, from the dawn of the twentieth century and through the end of World War II, sailors, marines, and soldiers alike were essentially the *only* group of Americans branding their hides, with pictures of historical sailing ships, lascivious (and lovely) pinups, and patriotic, banner-wielding eagles.

After their service, many of these courageous souls were dumped into an unfamiliar postwar society, and nobody really thought of the difficulties associated with this. Men returning home from war often struggled to adjust to a very different lifestyle. They felt out of place and bored with life—things were too easy here in America, especially when compared to the campaigns in Europe, with their gruesome warfare in subzero temperatures. But then the Harley-Davidson Motorcycle Company offered adrenaline-starved junkies the best fix they'd ever taste: a little two-wheeled blood-boiler they dubbed "the knucklehead." Now the only thing missing was likeminded people with whom you could share such an experience as war, and who would also understand what you were going through.

Thus, the motorcycle junkie was born.

It seemed for many returning veterans that a significant lack of camaraderie existed among civilian Americans—"brotherhood" is a difficult thing to comprehend when you haven't fought for survival or entirely relied on someone else to keep you alive. In combat, you prepare yourself to die for the soldiers next to you,

because they are ready to die for you. Because of this, your fellow fighters become close—closer than your oldest friends, and in some cases, even closer than blood ties. But yanked from the thoroughfares of war, and thrown back into civilian life, you don't experience that sort of brotherhood anymore. Your neighbors wouldn't take a bullet for you. And I doubt you would for them.

So veterans sought out other veterans, people they *knew* they could rely on. And life was easier, or at least easier to handle. And these tattooed men, who spent all of their time either alone or within small, ostracized groups of fellow outcasts, were seen as unstable and degenerates.

Though I won't get into it at all, it's worth mentioning that this is where motorcycle clubs began: with people who chose to live with their new family on two wheels,

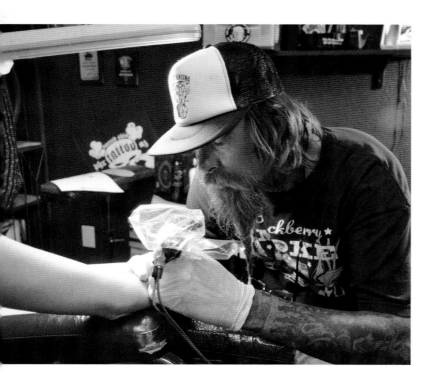

their family that they could rely on without any shadow of a doubt. And with the newfound, freewheeling spirit these mutants discovered came the inevitable good time, and many decided this was how they would live out their lives—on the open road, burnin' rubber.

But the times changed. It used to be that you could go out and have some beers with friends, maybe start a fight, and scream out a burnout down the street as the sun rose at your back. Andy Griffith would show up and tell you to go home. And that was the end of it. Nowadays, if you get caught with keys in your possession after a single beer, you're going straight to the slammer for the night and walking out the next day as a dangerous criminal. Many young people who wind up getting caught having a beer under age carry a rap sheet they'll *never* be able escape from—they're sucked down without a chance to grow up. And before you know it, there's a specially mandated helmet for every sport with little more danger than shuffleboard, hand sanitizer in every hallway of every commercial building in the northern hemisphere, and harsh penalties for incorrectly buckling the secondary five-point restraint system for your child. (Hell, I didn't even know what a seatbelt was until I was old enough to drive. I'd never seen one before. All reason has left our daily lives.)

So the times changed to accommodate weak individuals and give them a fair chance at life, and in the wake, the good time turned into a serious fucking ordeal. But just as the those phantom riders on two wheels fought for our freedoms abroad, we consider ourselves the last vanguard that continues to fight for freedom—life, liberty, beer, speed, fast times, and fast rides—on the home front. Instead of surrendering to a safe and censored society, we resist, and for this we're told that we're evil. Some even buy into this idea. But why?

Bikers are some of the greatest people on the earth, but John Law and his media whores would have you believe they're a bunch of murdering, ravenous thieves and killers, each and every one of them. But the truth is that they all have day jobs, just like you and me. They're not drug dealers and weapons runners. They don't commit heinous crimes or incite outrageous shit. Did you know the Hells Angels contribute millions of dollars to children's health research every year? I'll bet you didn't—people are much too afraid to find out for themselves, so they just feed the stigma and continue blindly down that shitty and overly censored path. And we can't do a thing about it.

Even so, I can say that I'm happy tattoos are becoming more widely accepted and less shunned, and hopefully I'll see a day when tattoos are not looked down upon by anyone. It just seems funny how our ancestors viewed tattooing as such a good thing, and now, just a century or two later, we've moved from admiration, to sheer disgust, and all the way back to a nearly unified acceptance for this strange and commonly taboo practice.

—Sara Liberte and Chad Lemme

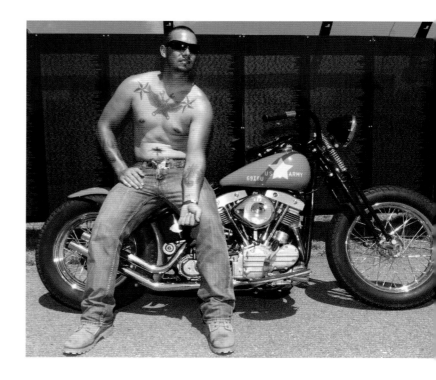

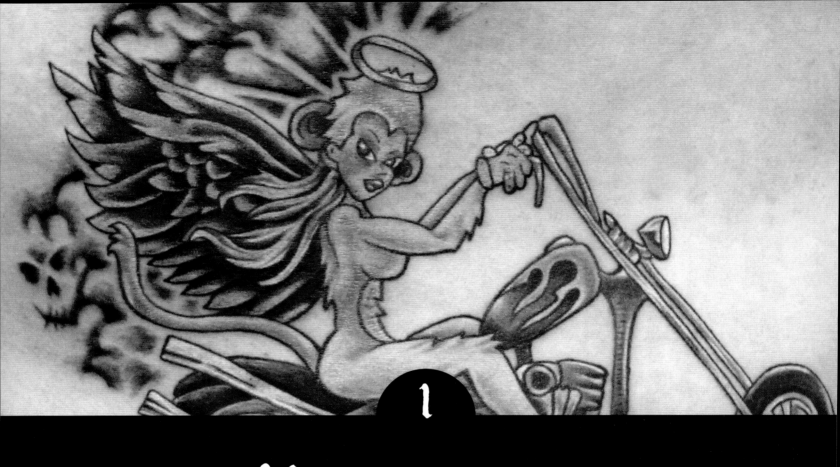

1

Motorcycle
Tattoos

Bikers have tattoos, every tattoo owns a motorcycle, and every motorcycle owns a leather jack—sweet Jesus, I'm not making sense.

There's a common thread here somewhere, though, and I believe it to be leather jackets, motorcycles, and tattoos. At motorcycle rallies you often hear something like, "Hey, have you seen my friend Joe? He's tall, wears a leather jacket, has a beard, and a bunch of tattoos." Well, that just narrowed it down to every fucking dude at the rally.

The clichés and stereotypes do exist. We're taught that stereotypes are bad, but Christ, if it walks like a duck and talks like a duck, well, then, it's probably a duck.

It seems today that everyone who rides has a tattoo, or two, or three, or an entire sleeve. It's no secret that motorcycle riders are big on self-expression, proudly displaying the artwork that carries deep meaning for them, whether it's on their skin or on their bike with custom paint or parts.

After many years on the road and within the motorcycle world, we've noticed that there are several different approaches to "biker ink." There are the bikers who know exactly what they want tattooed; sometimes these bikers are artists themselves, and even dreamed up the artwork on their own. Next is the biker who's going for a certain look—the art doesn't necessarily hold much personal significance. Last on the list is the biker who just strolls into a tattoo parlor, thumbs through some tattoo flash art (designs readily available for you to choose from), and makes his or her pick. This biker is more concerned with having some ink to complete the process of becoming a "biker"—the tattoo becomes a rite of passage.

We spoke with several tattoo artists, including Pinky from Sacred Skin Tattoo in Payson, Arizona, who shared a few ideas on how she breaks down her clients.

Some clients come in with absolutely no art or design in mind … they simply want to go through the motions of getting a tattoo and have some ink on their skin. They will look through previous work we have done or flip through some tattoo magazines and just randomly pick a design that looks "cool." Now if the client is young I usually try to talk them out of it—ask them to really think about something that is worthy enough to be on their skin for life. If the client is older, well, I usually chalk it up to the hope that this person should know better, so if they want it, they get it."

—Sara Liberte

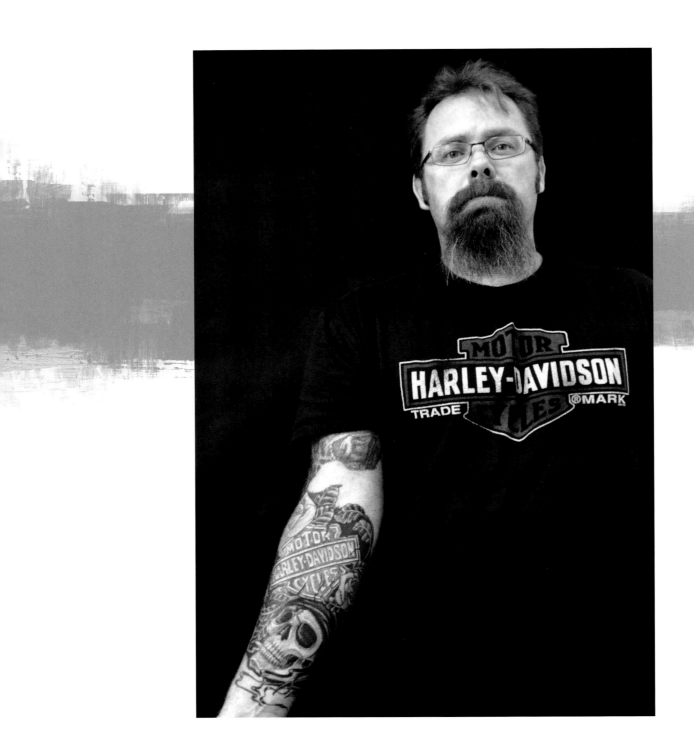

Brand Loyalty

Finding a biker with a Harley-Davidson Bar & Shield tattoo is like finding, well, beer in a bottle. Some riders sport a brand or corporate logo, but it doesn't always have to do with motorcycles.

Take Lemme, for instance. He was paid by Advanced Armament to put their logo on his back. Advanced Armament is just one of many companies that actually pay you to wear their tattooed logo on your back, like a living, breathing biological billboard. More mobile than a billboard, Lemme's back tattoo is an advertisement for a company like Advanced Armament; it's different, it's visible, and to buy the same space anywhere else is less permanent and more expensive. It also builds word of mouth, the best kind of advertisement there is—you can't beat a good old recommendation from someone you trust. Imagine seeing a brand logo tattooed on someone's body—you have to imagine that person is pretty serious about liking that brand to go so far as to have it permanently tattooed on their body, right? Probably might make you consider that brand when it's time for you to make a purchase. Though it's counterintuitive (logos as tats?), it's a genius marketing plan. So genius, in fact, that some companies will run promotions, like free product giveaways or free vacations (sometimes even just cold, hard *cash*) if you tattoo their logo on your body. Harley-Davidson is one of the most commonly tattooed logos, but it happens without remuneration from the company.

That's some serious free advertising Harley-Davidson is getting from its loyal customers! I often wonder, what they do for these customers to show their sincere thanks. Oh yeah … they charge big money to attend their celebration parties every five years in Milwaukee!

Some bikers are flat-out stoked to bear the badge of a favorite motorcycle. Just as a runner may be loyal to a certain brand of running shoes, a biker becomes loyal to a favorite brand of motorcycle. The rider gets to know every inch of the machine, which eventually becomes an extension of their body. With such an intimate connection to the machine, it's only logical to have its logo inked onto your flesh; after all, riding *does* pretty much make you one with your machine.

Within one company there are many different logos. These logos cater to different aspects of the brand. One logo may be more racy (all about the speed of the brand), and another logo may be more cultural, showcasing the casual lifestyle the brand represents. The H-D Motor Company offers thousands of logo designs to suit every one of their dedicated enthusiasts. From the race fan to the weekend warrior cruiser fan, there is a logo design for everyone to showcase on his or her bicep, back, head, hand, and heart (well maybe not the heart, but you understand).

So why do these bikers go so far as to brand themselves? We can break it down to a few different reasons. Sporting a biker tattoo reveals a membership in a special cult or group—the tattoo gives the wearer

a way to bond with others who share the same passion or values. Another reason is that an image can harbor special personal meanings; looking at a logo tattoo can create a powerful recollection of all the positive memories associated with the brand. I guess another reason could be to connect with personal ideals or morals—the tattoo can remind the wearer of his or her ideal life, and they can draw inspiration from what it represents to them.

Whatever the reason, the big company is no doubt laughing all the way to the bank. And for some riders, that's OK.

—Sara Liberte

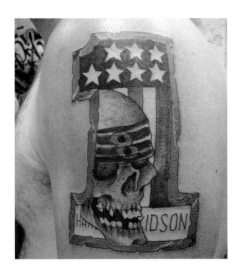

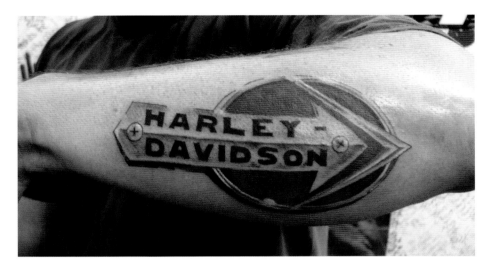

▲ This tattoo portrays the classic H-D No. 1 with American flag inlay, and this fan added a skull with the No. 8 on the headband—perhaps this is a racing number. Notice the orange accents—classic H-D colors!

▶ Above right: This arm tattoo is a perfect example of a classic Harley-Davidson tank emblem. The emblems were metal and used to be bolted to certain models of tanks.

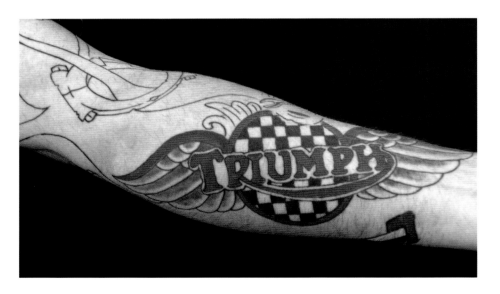

▶ Here is a devoted Triumph rider. Love for the brand has left its mark on the inside of this guy's arm, proudly displaying which make of bike he prefers.

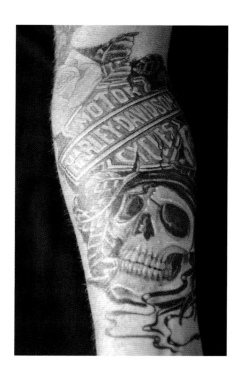

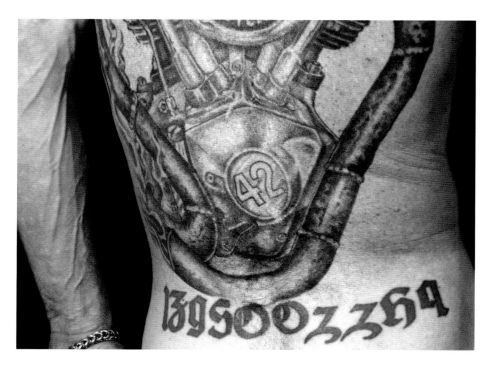

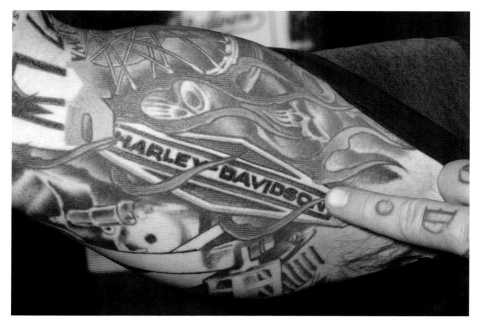

▲ Above left: Skulls, roses, H-D Bar & Shield—can any more be said about the devotion to Harley-Davidson than what is inked on this arm? The detail work in this piece is very impressive, and was inked by Long Jon at Sacred Skin Tattoo in Payson, Arizona.

▲ GTP—known in the motorcycle world as George the Painter—has his shovelhead permanently inked on his back, the perfect canvas for a large piece such as this. The numbers across the bottom make up the VIN for the engine—talk about dedication!

◄ This full-sleeve arm tattoo pays homage to a certain brand of motorcycle—yes, that's right, it's Harley-Davidson! *Bart Mitchell*

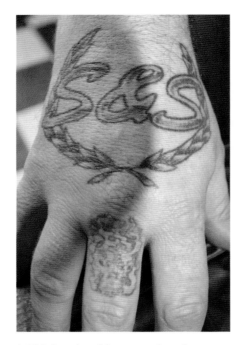

▲ This hand emblem reveals serious dedication to S&S, a company with an outstanding reputation for quality engines and parts made in the USA.

▶ Custom motorcycle builder Dave Perewitz displays his love of the Motor Company on his full-sleeve tattoo.

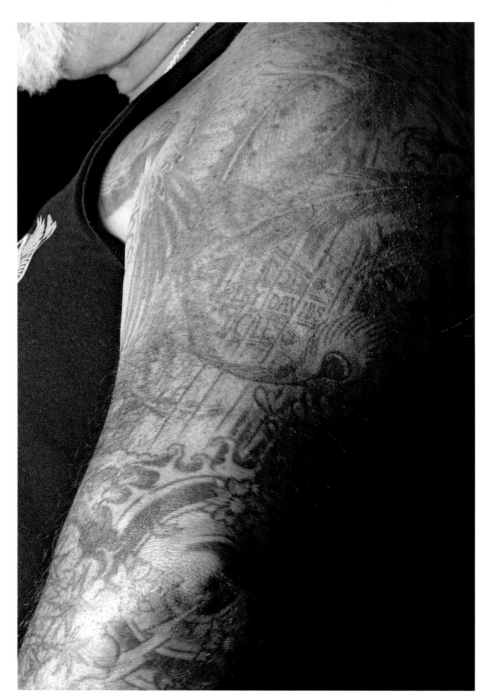

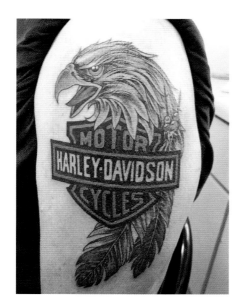

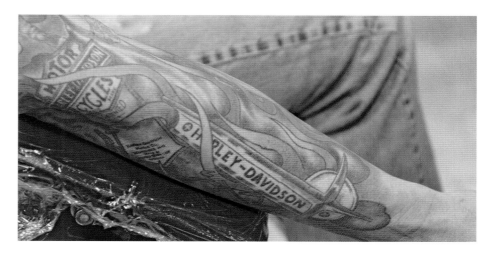

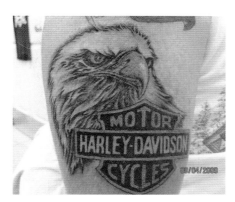

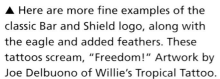

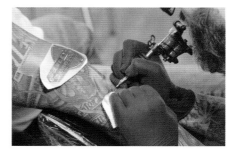

▲ Here are more fine examples of the classic Bar and Shield logo, along with the eagle and added feathers. These tattoos scream, "Freedom!" Artwork by Joe Delbuono of Willie's Tropical Tattoo.

▲ Take a look at the outstanding work depicting moto-brands and logos by the highly sought-after motorcycle lifestyle artist Darren McKeag of Slingin' Ink Tattoos.

This sleeve features numerous accolades to the "factory" and this rider's love affair with motorbikes, courtesy of tattoo artist Darren McKeag of Slingin' Ink Tattoos, Grinnell, Iowa.

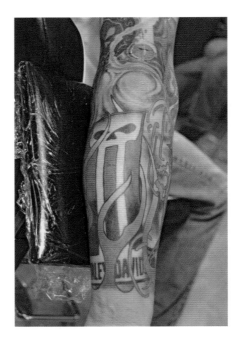 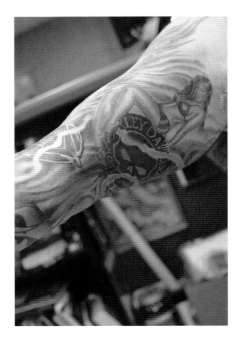

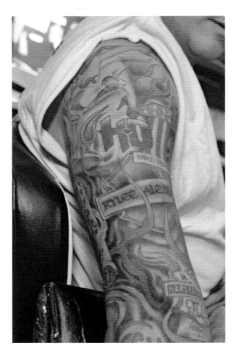 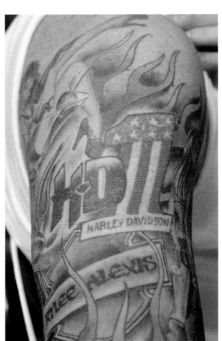

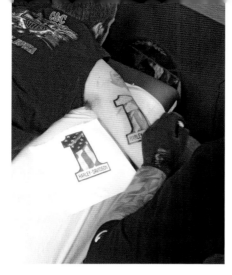

▲ Do you have a love affair with your brand of motorcycle too? A love affair so torrid that you are willing to endure hours of pain for it to permanently become a part of you?

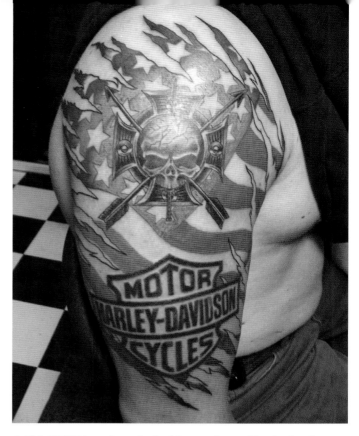

▲ This HUGE logo is part of a bigger piece with plenty of meaning. Artwork by D.C. of Willie's Tropical Tattoo.

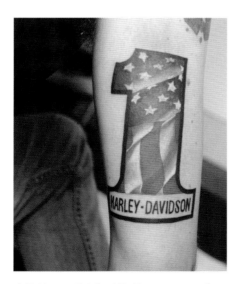

▲ Tattoo artist Scottie Bruggeman of Slingin' Ink Tattoos perfected this Harley-Davidson "No.1" Americana logo.

▶ A simple Bar and Shield with wings sits tall on the back of tattoo artist Noah Ogeen. *Steve Sullivan*

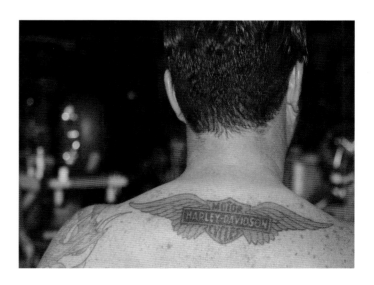

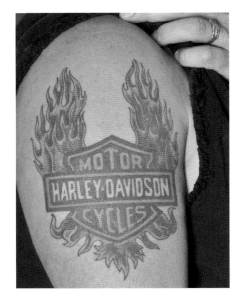

▲ "Up in Flames" is a good title for this different take on the classic Bar and Shield tattoo. *Bill Tinney*

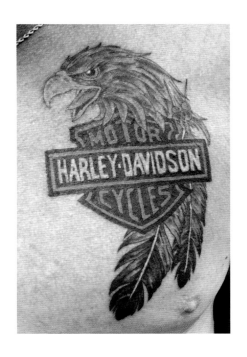

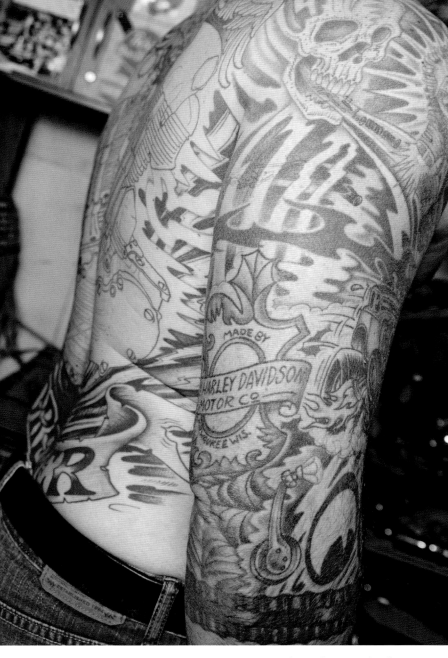

◀ Freedom is the theme of this brand tattoo. It's the classic Bar & Shield with eagle head and feathers, and "live to ride, ride to live" is what this biker tattoo is saying.

▲ In another tribute to the factory, this classic H-D emblem is part of a full sleeve.

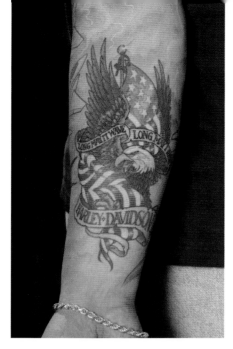

▲ Having the same passion for a brand as you do for your country shows die-hard dedication. *Bill Tinney*

▲ This work in progress features the lettering of Harley-Davidson beginning to show.

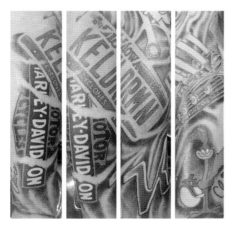

▲ Dedicating the entire real estate of your arm to a certain brand is nothing short of making a statement. I just hope he doesn't ride an ironhead—the constant maintenance could change his love affair real fast, and leave this boy with a serious case of tattoo regret.

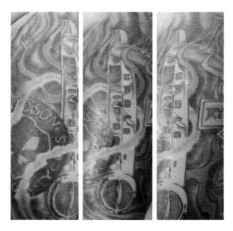

▲ I like the way this brand logo is worked into the full sleeve. The blended flames tie it all together.

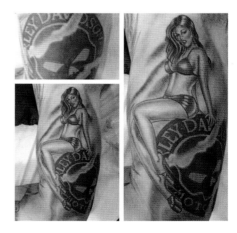

▲ Bikes, babes, and booze—what guy doesn't love these three things?

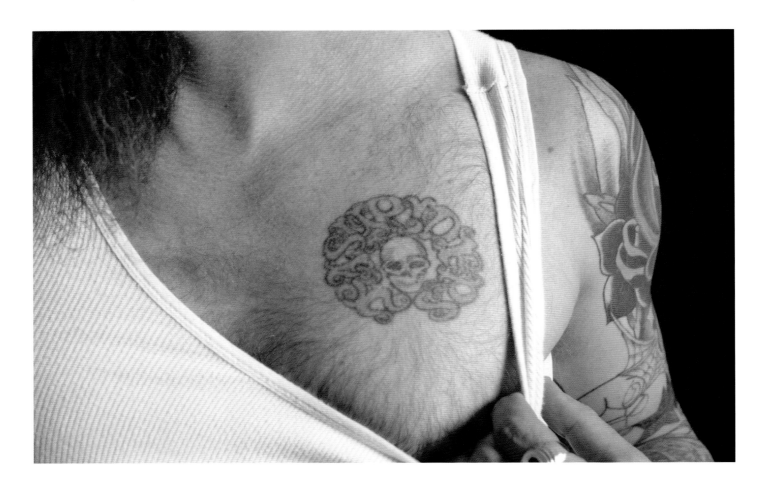

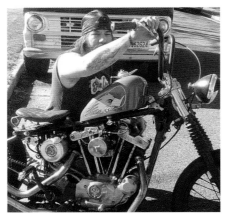

▲ If you like motorbikes, chances are you have read an issue of *Easyriders* magazine. This guy tattooed one of the older *Easyriders* logos on his chest.

◀ Larry Gregoire of Brooklyn, New York, has the "Thrush Muffler" logo tattooed not only on his arm, but also painted on the tank of his hardtail sportster.

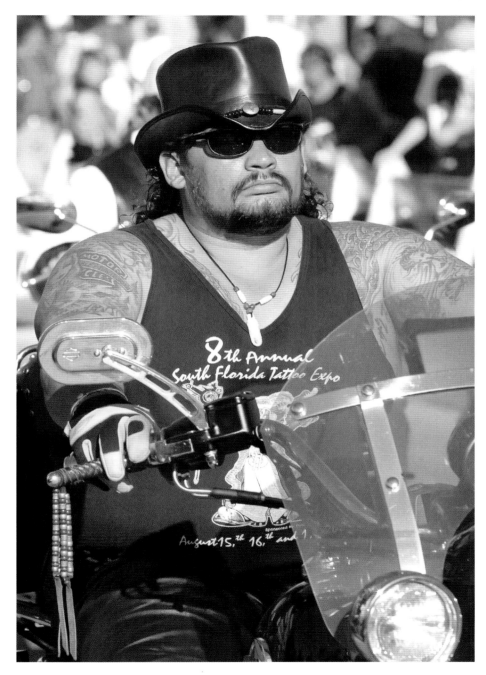

▲ I see a little love for H-D on this guy's fully covered arm.

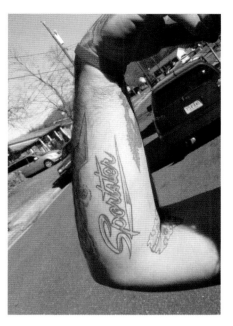

▲ Inked dedication to certain models of bikes isn't rare—this guy just loves his sportsters.

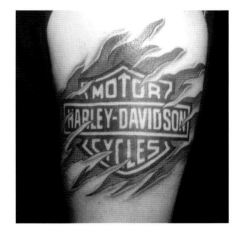

▲ Ripping flesh shows that deep inside this soul lives a passion for Harley-Davidson. The artwork is by D.C. of Willie's Tropical Tattoo, Florida.

Motorcycle Phrases

Bikers have many sayings, mottos, and maxims. In fact, they're almost as bad as some of their daughters, who text them trite statements like OMG (oh my god!), LOL (lots of laughs!), TTFN (ta ta for now), and ROTFLMFAO (rolling on the floor laughing my fucking ass off).

How many bikers do you know who say *ta ta*? Not very fucking many. And neither should their children!

Vendors, of course, are quick to cash in on these little biker sayings, with items like stickers, T-shirts, patches, and more. Bikers, like any serious enthusiast, gobble that shit right up. Some take these sayings as personal mottos, while others adhere to them as a serious way of life. Some mottos or ideas become so sacred to certain bikers, you'd think they were defending quotes from Scripture. Others prefer to have the words or letters permanently inked onto their skin as a constant reminder of who they are—maybe as a precaution in case they wake up one day with a bout of amnesia?

What are some of the things bikers tattoo all over their bodies? Well, some phrases express the lifestyle—the dirtbag, biker-bum lifestyle. George the Painter, for instance, proudly displays "Livin' La Vida Dumbass" as a necklace, and "Rat Life" for a hand bone tattoo. Out of all of his tattoos, I'd have to say his "White Trash Icon" arm piece is hands-down my favorite.

Another popular phrase we see is "Choppers," or "Choppers till you die." These guys are expressing their love for the stripped-down, far-from-the-factory machines that are ridden hard. They have no love for factory stock models, and may even sport some lettering tattoos like FTF, which stands for "Fuck the Factory." Speaking of hardcore letter tattoos, FTW is another popular one. This one usually has a few different meanings, but the most common ones are "Fuck the World" and "Forever Two Wheels." The speed guys might display WFO—"Wide Fucking Open"—representing how much they love to roll. The throttle is always on with these cats.

Regardless of the sayings you find around the motorcycle world, rest assured that some serious planning and thought was put into every tattoo, and the phrase carries strong personal meaning. Much can be told about someone from word, letter, or phrase tattoos.

—Sara Liberte

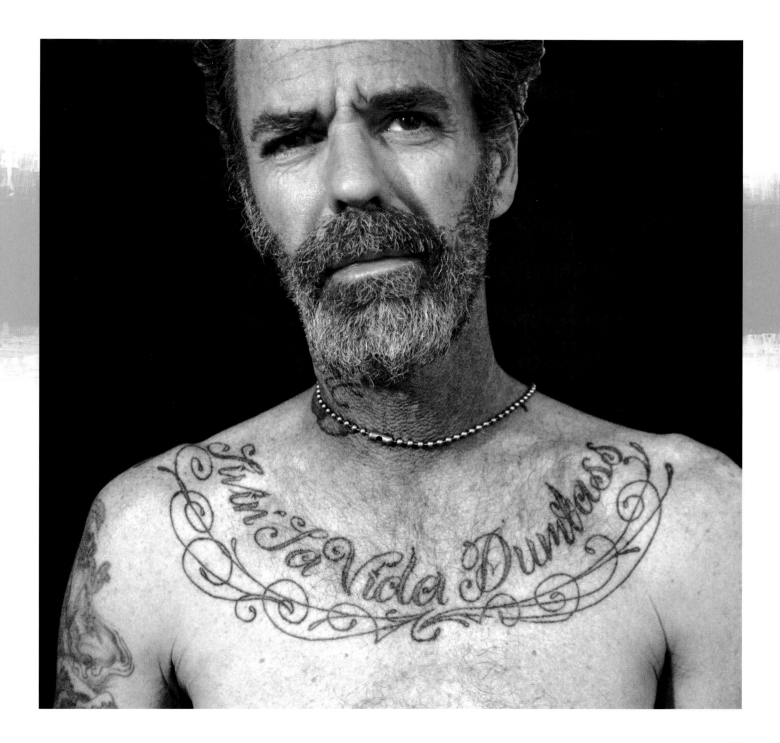

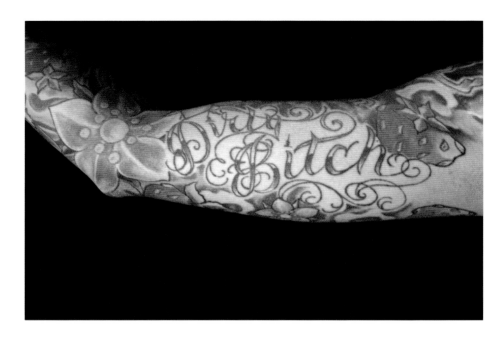

◀ "Dirty Bitch" tattoo artist Pinky Barwood, of Sacred Skin Tattoo in Payson, Arizona, displays her biker/gypsy attitude on her arm. "Dirty Bitch," she said, "it just seems natural."

▼ George the Painter says his collar tattoo sums up his life entirely: "Livin' La Vida Dumbass," it reads, "because that's what I'm doin.'"

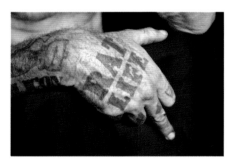

▲ George the Painter again displays his lifestyle ink: "Rat Life" adorns the top of his right hand. "You don't really need an explanation for that one," he told us.

▶ Above "Rat Life," George's arm reads "White Trash Icon." "That's what I am," he said. "I live in an RV and move around, I ride my motorcycle, and live a white-trash lifestyle."

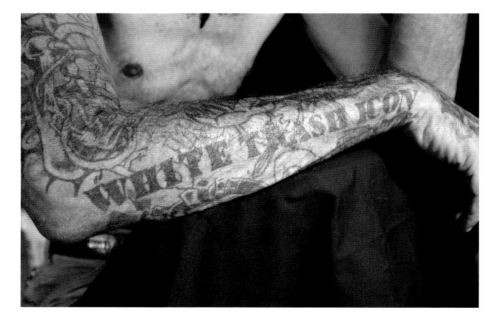

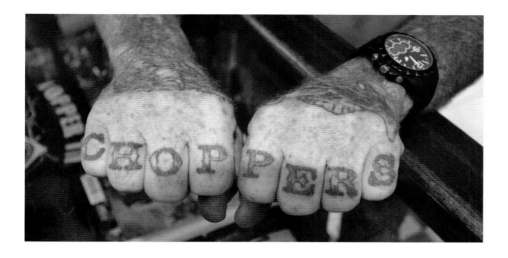

◄ Knuckle tattoos are a preferred place to display words of meaning. This tattoo is clearly from a dedicated chopper rider.

◄ "Let's ride" and "Hold Fast" are (according to my friends) my slogans in life, so I had these permanently inked by my tattoo artist, Brian Jones.

◄ "'Choppers 'til you die' says it all for me," says Mike Grawunder, of Ontario, Canada. "All of my tattoos relate to my life."

▲ This biker pays tribute to his childhood hero, Evel Knievel, a legend to many motorcycle enthusiasts.

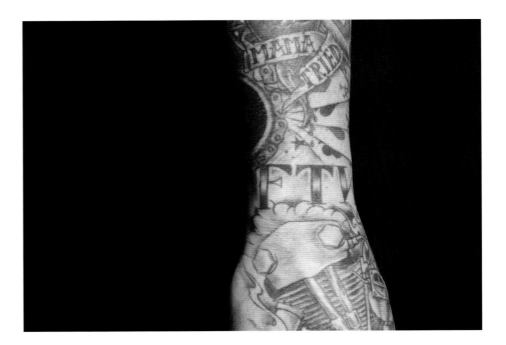

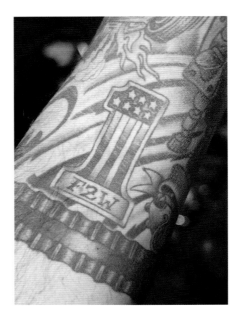

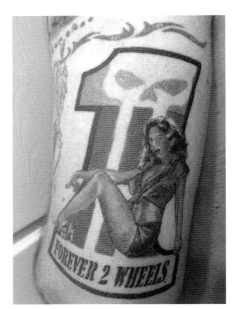

"FTW." We see these letters all the time in the motorbike culture, and they can represent many different things to many different people.

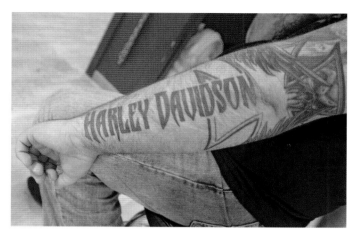

A script style statement says it all. If you want someone to know what you are about, bare it all in black and white or color.

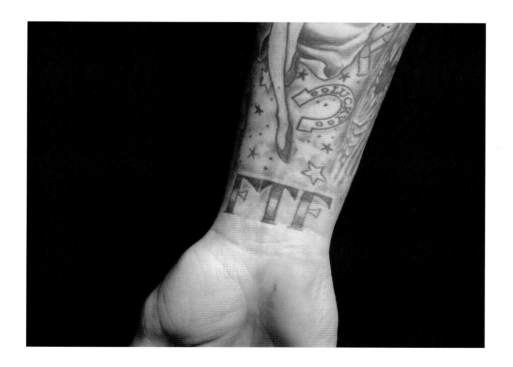

◄ "Fuck the Factory" is a saying heard constantly in motorcycle culture. While some are dedicated to factory models, others feel jaded by them, or taken advantage of by them.

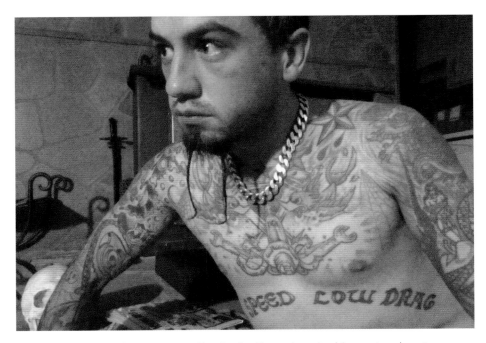

▲ With "High Speed, Low Drag," Charlie the Nomad carries his mantra close to his heart.

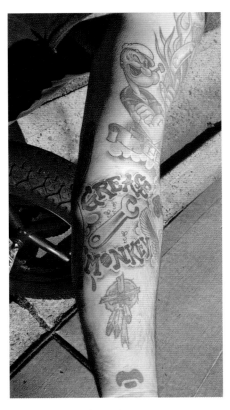

▲ "Grease Monkey" is a common term to describe a mechanic who prefers to work on his or her own cars or bikes.

◀ ◀ "Ride to Live" has got to be the most popular motorcycle phrase tattooed. This one means business with that sinister skull. The artwork was by D.C. of Willie's Tropical Tattoo in Florida.

◀ This biker's high-octane lifestyle prompted him to "knuckle-letter" his toes in a clever flip of the usual knuckle motif.

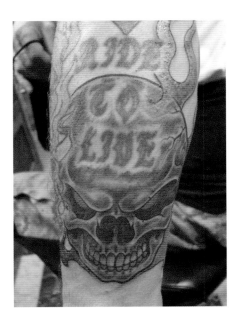

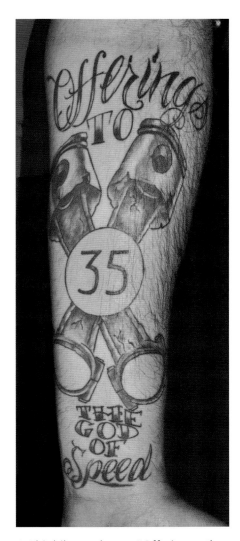

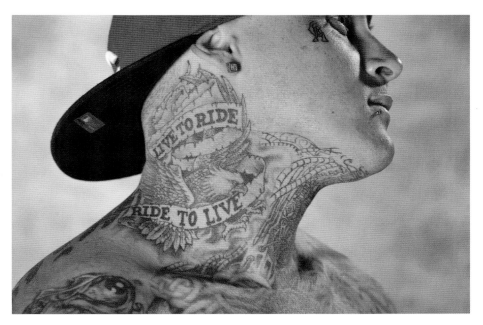

▲ A bold statement, especially for a neck tattoo—it must be your way of life, because those who "live to ride" "ride to live" as well. *Bill Tinney*

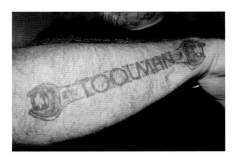

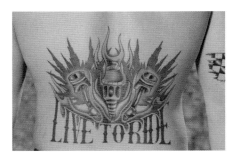

▲ This biker makes an "Offering to the God of Speed;" those crossed pistons and the number 35 can only point to one man: this is a tribute to the world's fastest Indian pilot, Burt Munro.

▲ The best part of a tattoo is the opportunity for self-representation, whether it's a portrait, an image, or a nickname like "Toolman."

▲ "Live to Ride" is proudly displayed on this back piece, as are some pistons and a spark plug. *Bill Tinney*

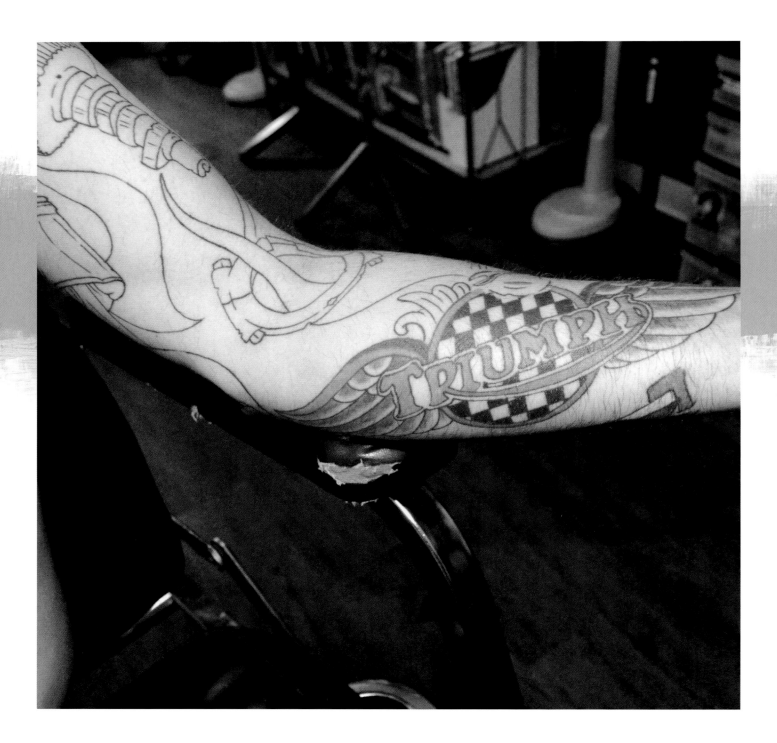

All Shapes and Sizes

Although bikers are often grouped under one big stereotype—good for nothing sleazeball—there are actually many different types or "classes" of bikers.

Let's cover the main categories. There are *gearheads*, who prefer to do their own mechanical work, and *weekend warriors*, who just want to "get their motor runnin' and head out on the highway!" Then you have the *speed freaks*; speed freaks are all about trying to race anyone and anything they can find at a red light. And let's not forget the *dirtbags*; these guys ride hard and party harder (don't worry, they won't be offended by the name—they embrace it!). We can go even further and break the classes down into the types of bikes that are ridden: the hardcore, old-engine guys; early knuckleheads and panheads; hardtails; dressers or baggers; cruisers; sport bikes; and performance-geared chassis like the FXR guys. Whatever their type, their dedication, passion, and personality can be seen in the ink they put on their bodies.

So what type of ink do these different types of bikers get?

Well, the gearheads may choose engine parts, pistons, spark plugs, or magnetos. The cruiser guys may have eagles, wings, or anything relating to the feeling of freedom they get from riding their bike. The sport bike guys might have racy symbols, or checkered flags and such. The point is that by looking at an arm of tattoos on a biker, you can get an idea of what type of biker they are, and maybe a glimpse of what they deem most important in the biker lifestyle.

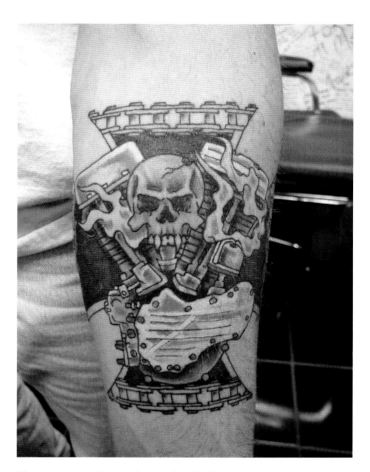

The iron cross, the panhead, the skull, and flames—this tattoo just sums it all up. The biker lifestyle is here for all to see.

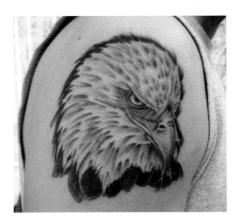

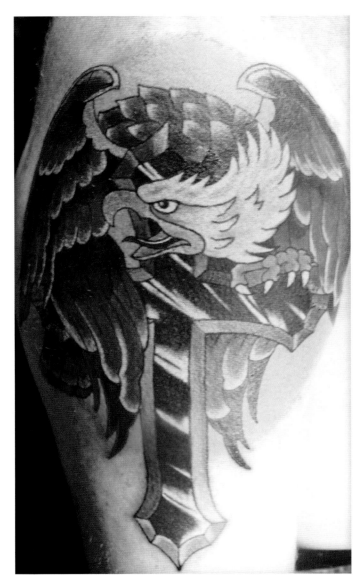

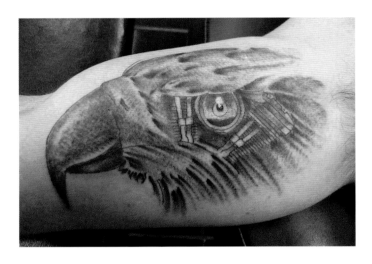

The bald eagle is a symbol that seems to go hand-in-hand with motorcycling and bikers. As an American symbol of freedom, eagles are always showing up on bikers as tattoos.

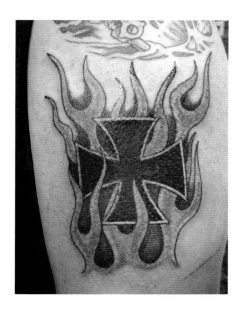

◄ The iron cross became popular when Jesse James of West Coast Choppers hit the scene back in 1999 with his hardcore rigid choppers. It seemed everyone was wearing a WCC T-shirt with the iron cross, and some wanted a tattoo of the old-world symbol.

◄ A winged wheel on the calf is all this guy needs to remember his favorite pastime.

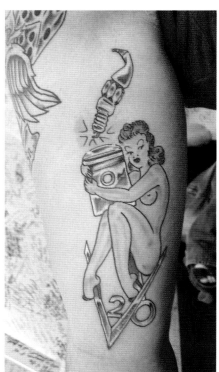

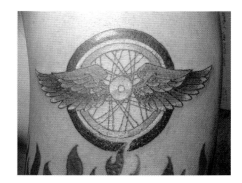

◄ Pistons, spark plugs, and pinups—all symbols of the custom moto-culture that motorcycling belongs to.

▲ Wings and wheels is a simple statement of the love of the freedom obtained from riding. "Riding is so much like flying," this biker told us, "there is nothing better and no better way to describe it."

▶ We love this play on Route 66! It's every motorcycle rider's favorite stretch of American blacktop to ride, and this has a true hardcore biker's twist on it—Route 666, Satan's path to eternal damnation!

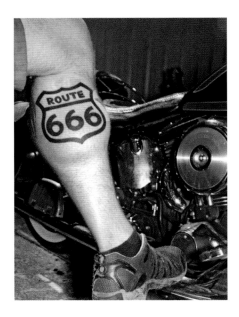

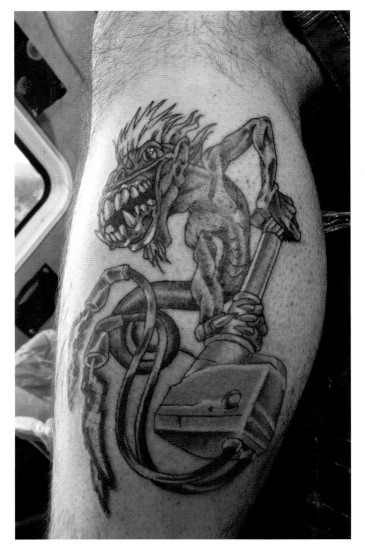

▲ This is a magneto demon, because everyone who owns a motorcycle with a magneto knows there is a demon living in that thing.

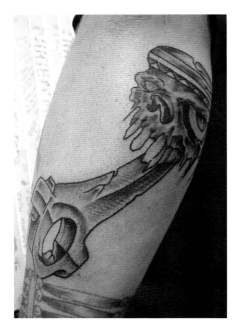

▲ We like this piston skeleton tattoo— it would also be a cool jockey shift.

▶ It seems every gearhead gets a piston on them at some point. Flames are always great fillers on arm sleeves.

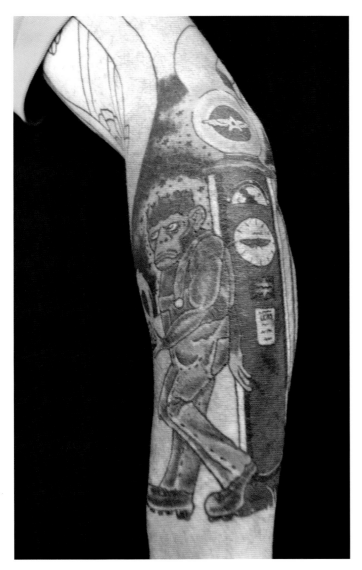

▲ A grease monkey hanging out against an old gas pump; moto-culture at its finest.

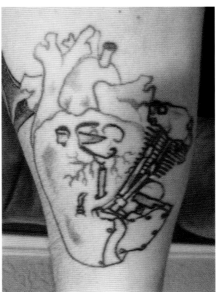

▲ For Buddy Montgomery, of Kansas City, Missouri, "The knucklehead heart shows the relationship of the biker and his love."

▶ Nothing says dedication to your engine like having the VIN tattooed above your ass. If that isn't proof of ownership, I don't know what is.

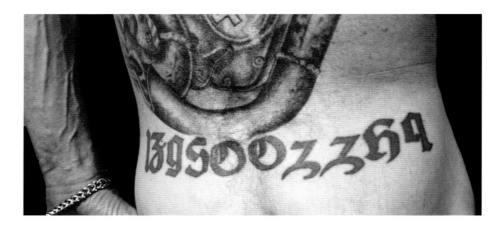

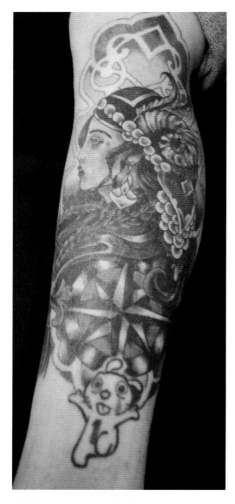

▲ This moto-gypsy belongs to tattoo artist Pinky Barwood of Sacred Skin Tattoo. "My gypsy lifestyle of riding and traveling is right here in this art of mine," she says.

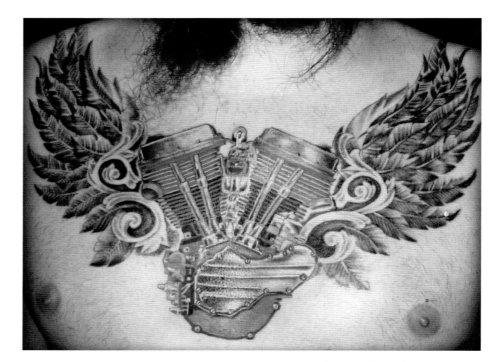

▲ This panhead with feathered wings chest piece is extremely cool; the detail is amazing, and only the manifold has color.

► The eagle is a common motif among motorcycle enthusiasts, although you don't see many on stomachs. *Bill Tinney*

▼ The Ratfink is always a clear giveaway of a moto-culture fan. The artwork is by Joe Delbuono of Willie's Tropical Tattoo in Florida.

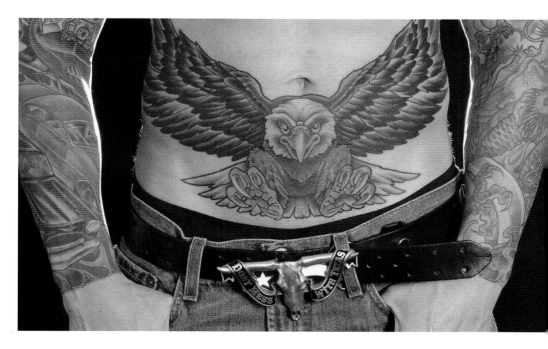

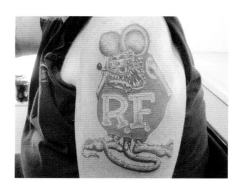

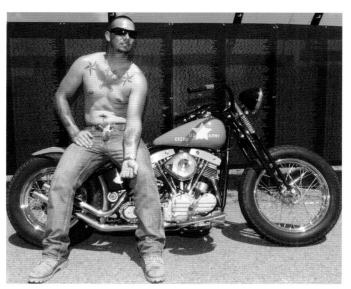

▲ Of course, military history dovetails well with motorcycles and tattoos. What a bad-ass bike! *Bart Mitchell*

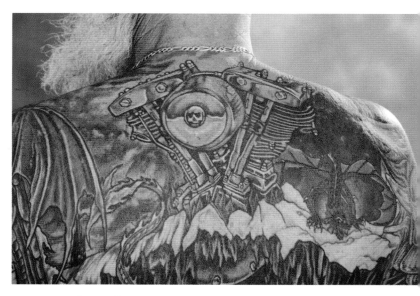

▲ Intense color work on this back piece is centered around a shovelhead engine. *Bill Tinney*

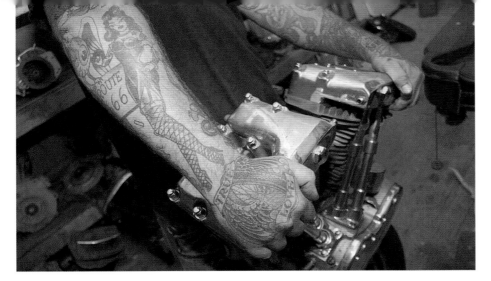

▲ Tattoo artist Noah Ogeen shows off his ink and this cool shovelhead engine. *Steve Sullivan*

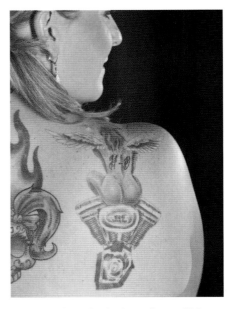

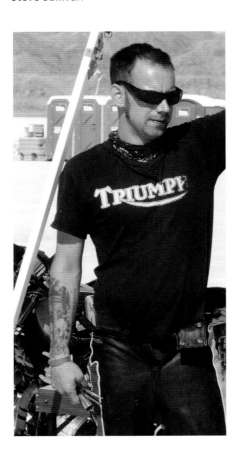

▲ This girl no doubt has a love affair with her V-Twin engine. A cool naked angel with "H-D" tattooed on her own back sits on top of it. *Bill Tinney*

◄◄ A true motorcycle enthusiast on the salt at Bonneville. Racing is in his blood and depicted on his flesh. *Bart Mitchell*

◄ Tattoo contests abound at rallies, and attendees proudly display their love of motorcycling on all parts of their bodies. This guy shows off his skull pistons and spark plugs, and what looks like an eagle and wrench can be seen beneath his shirt. *Bart Mitchell*

▶ The lucky No. 13 just screams, "I have had an engine blow up on me."

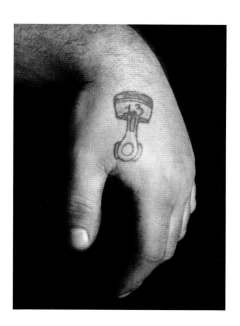

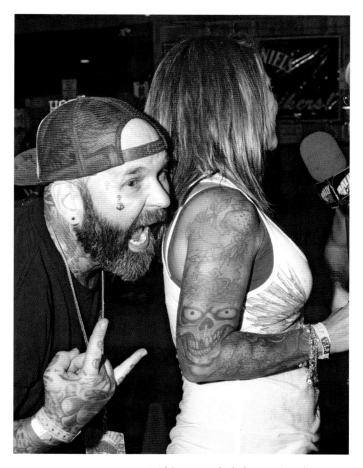

▲ This young lady has a nice sleeve with artwork relating to motorcycling. *Bart Mitchell*

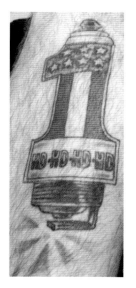

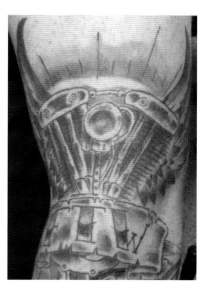

▲ Whether they're displayed by themselves or part of an entire sleeve of moto-culture artwork, spark plug tattoos are found all the time.

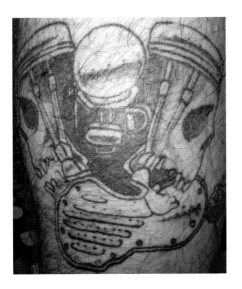

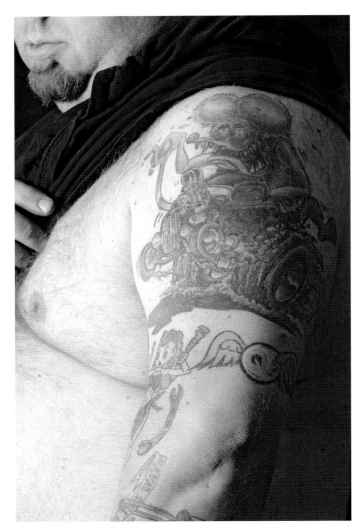

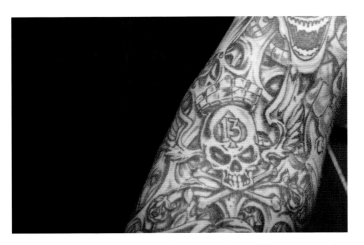

▲ ▲ The powerplant of the motorcycle, often referred to as the "heart" of the machine, is one of the most common biker tattoos permanently inked into the skin of the proud owner.

▲ The hot rod culture overlaps with the motorcycle culture, so symbols of the Von Dutch, Ed Roth era are commonly inked on the skins of moto-junkies.

▲ Skulls, wings, and flames—all the necessary components for the perfect biker full-sleeve tattoo.

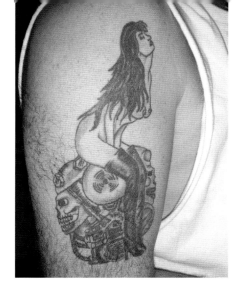

▲ "Going for a ride" has never been taken so literally! Here, an engine, skulls, and a long-legged temptress all make for the ingredients of a good ol' biker tattoo!

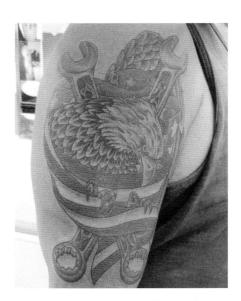

▲ An eagle, an American flag, and some crossed wrenches make it easy to tell that this guy is a fan of American-made power. The artwork is by Joe Delbuono of Willie's Tropical Tattoo in Florida.

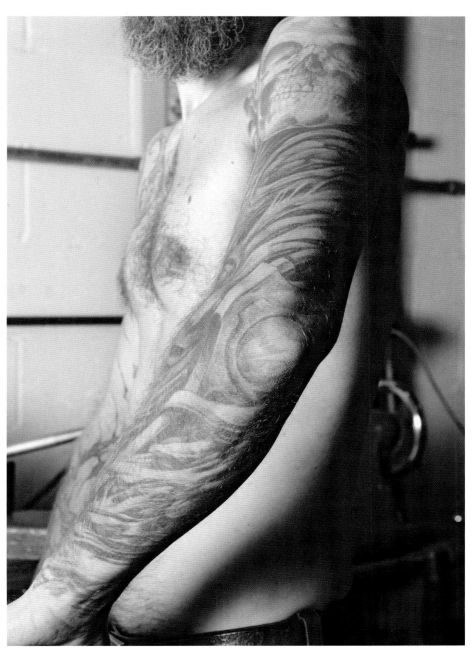

▲ The piston's connecting rod is cleverly positioned on the elbow of Iliya Hamovic, of Steelborn Choppers.

Slingin' Ink owner and specialized tattoo artist Darren McKeag prepares to lay down the start of a motorcycle sleeve. This tattoo will be composed of engine components.

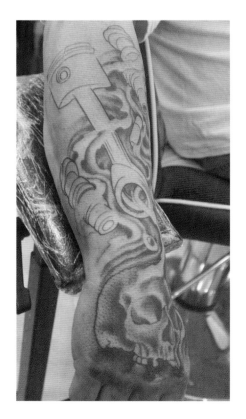

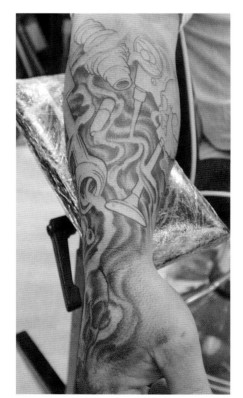

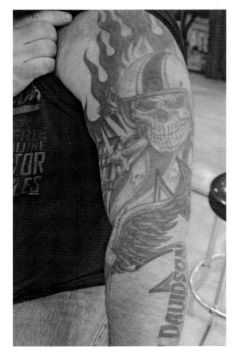

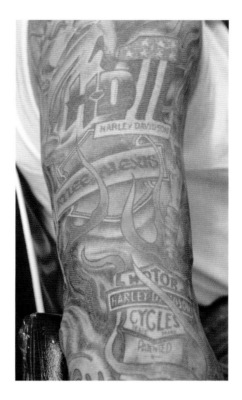

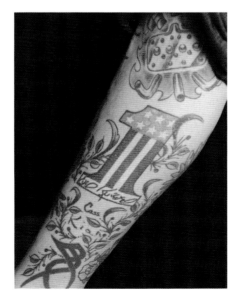

◄◄ This arm features another tribute to biker icon Evel Knievel.

◄ What a loaded arm! This guy's colorful limb features, in no particular order, three H-D tributes, at least two pretty ladies (see the heel above and the boot on the right?), an homage to a woman named Rylee Alexis, and an incendiary infernal Hellfire billowing over his elbow; who knows what else we can't see?

◄◄ This dedicated H-D biker bicep features a skull with a motorcycle helmet, wings, and the flames of hell igniting his shoulder—no question this guy rides a motorbike and loves it.

◄ This arm features another tribute to biker icon Evel Knievel.

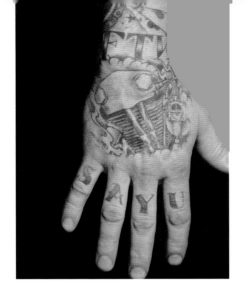
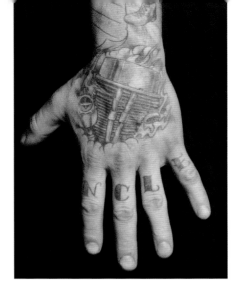

◄ This guy's engine-revvers feature more top-of-the-hand engine tattoos—a panhead on the right and a knucklehead on the left. He looks like a brawler—his finger ink exclaims "Say Uncle." Shit, these are awesome!

▼ Motorheads are motorheads—they like cars, bikes, and anything they can work on and go fast with. That V8 ain't for tomato juice!

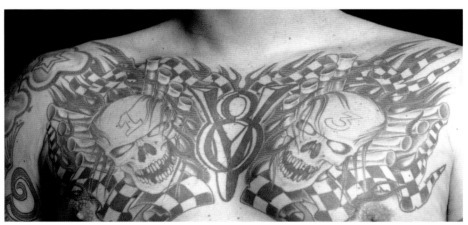

▲ Chains, spark plugs, ladies, sprockets, and skulls—more ingredients to a great biker tattoo.

► Route 66 is aflame, along with a Harley-Davidson logo, a few wrenches, and a greasy sparkplug. This sleeve is dedicated to motorcycling. *Bill Tinney*

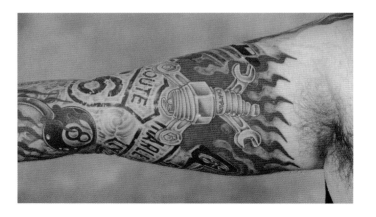

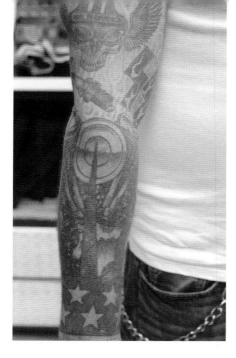

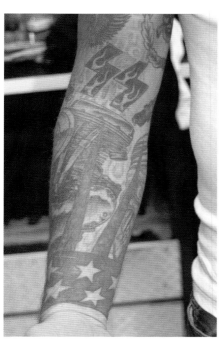

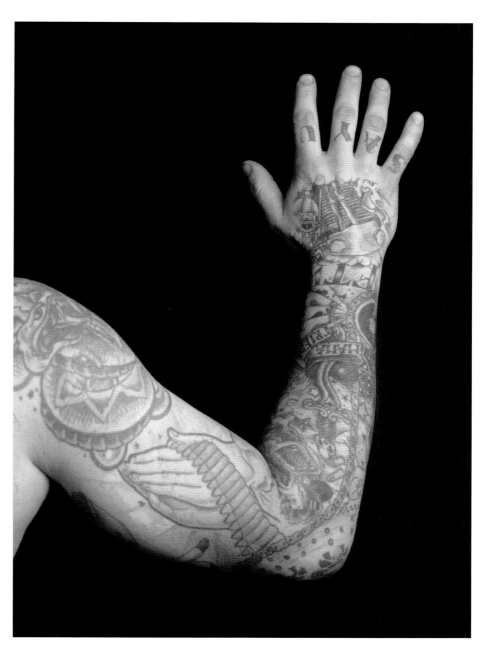

▲ This full sleeve is full of motorcycle components. The artwork is by Joe Delbuono.

▲ Though unconventional, the top of the hand is a great place to display an engine. What else can you spot on this guy's sleeve?

This intricate full-sleeve tattoo has lots of cool hidden things—you'll often find spark plugs, skulls, and spider webs when scoping out a sleeve.

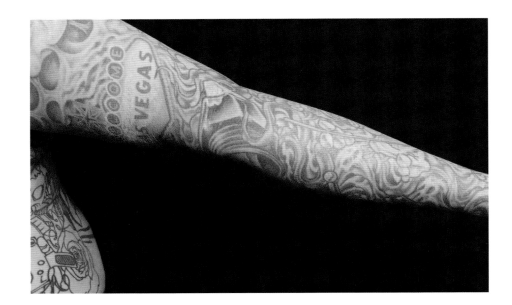

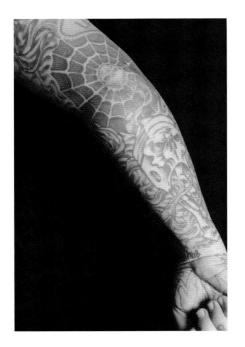

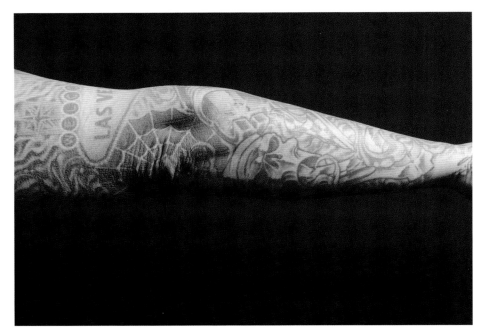

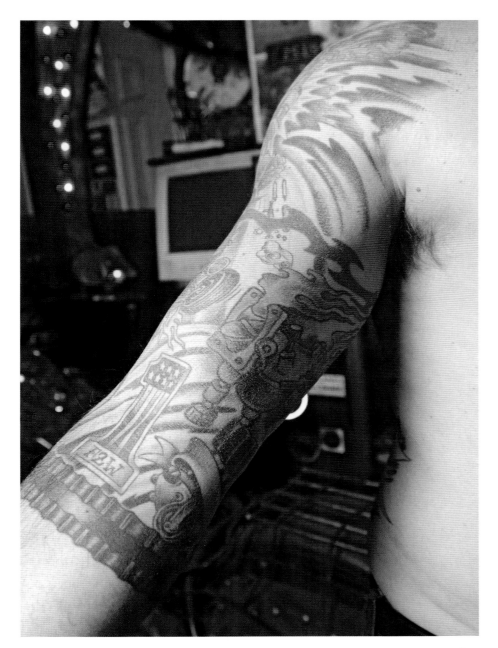

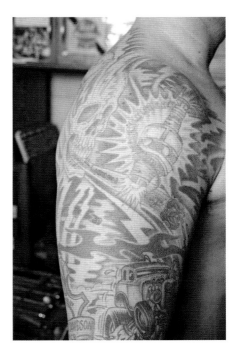

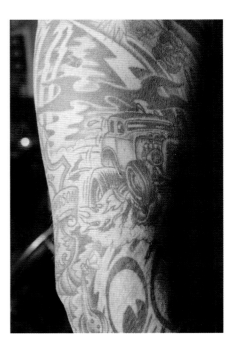

Motorheads love moto-culture—but most don't limit themselves to bikes or cars only. It's common to see both a motorcycle and car (or automotive symbols and subjects in general) combined on a full sleeve.

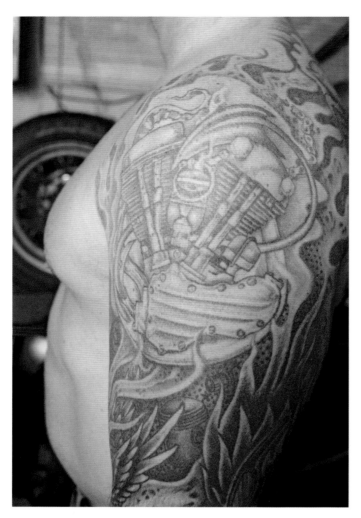

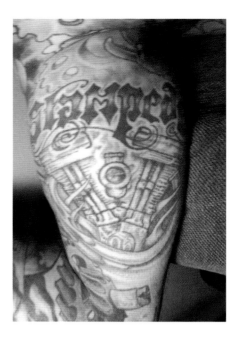

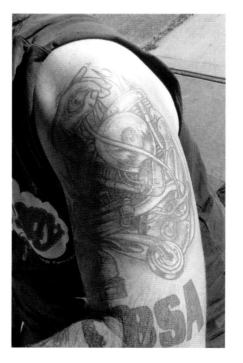

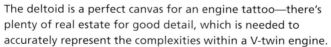

The deltoid is a perfect canvas for an engine tattoo—there's plenty of real estate for good detail, which is needed to accurately represent the complexities within a V-twin engine.

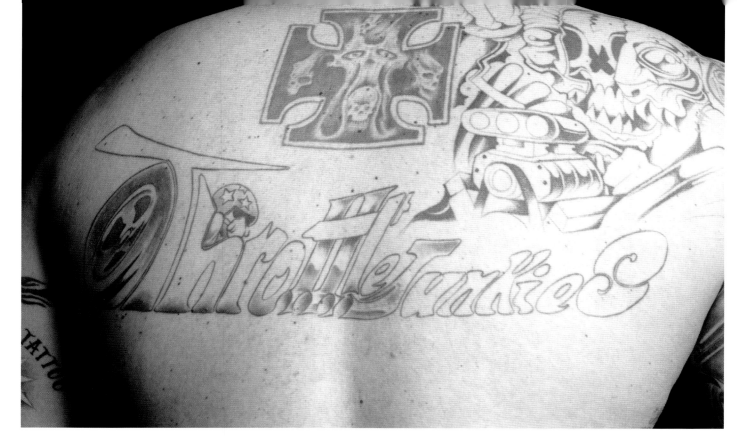

▲ Many tattoos cannot be completed all at once. You can see where the artist has started to create the chrome patina for this throttle junkie's work in progress.

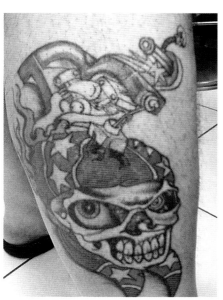

▲ Above and right: Skulls and engines go together like peanut butter and jelly.

▲ These engine parts are not quite complete yet.

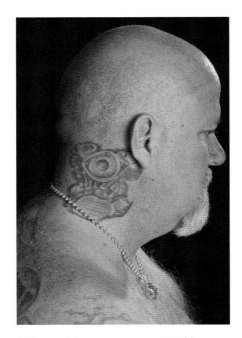

▲ Some riders are so committed to a certain power plant that they have it tattooed onto themselves. *Bill Tinney*

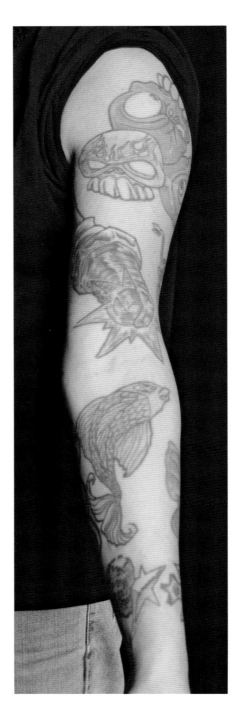

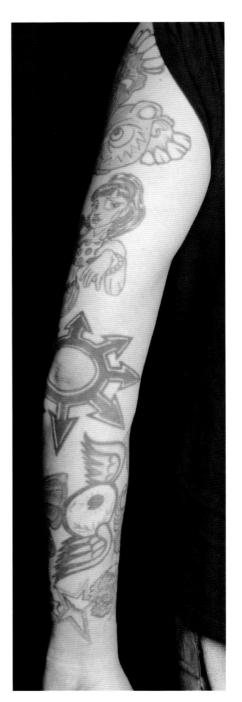

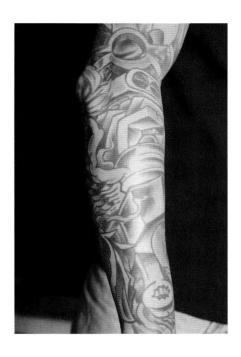

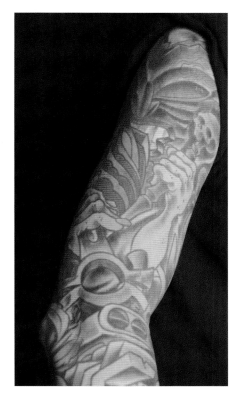

Here are some great examples of full sleeves with intense colors and vivid pictures, many of which blend motorcycles with greater automotive culture. From pistons and blown hot rods to skulls, spark plugs, connecting rods, ladies, and more (fish and winged eyeballs?!), it's all in there. If guys like this are cool enough to let you check out their art up close, consider yourself lucky; not only is this great stuff to look at, the artwork is of high caliber.

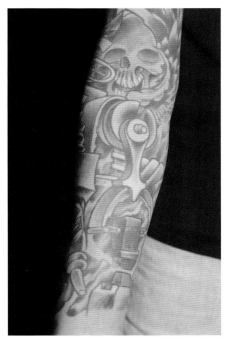

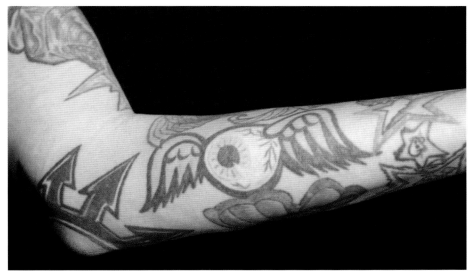

▶ What's your definition of dedication? This guy used to lose his parts manual all the time, and then decided to just have the exploded engine view tattooed over his love handles for easy reference. Smart like a fox!

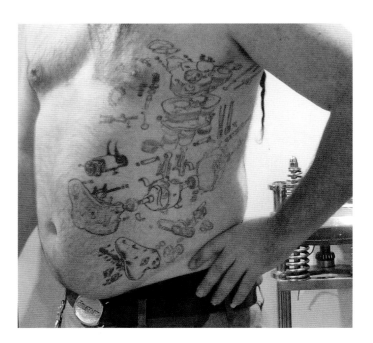

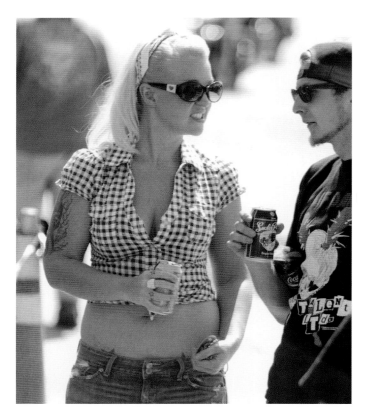

▲ Sometimes your ink leads to sweet dates. Who knows where the day will lead for this gingham-clad beauty and her Sucker-Punch slurpin' companion? Savvy readers will spot two things about her right away—the flames on her arm, and the wings peeking above her waistline!

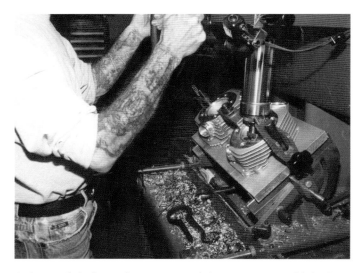

▲ An armful of tatts is a common sight on many machinists' and mechanics' arms. How many parts from his cabinet do you think are on his arm?

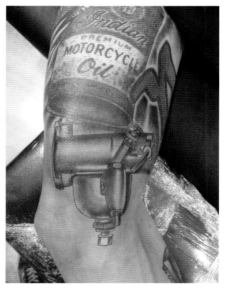

▲ Motorcycle memorabilia like the classic Indian oil can and the carburetor below clearly state this guy is into the older, more vintage motorcycle culture.

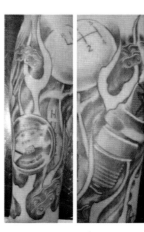

▲ We're pretty sure it's safe to say that this guy had some electrical issues to work out on one of his motorbikes—a gremlin near a magneto cannot be a good thing!

▲ Engine parts, billowing flames, and greasy motorcycle chain all make for a great moto-inspired sleeve.

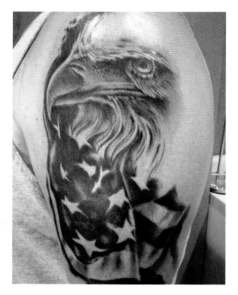

▲ Eagles and motorcycles are both symbols of freedom—this fresh tattoo speaks volumes about the biker.

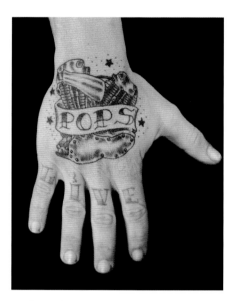

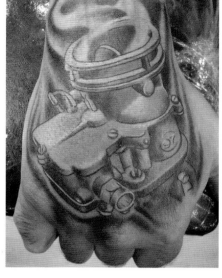

▲ The only thing you'll hear if you mess with these guys is a four-knuckled crescendo of pain! Hand bones are great canvasses for these knuckleheads and carburetors. The biker's father may have been the inspiration for his big twin tattoo—nothing like riding with your pops!

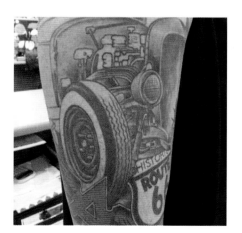

▲ For many lifelong bikers, tattoos are less an aesthetic choice and more a lifestyle statement.

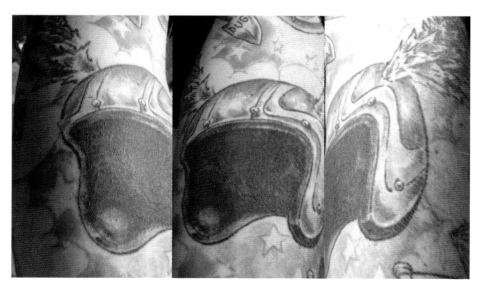

▲ This guy's arm features a motorcycle helmet spewing sparks onto his shoulder. The artwork here was done by Latricia Horstman.

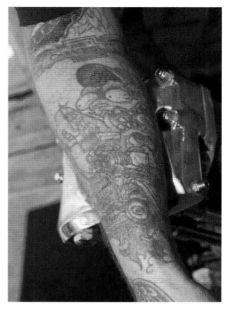

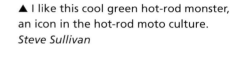
▲ I like this cool green hot-rod monster, an icon in the hot-rod moto culture. *Steve Sullivan*

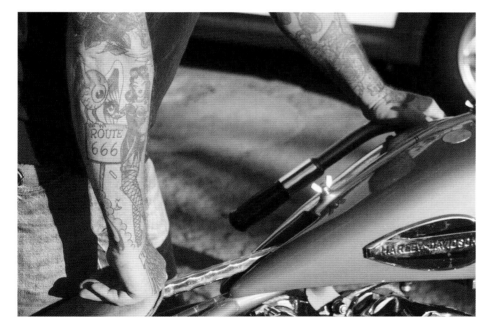
▲ A take on one of the most favored roads to ride across America—Route 66—now becomes Route 666. *Steve Sullivan*

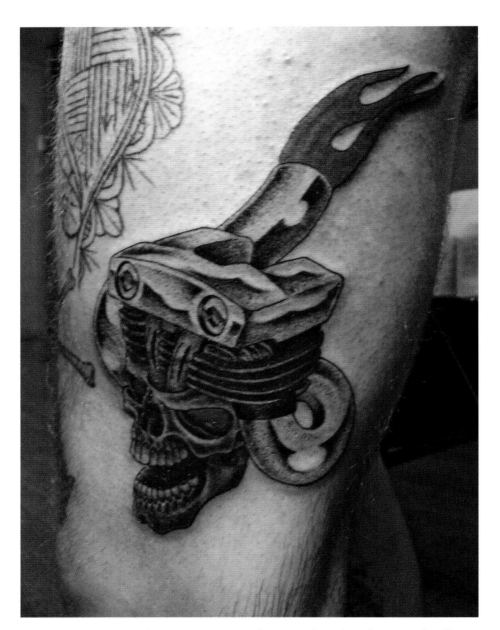

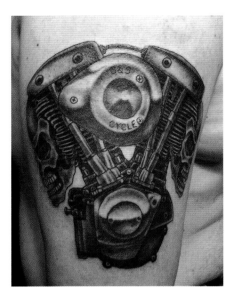

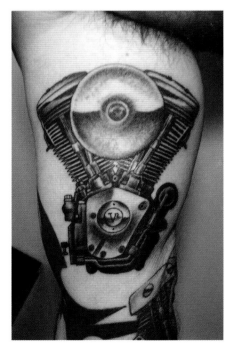

Some tattoo artists excel at certain genre's subjects, and it's clear that D.C. of Willie's Tropical Tattoo has a thing for V-twin engines. His work is highly detailed.

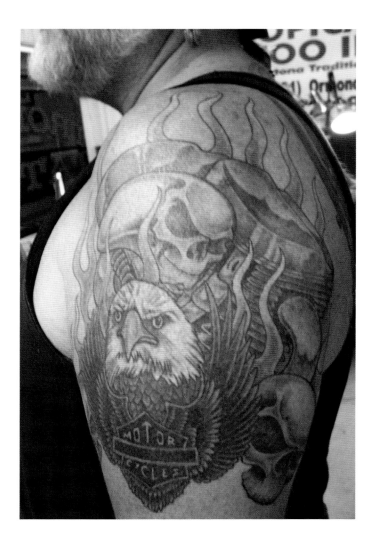

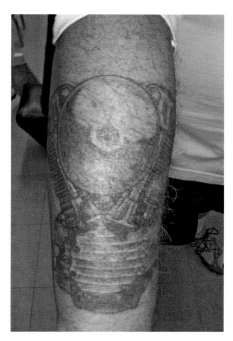

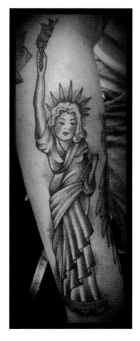

◀ A pin-up–style Statue of Liberty is a cool take on the American theme. The artwork is by Richie Pan of Dark Star Tattoos in New Jersey.

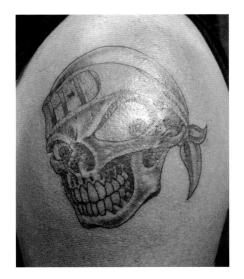

▲ A different way to show loyalty to a brand could be a skull wearing an H-D headband. The artwork is by D.C. of Willie's Tropical Tattoo in Florida.

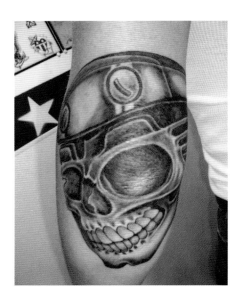

▲ Another tattoo by D.C. of Willie.

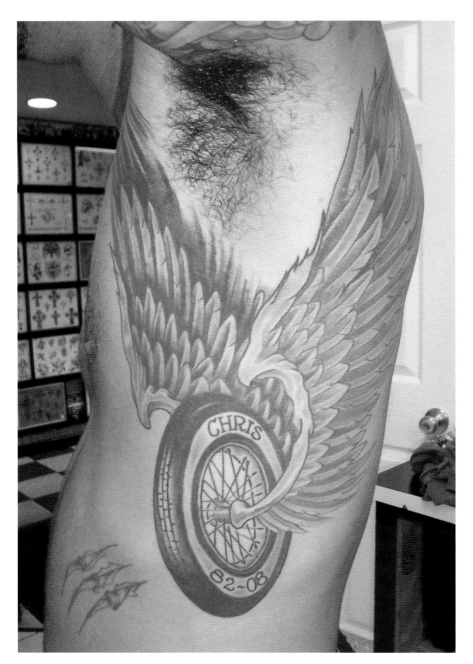

▲ A wheel with wings has been a motorcycle symbol since World War II, and this beautiful side piece was done by D.C. of Willie's Tropical Tattoo in Florida.

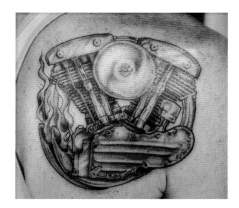

▲ Check out the incredible detail on this engine back piece by Richie Pan of Dark Star Tattoo in New Jersey.

▲ A traditional black and gray tattoo of a classic engine. The artwork is by D.C. of Willie's Tropical Tattoo in Florida.

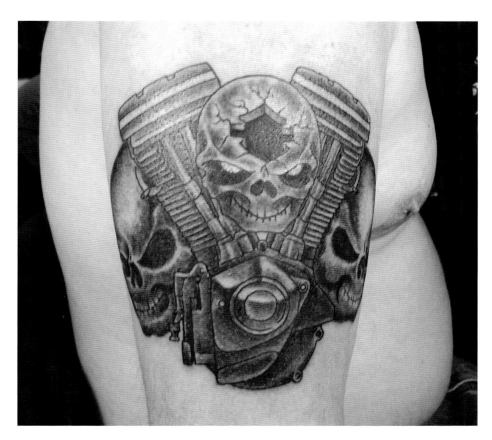

▲ This cool Evo engine features three skulls; the middle one even has a Bar and Shield outline in its head. The artwork is by D.C. of Willie's Tropical Tattoo in Florida.

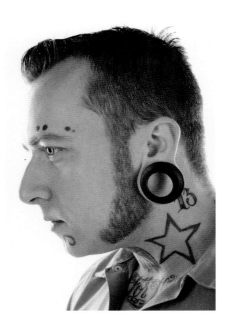

◀ Despite the native South Sea tattoos around his eyebrows, chin, and that hoop in his ear, this guy features what could be called a Sturgis star right above his jugular. *Shutterstock*

▼ This woman of the road has one sleeve, and the other looks like it's a work in progress. And is that an Indian Larry "Question Everything" tattoo above her elbow? *iStock*

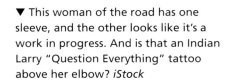

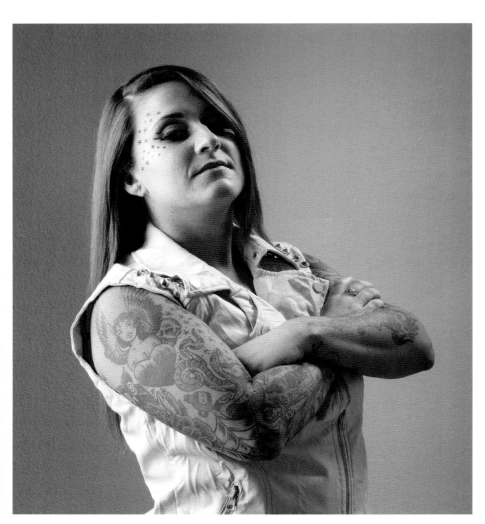

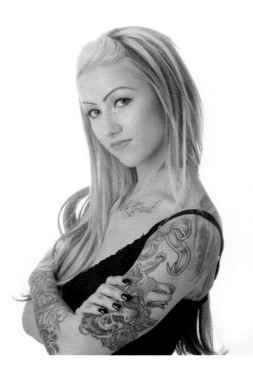

◀ Ladies can ride—this one has a necklace tattoo beneath her chin, wings around her neck and shoulders, a sword-and-skull motif on her upper arm, and more intricate webbing below her elbow. *Shutterstock*

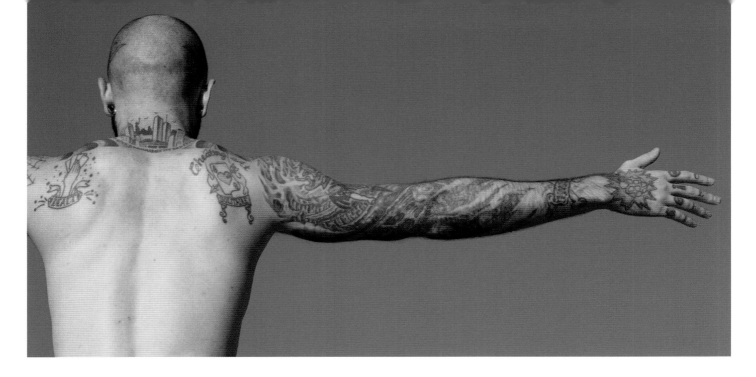

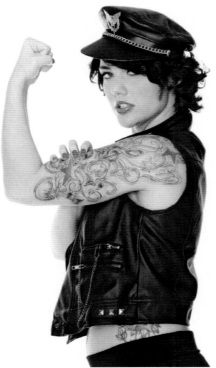

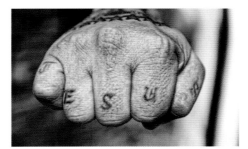

▲ A clear blue sky is the perfect backdrop for this guy's inky wingspan. *Shutterstock*

▲ Who wants a Jesus sandwich? You'll find all kinds at motorcycle rallies. *iStock*

◄ This biker babe has the stars of Sturgis constellating up her arm. *iStock*

► Another Sturgis constellation can be seen behind this dude's meaty arms. *Shutterstock*

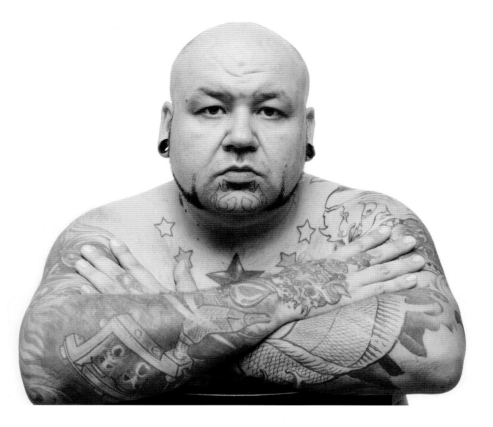

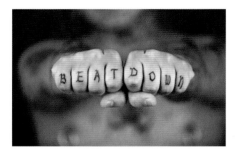

▲ I don't think this guy and the one with "Jesus" on his knuckles would see eye-to-eye on every issue. *Shutterstock*

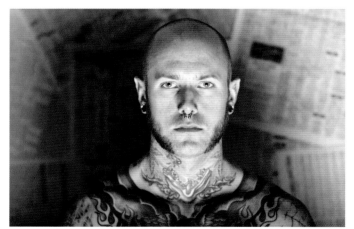

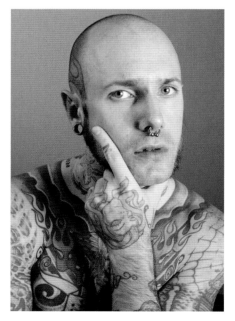

▲ Above and right: This guy features an entire torso of intricate figures; we can't see it, but his chest features a V-twin knucklehead below and an eagle behind his hand. *Shutterstock*

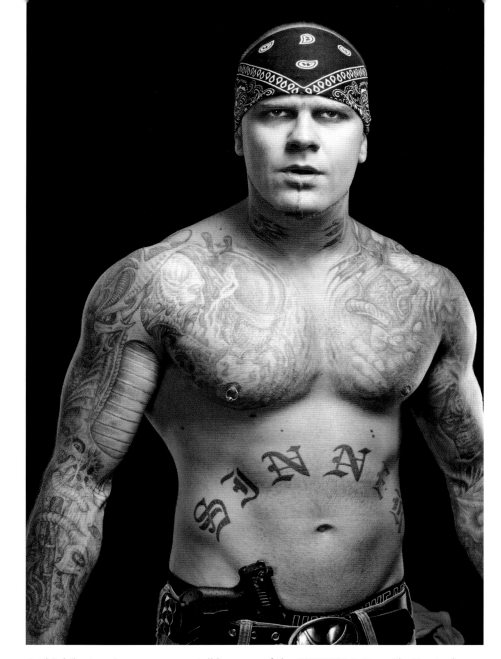

▲ Sometimes listening to Thoreau is what's best for a biker: "Simplify, Simplify, Simplify" with a pair of shoulder crosses. *Shutterstock*

▲ This biker's a sinner—you can tell because of the "SINNER" tattoo. *Shutterstock*

▶ That is one big biker—he features an angel (or possibly his child or lover) on his upper arm, traditional henna-style tattoos on his chest, and more on both forearms. *Shutterstock*

Bikes on Bikers

For some bikers, the best tattoo is of a motorcycle. It's usually their own bike (or one that was handed down from generation to generation), and holds a lot of sentimental value. These are the guys who, when you ask them about their tattoo(s), tell you a very cool and personal tale. It's these stories that I love—stories of how a father purchased a bike brand new as a young man and courted his wife with rides; stories of how the bike was the only means of transportation in the family for years, and then how the bike was handed down to the son; how that son took such good care of the bike, servicing it in the garage, making sure it was always in top running condition and started with just one kick every time. Dad might have taken his son out for a ride on that bike, as well as the occasional moonlight ride with Mom on a Saturday night. Tattoos that reveal personal family history are my favorites.

We also see tattoos of fictional motorcycles—animated bikes with animated characters riding the snot out of them, like the old Ed Roth–inspired big green jockey shift monsters, slamming gears and sliding in sideways! These are very cool pieces of art, and I enjoy looking at the level of detail in these tattoos. There is always something cool hidden in the art that has a personal meaning.

Some motorcycle tattoos are of dream bikes, the one the wearer covets. The tattoo is a constant reminder of their goal—someday the inky engine on the arm will be a real engine sputtering oil underfoot. Other tattoos could be the dream bike that slipped through the biker's fingers, the one that got away. Some regret their early bike sales of what would later become classic motorcycles, like early panheads and knuckleheads from the 1930s and 1940s. We see tons of these tattoos and listen to the sad stories that go along with them. "If only I had kept that bike . . ." It's a story everyone can relate to, a vision of a dream now past.

—Sara Liberte

Who knows what the creature is riding the bike, but it's pretty badass to be riding a rigid chopper with ape hangers!

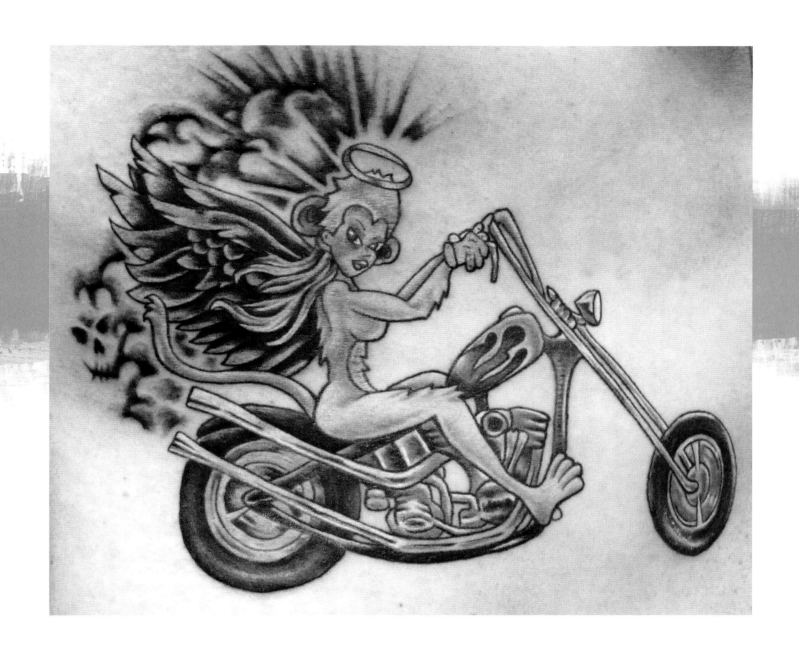

► Is there anything more badass than a vegetable on a motorcycle? Of course there is. This biker must be from the Midwest—a corn cob screamin' down the highway atop a motorcycle just screams "Hey, I'm from the Midwest, I like corn and motorcycles." *Bart Mitchell*

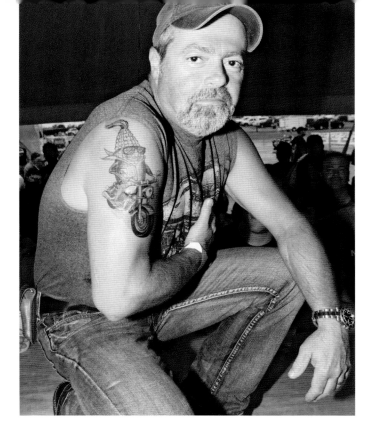

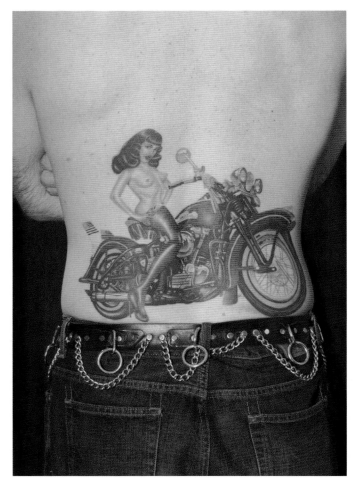

▲ A cool Bettie Page–style pin-up lady straddles an old Knucklehead. *Bill Tinney*

► Not only does this biker's arm showcase his love of the biker lifestyle with a full-size bike on his sleeve, but his cap displays his favorite brand of beer. *Bart Mitchell*

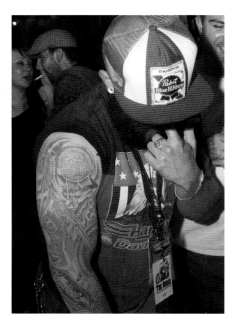

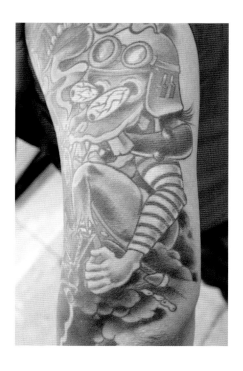

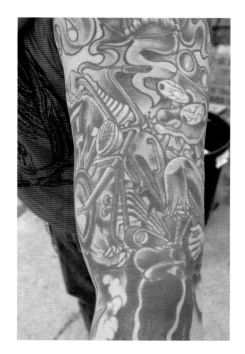

◀ This green and bug-eyed jockey, shift-riding monster is reminiscent of the Ed Roth era moto-culture artwork. The monster was made by tattoo artist Darren McKeag of Slingin' Ink.

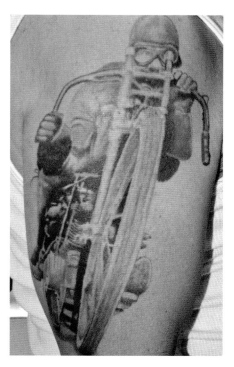

▲ This black and gray tattoo shows an early boardtrack racer—it's truly an iconic image.

◀◀ This could be a tribute to Marvel Comics' Ghost Rider, an infernal skeleton biker with flames shooting out of his head. This piece was done by D.C. of Willie's Tropical Tattoo.

◀ Check out this boney skeleton riding a wishbone chopper in traditional black and gray ink. This piece is by D.C. of Willie's Tropical Tattoo.

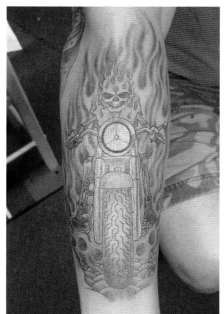

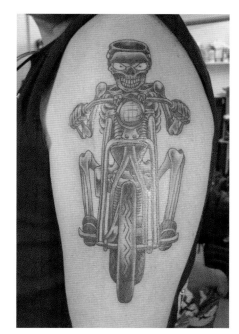

▲ What a crazy hardtail ride tattooed on this guy's arm! This one belongs to Randy "Goose" Stopnik.

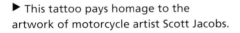

▶ This tattoo pays homage to the artwork of motorcycle artist Scott Jacobs.

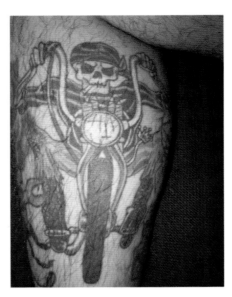

▲ A common sight is a hellspawn skeleton riding a bad ass chopper! It looks great in black and gray.

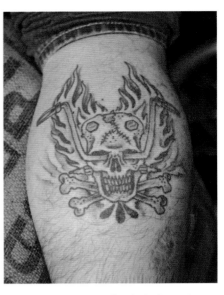

▲This Frankenstein-freak skeleton is hardcore—a set of ape hangers run through his eye sockets.

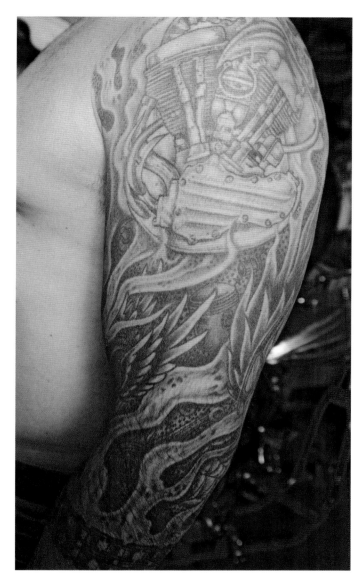

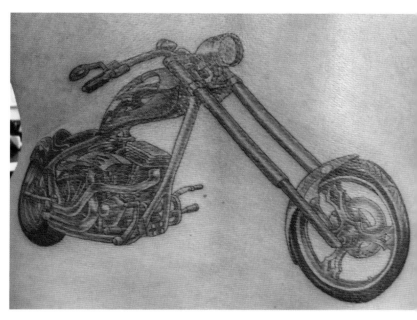

▲ The back was the perfect canvas for this stretched-out chopper tattoo by D.C. of Willie's Tropical Tattoo in Florida.

▲ Here's a rare sight—a panhead rear cylinder and a knucklehead front cylinder! These are usually only built by those with ample patience and dedication.

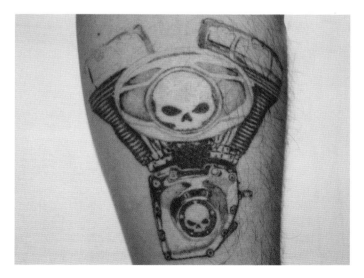

▲ A V-Twin engine looks awesome in black and gray, and this one comes with a matching skull air cleaner and cam cover.

▶ "Death or Glory" with a set of "z"-style handlebars inked across a jacked bicep; need we explain more?

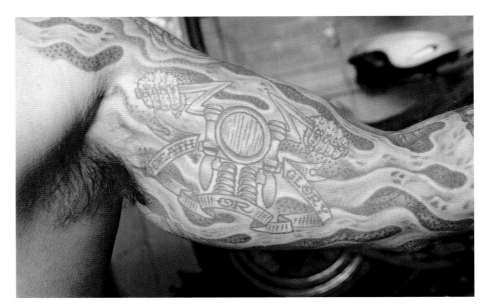

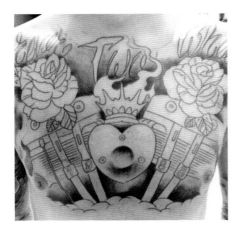

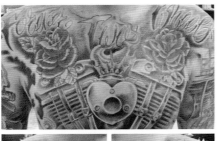

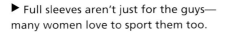

▲ ▲ It's shovelheads for life for this guy—look at that amazing chest piece!

▶ Full sleeves aren't just for the guys—many women love to sport them too.

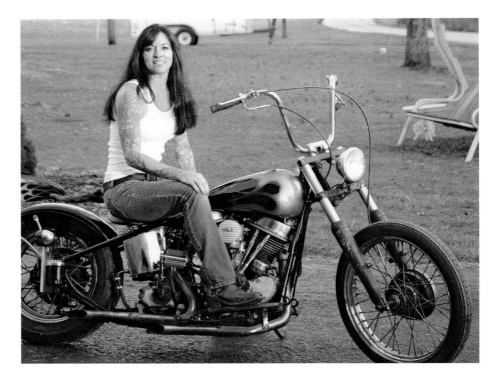

A deltoid tattoo, a bike, and your sweet lady to ride with—life doesn't get any better!

▲ It's not hard to spot a hardcore rider: check out A) the cool shovelhead, B) the hair, and C) the tattoos on his arms.

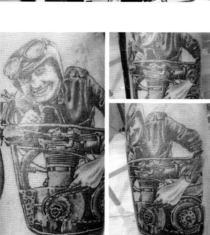

▲ This is another homage to Burt Munro, the legendary "World's Fastest Indian." The artwork was done by Darren McKeag of Slingin' Ink.

▲ This rigid panhead is going to be nothing shy of amazing when it is completed—is that that shadow of the bike beneath it?

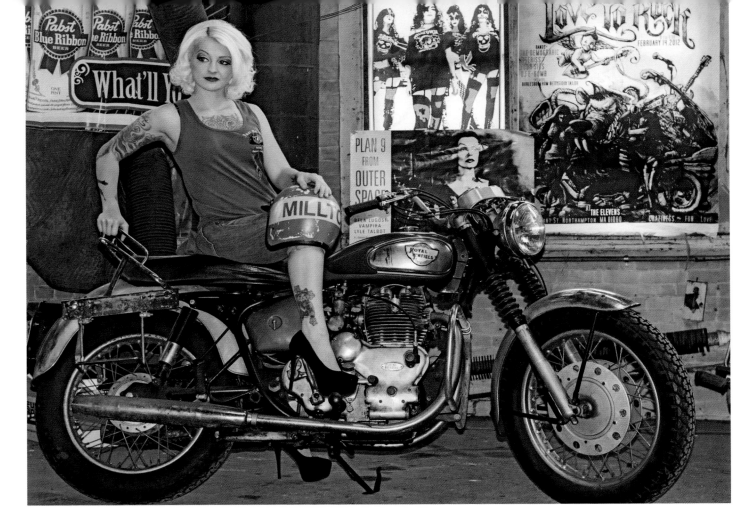

▲ Nothing like a pretty lady on a bike!
Check out Voodoo Jes as she shows some
leg atop a 1966 Royal Enfield 750cc
Interceptor. Her leg tattoo is by Lance at
Milltown Ink Tattoo. *Christian Rowell*

► For most guys riding today, the passion
was fuelled by early days of watching the
great Evel Knievel.

►► Googley-eyed monsters riding
motorcycles are inspired by the early hot
rod culture of the Ed Roth era. I wonder
what he's staring at?

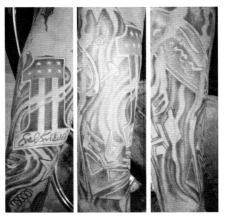

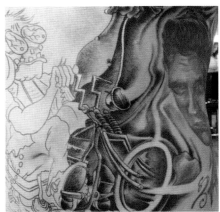

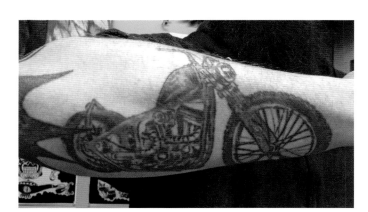

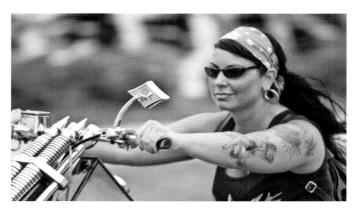

▲ For bikers who love their rides like others love their children, there's nothing to do except tattoo it on their arms. This piece was done by Latricia Horstman.

▲ The girl riding this killer chop has some awesome ink on her arms—looks like a pinup inked on a pinup! *Tom Tobin*

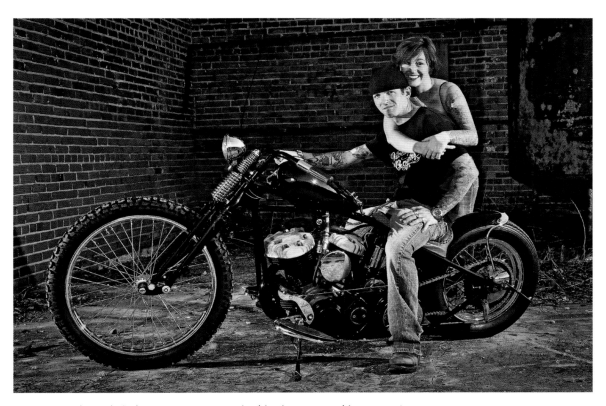

▲ It's a match made in heaven—two moto-junkies just covered in tattoos!

Rally Tattoos

Daytona, Laconia, Sturgis: these are the Big Three of motorcycle rallies in the United States, and quite the spectacle for the uninitiated. To be honest, there aren't that many bikers we run into who haven't attended at least one of these rallies. Each rally has its own unique quality, and everyone enjoys them for one special reason or another. Some prefer the riding the area offers, some like the history and racing attached, and others enjoy the party scene.

Tons of smaller rallies have popped up over the years and continue to gain recognition in their own right. Attending one of these rallies can be a memorable moment in one's life—you'll see things you never dreamed possible, or you might partake in activities you never thought were possible, let alone considering participating in. For some, it's such an experience that they simply *must* immortalize the event with a tattoo. This is easy to accomplish because these events feature myriad tattoo artists, available to help you savor your experience for a lifetime.

Everyone has their own reason for getting a rally tattoo. Maybe that's where they met their spouse, or where they finally found their inner being or true calling in life. Maybe it's where they got so insanely drunk that they

lost all control of their bodily functions and had the most outrageous time of their life. Whatever the reason, rally tattoos always have very good stories attached to them.

But not everyone who gets a tattoo at a bike rally is getting it to commemorate the event; some amazing tattoo artists travel to bike rallies all around the country, giving people the opportunity to get some seat time with them on the road. This is a great way for people to get work from artists they admire, where otherwise they would have had a very hard time getting to them for logistical reasons.

We do feel obligated to point out that while you can get lucky and meet some really talented tattoo artists, you're just as likely to meet some very terrible ones. You really need to do your homework to be sure you're getting the best. We have a section in this book all about tattoo regret, and the regret is there for life (most of this regret happens at a rally after a few too many beverages, when your judgment is impaired). Not only is there regret for the picture itself, like with misspelled names or names of former lovers, but there's also regret over picking the wrong tattoo artist. An impulsive tattoo is always a bad tattoo once you're shown just how much more an extremely talented artist can offer.

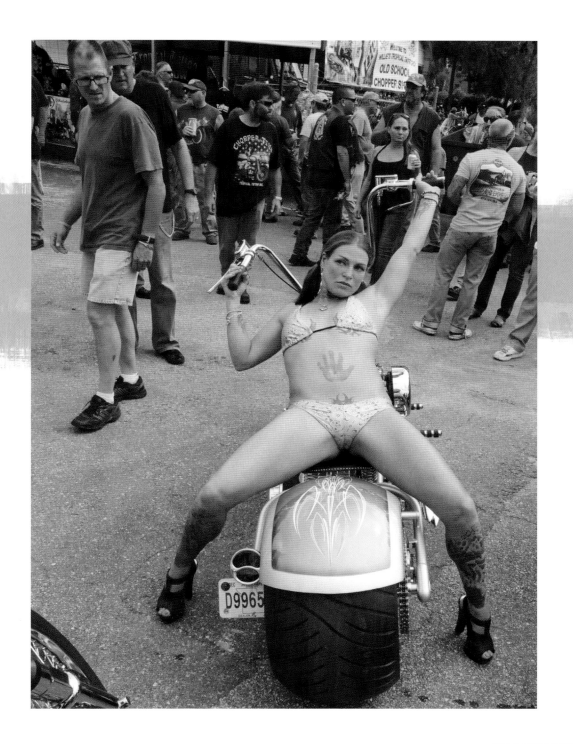

▶ The *Horseback Street Choppers* magazine host an event called "The Smoke Out" that has been running strong for 13 years. Most who attend are hardcore riders dedicated to the sport of motorcycling. This fan shows his love for the event with a tattoo in its honor.

▶ ▶ Dan Townsend is proud to have been able to ride his motorcycle to Sturgis for three years in a row; he has plans to add to this tattoo and his memories of his Sturgis rides (the lady on top doesn't hurt, either).

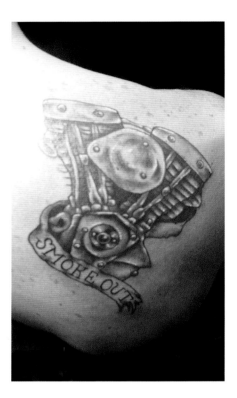

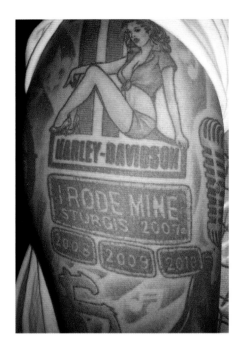

▶ The Hogs on the High Seas rally is an annual cruise meant to raise money for kidney dialysis research. While I personally have not attended a cruise rally, I have heard the parties on the ship are quite the spectacle.

▶ ▶ The guys who attend the Smoke Out Rally are your typical hardcore, dirtbag bikers, and that's *not* an insult. Trust me, that's what they're proud to be!

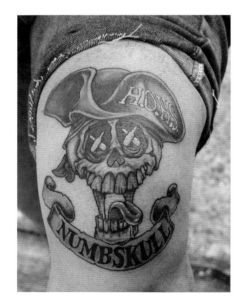

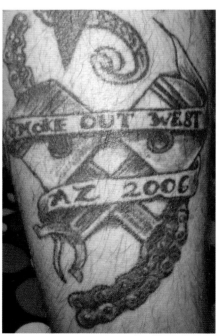

▲ I love this girl's Día de los Muertos skull chest piece.

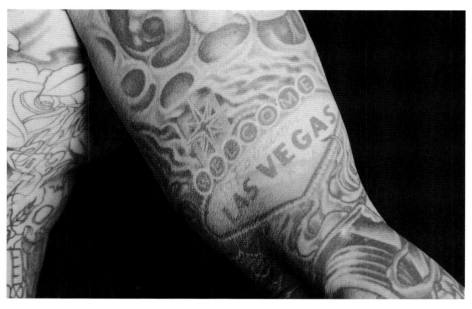

▲ What happens in Vegas doesn't always stay in Vegas. Vegas has a rally that's been going strong for over 12 years now.

▲ Beautiful girls with full sleeve tattoos are always a welcome sight for bikers during bike rallies.

▲ Here is a typical rallygoer with an armful of tattoos camped out near his trusty steed.

▶ At Mountainfest in West Virginia, a bunch of typical bikers take a break from partying to party with me. All sport some cool ink on their arms, and with plenty of funny stories to back 'em up!

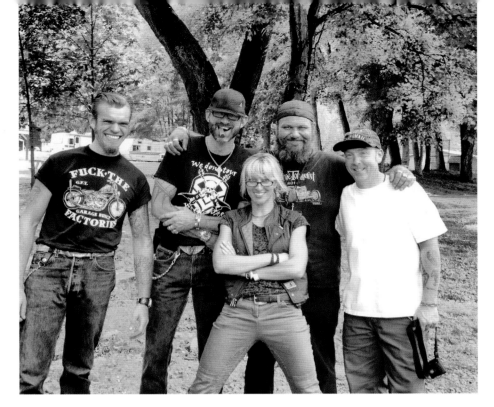

▲ Beautiful girls with full sleeve tattoos are always a welcome sight for bikers during bike rallies.

▲ Daytona Bike Week brings in tons of rally riders; this lady biker got herself a cool beach scene and all the fun Florida sun Daytona has to offer.

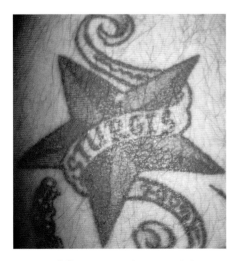

▲ Many bikers agree that Sturgis is the mecca of all biker rallies—the big one, the best one, the one you must do before you die. Nothing like a classy Sturgis star to commemorate it.

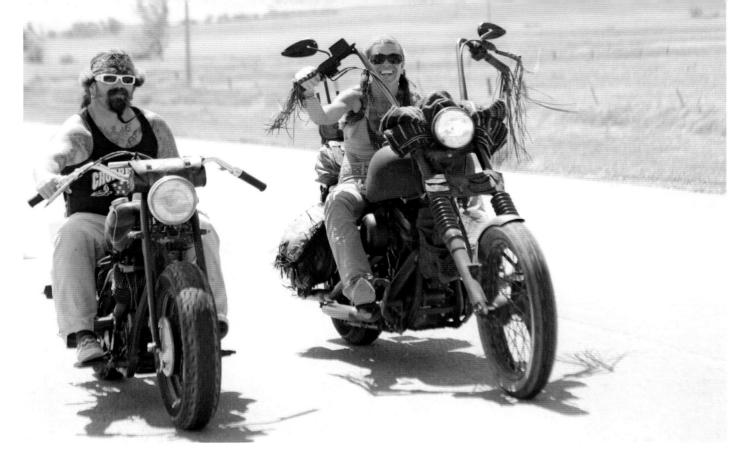

▲ A typical scene from the early rally days—tattooed bikers mud wrestling!

▲ Friendly faces are easy to find all over Sturgis.

◀ It's a customary gesture to flip the bird with your tattooed arm at a major motorcycle event.

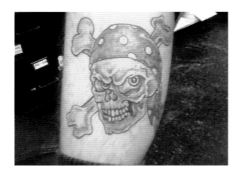

▲ At any given motorcycle rally, you are bound to come across a tattoo of a 'do-rag-wearing skeleton. It's just a simple fact.

▲ This young mom enjoys the biker/tattoo lifestyle so much she is bringing her little bundle out to enjoy the scene as well.

Rallies aren't just for loners. Many couples decide to get each other's names inked on their bodies during these events.

Tattoo contests are becoming more and more popular during motorcycle rallies.

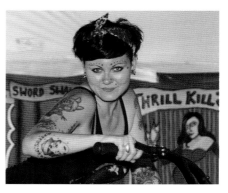

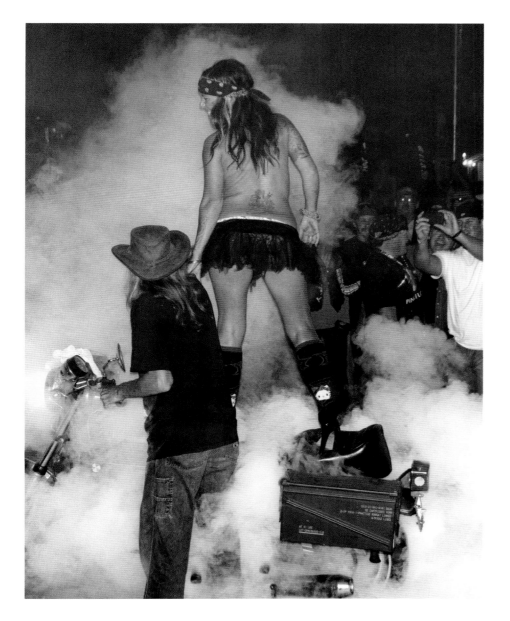

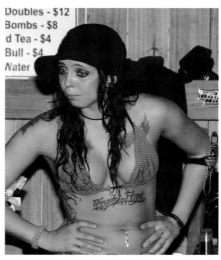

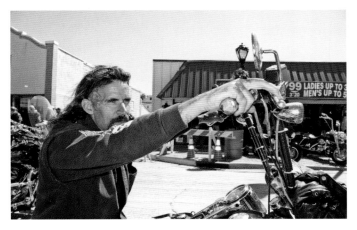

▲ Hand and knuckle tattoos peek out as this guy cruises his aped bike down Main Street. *Tom Tobin*

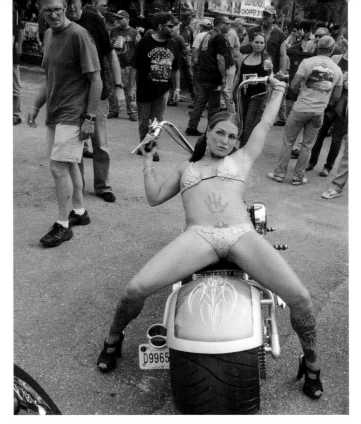

▲ Sometimes just sitting on your bike and watching all the tattooed bikers and bikes is the best part of a rally—this woman is certainly enjoying it. *Tom Tobin*

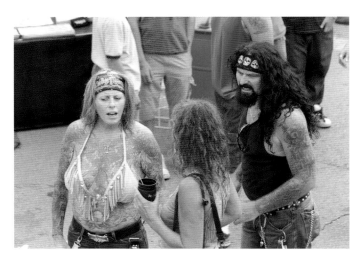

▲ For some, the rally is the best time to show off their collection of ink. With the warm weather it's the perfect season to dress light and swap stories with everyone around—just look at that full-body tattoo!

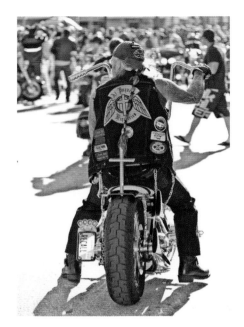

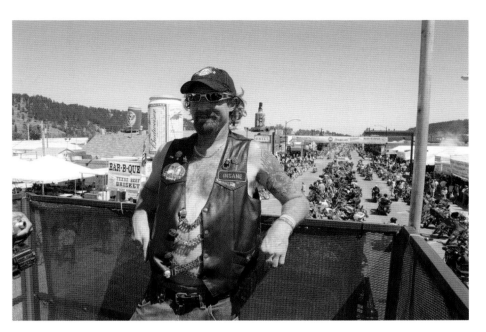

▲ This guy has no doubt attended many motorcycle rallies, and you can tell he's loving it! *Tom Tobin*

▲ Nothing like taking 'er easy at Sturgis. All this guy needs is a beer and another tattoo—no doubt he'll find eager artists all weekend. *Shutterstock*

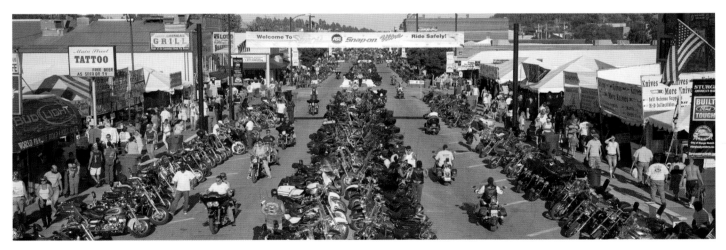

▲ It's hard to imagine just how many bikes and bikers (and tattoos) you'll find at the major rallies around North America. *Shutterstock*

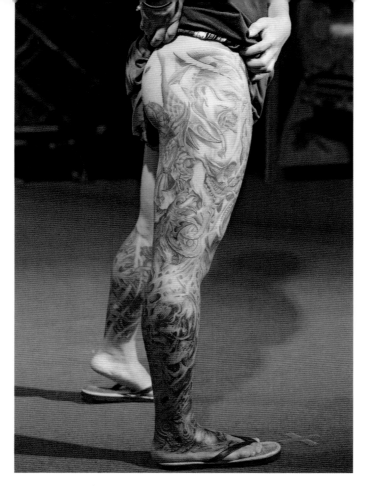

▲ Though it may seem hard to take this biker seriously—are those flip-flops?—he's probably showcasing his legs at a tattoo competition, another staple of biker rallies. *Shutterstock*

▲ Friends and spouses will often dress the part at a rally—what are the chances she rode in as a passenger on the back of his bike?

▶ Another pair of knuckle tattoos emerge from the darkness! "Knucks" like these are common at biker rallies, but hopefully this isn't the last view you get of 'em. *Shutterstock*

▶▶ It's easy to find tattooed ladies at biker rallies. It's not easy to find ones who look this good. *Shutterstock*

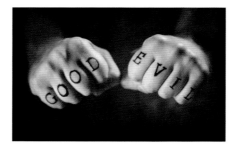

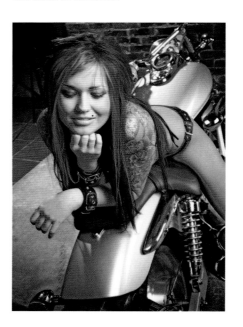

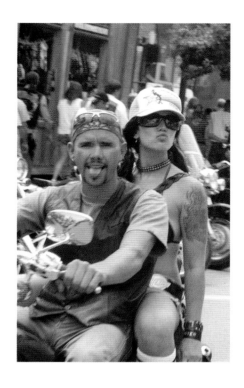

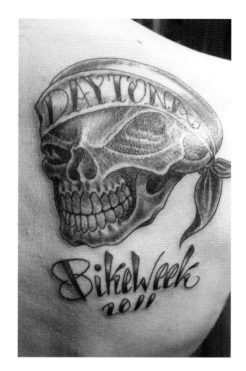

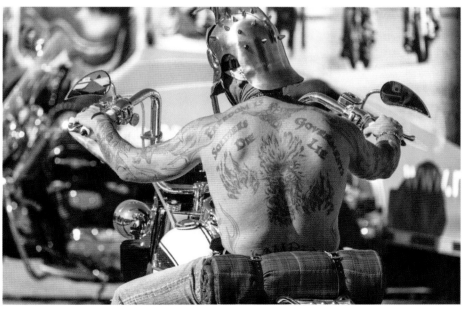

◀ ◀ A couple of bikers goof off for the camera as they roll down Main Street during Daytona Bike Week.

◀ You can imagine getting a bike week tattoo during the rally is pretty popular. For some, there is nothing better than rally week. This piece was done by D.C. of Willie's Tropical Tattoo. *Bill Tinney*

▲ A Sturgis cap, a Harley-Davidson shirt, and a screaming eagle on his bicep—this guy loves the biker culture.

◀ This rallygoer wants everyone to know that Freedom Is Not Free; Soldiers Die; Governments Lie. *iStock*

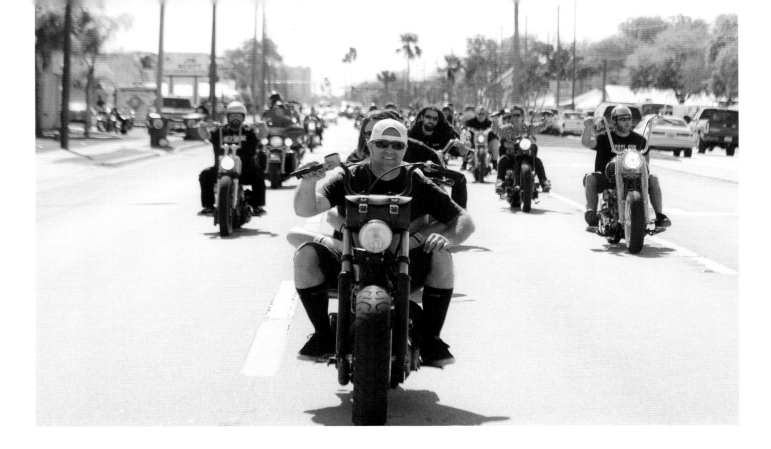

▲ A mass of tattooed bikers take over the streets of Daytona Beach Florida during bike week.

▶ A common sight at the rallies these days is guys sporting the "greaser" look: slicked hair and plenty of tattoos.

▶ ▶ I found these "twins" at Willie's Tropical Tattoo Chopper Show during Daytona Bike Week.

▶ I'm not sure whether this guy is showing off his tattoos or his battle scars from a game of paint ball during Daytona Bike Week.

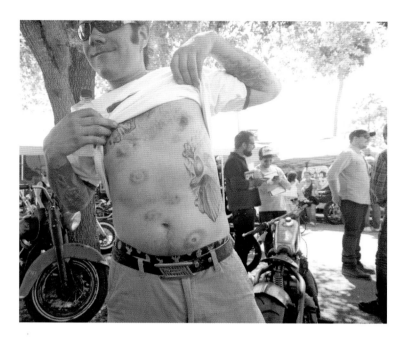

▲ Though the photo is blurry, the amount of work on this girl's back is evident. As you walk around the rallies, you're sure to see tons of ink on people parading about. They usually dress so the ink shows.

▲ A common sight at a rally is a sea of bikers having a good time and usually covered in tattoos.

These are some great example of the sights to see while walking up and down Main Street during Sturgis Bike Rally.

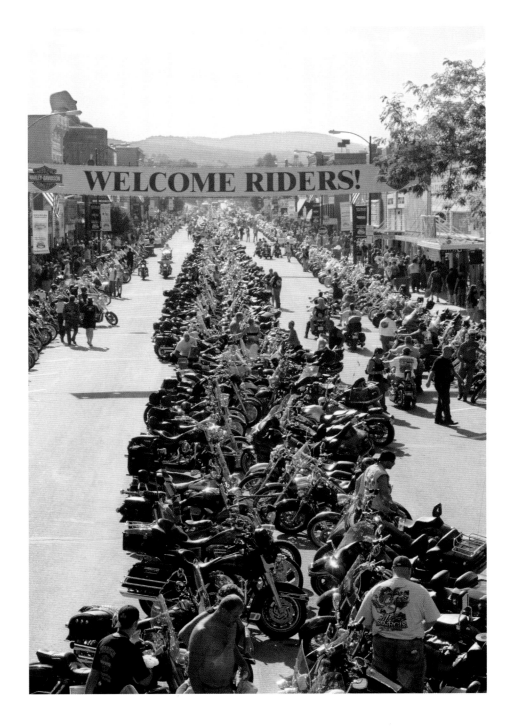

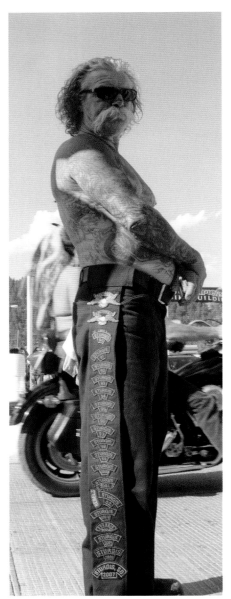

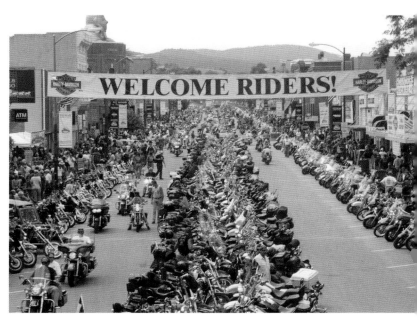

▶ To show off their tattoos, these guys decided to don some bikinis and let it all hang out. Who do you think wins the contest?

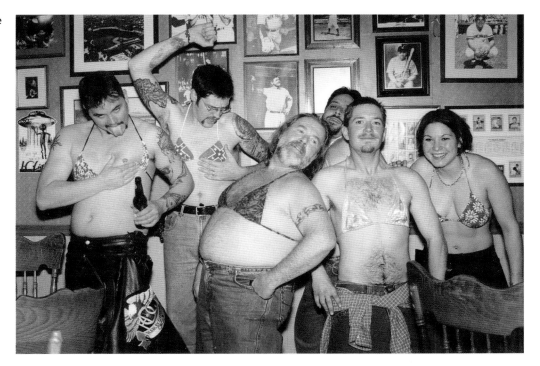

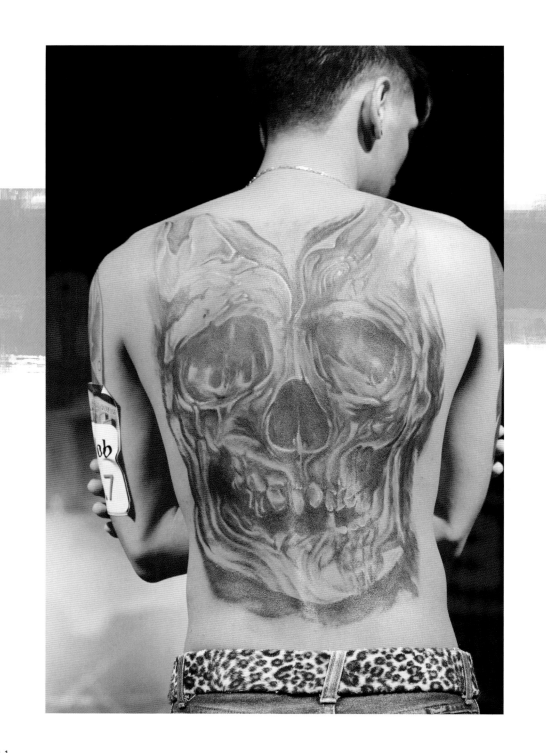

Rally Tattoo Contests

You'll usually find a tattoo contest at any given rally. These contests often turn into quite an event, drawing a huge crowd with loud music and lots of alcohol. The contestants parade across the stage and show what they've got (this usually just turns into an opportunity for girls to practice taking their clothes off onstage). There are, however, plenty of professionals who enter these contests with amazing works of tattoo art, and they travel to contests seeking cash and trophies.

We guess one of the saddest parts of a motorcycle rally is the assumption that it's all about walking down Main Street and gawking at each other. Some uninformed people might assume that the bikers aren't there to attend races or visit historical sites, but rather to get loud and drunk, gawk at insane, nonrideable bikes, and stare at the crazy "get-up-parade" of people riding them.

Rallygoers who are fully decorated with tattoos love to show them off. It's that simple—they dress skillfully and purposefully so that every inch of their art is visible. These people are out on Main Street for a mission: to be seen, and to have their photo taken. They encourage strangers to walk up to them and inquire about their body art. They don't mind getting stares because they're at the rally to be a spectacle and to interact with other spectacles. If you want to get a glimpse of biker tattoos, just attend a motorcycle rally or two. But make sure you go to the rally for the real reason: to celebrate the sport of motorcycling, to ride new roads, to see new scenery, to meet new and old friends, and to create memories to pass on to friends and family.

We like how some rally tattoos become bragging rights, proof of being there—as if the T-shirt, helmet sticker, and jacket patches weren't proof enough!

Riding Images

To illustrate just how common tattoos and motorcycles are, we've assembled a few images that we captured out and about on the road. These photos showcase almost every rider with a tattoo or four, or even a full sleeve for that matter. Motorcycles and tattoos go together like peanut butter and jelly, like milk and cookies, like ice cream and cake, beer and chips, whip cream and naked women … you know what we mean.

We also found some cool tattoos depicting people riding bikes. Some are portraits, others are famous riders, and others are just cartoon characters made up by a tattoo artist who was given free range. One very cool tattoo we found was a self-portrait by tattoo artist Latricia Hortsman, who tattooed herself.

She wanted to commemorate a wreck she had one year during Daytona Bike Week; the tattoo is of a pinup girl skidding sideways, all flat track racing style, with the words "Hold Tight." Though we love this tattoo, I'm happier that Latricia survived the wreck and is able to keep doing what she does: hitting the road and wielding the tattoo needle!

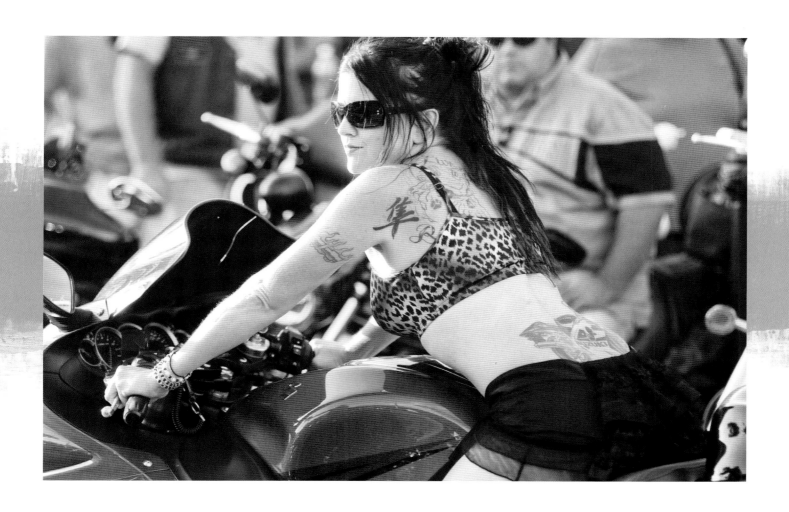

▶ Almost every bike rider in Sturgis has ink somewhere on their body. Here is Sidecar Sandy on her shovelhead, enjoying the great riding Sturgis has to offer.

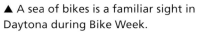

▲ A sea of bikes is a familiar sight in Daytona during Bike Week.

▶ Check out this killer rat rod, so popular in the motorcycle world. It's great to see these two cultures combined again.

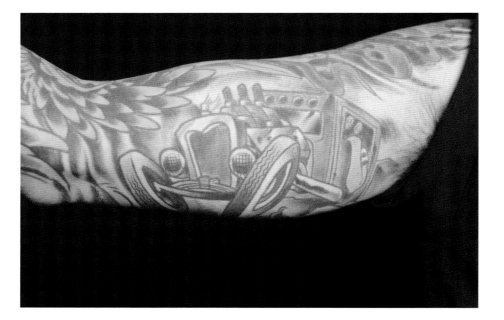

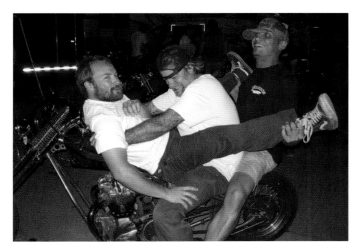

▲ There may be a fair amount of alcohol at Sturgis, as you can tell from this photo. At least there are some badass tattoos to go with it!

▲ Everyone should be as fortunate as me to one day see a topless pirate lady riding a panhead chopper.

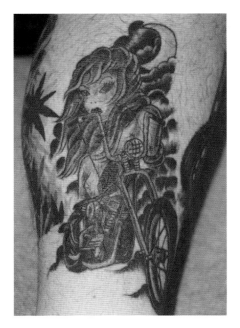

▲ Maybe topless women and panheads are more common than I thought! That is one lucky bike.

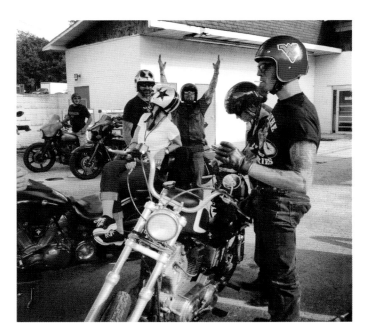

▲ A group of tattooed bikers enjoys a great day of riding together on some pretty amazing roads in West Virginia.

◄ What's more impressive about this panhead biker—his tattoos, or his beard?

◄ It's a knucklehead riding a shovelhead! Just kidding—this is Chad Lemme, the tattooed dirtbag writing this book with me.

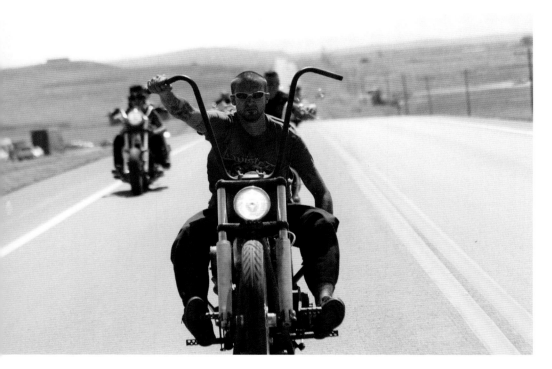

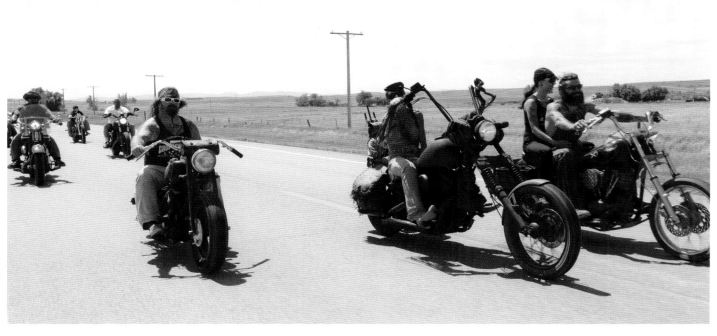

▲ A great bunch of riders on a variety of pretty cool bikes enjoys the amazing landscape of Sturgis.

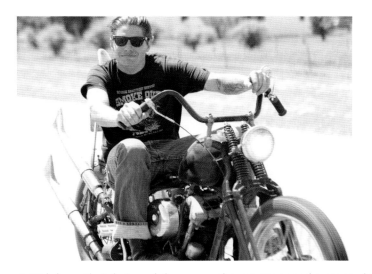

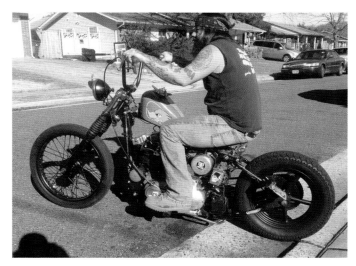

▲ Girls have their hair and shoes; guys have tattoos and motorcycles, oh wait, girls have that too!

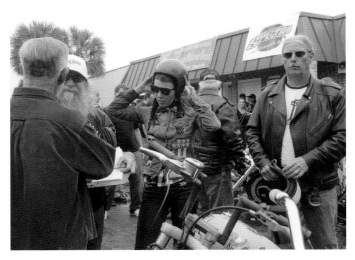

▲ Near Willie's Tropical Tattoo, in Ormond Beach, Florida, an epic gathering of tattoos and motorcycles can be seen during his "chopper time" show during Bike Week.

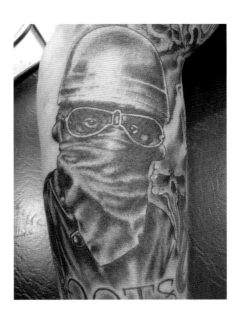

▲ This guy is jacked! Taking a break on Main Street and letting everyone check out your tattoos is one aspect of going to the bike rallies. *Tom Tobin*

◀ I like this black and gray portrait of a hardcore rider—helmet, eye protection, and bandana.

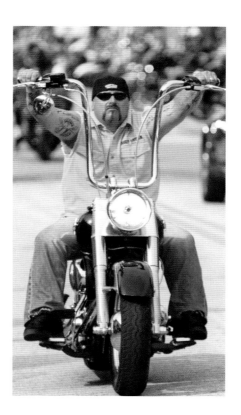

▲ It's always fun to see the characters who cruise their bikes up and down Main Street. To say these people don't want the attention is nuts—of course they want it! That's half the fun of owning a great bike and the tattoos to match. *Tom Tobin*

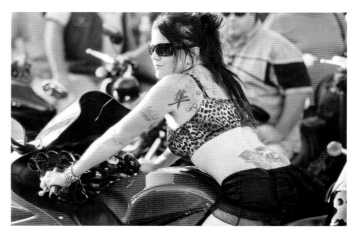

▲ Hanging out at a bike rally is your chance to see, be seen, and have a good time with others like you. *Tom Tobin*

▲ The couple that rides together stays together! This is tattoo artist husband-and-wife team Long Jon and Pinky Barwood, of Payson, Arizona.

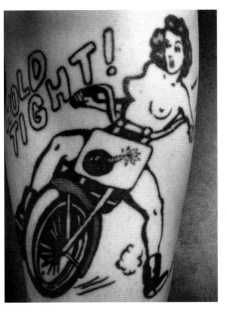

▲ After a crash in Daytona, tattoo artist Latricia Horstman gave this to herself as a reminder to *Hold Tight!* when things get sticky.

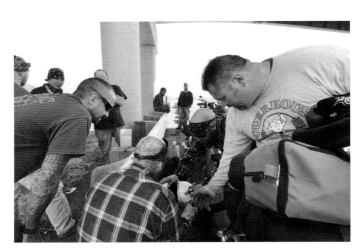

▲ Here's a typical scene from the side of the road—a brother's bike broke down, and all I can see is ink on the helping hands.

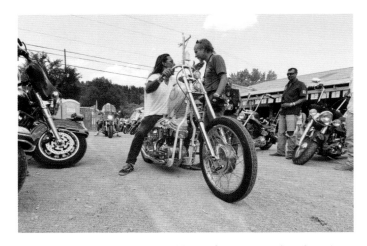

▲ Long front ends, a rigid wishbone frame, a panhead engine, and tattoos.

◀ Chad Lemme, George the Painter, Long Jon, and Pinky take a break at a local watering hole in Arizona.

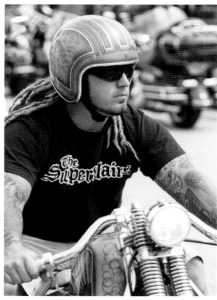

▲ Hanging out at a bike rally is your chance to see, be seen, hang out, and have a good time with others like you. *Tom Tobin*

◀ Chad Lemme cruises the amazing roads of Payson, Arizona.

2

Personal Stories

George Frizzell, a.k.a. George the Painter

ell, as usual, it's something like four in the morning and I'm enjoying yet another heaping helping of pharmaceuticals (sleep is rarely a consideration anymore). With my Pfizer breakfast under my belt and *Fear and Loathing* in the DVD player, I'm now in the right mindset to assemble words, thanks to the late doctor. Few others' ideas and observations blow my hair back as much as Hunter Thompson's—except for George's, of course. This man can write as well as he can paint, and he's one hell of a painter. (Yeah, it's not just a clever name.)

George's story is an interesting and wild one. It's like a comedy movie mixed with a graphic novel gone completely awry—sheer madness in every bit of it! His story is like riding a rocket ship of venereal disease and speedballs straight to hell. You need nitro-methane just to listen to it—if you've read any of his shit, you understand.

The precious hours I've spent sitting on the shitter, contemplating and reading his insanity in the pages of

The Horse Mag, inspired me to do more with my life than just sit around and try to think of new and interesting ways to justify being a homeless dirtbag. It was probably timed right; in our long hours of deep, culturally significant conversation about how spray paint makes a cardboard box house waterproof, or where to get the best deal on a case of SpaghettiOs for the month, I came to realize that we shared much the same philosophy.

Plato tells us that Socrates once said, "The unexamined life is not worth living." Now that may be true, but in this day and age, we need a little more than that. I'd say that the life led without drugs and hookers is not worth living, and I'm probably right. And according to George's endless stories, I think he'd agree.

Anyway, in the early fall of 2012, Sara and I had the fortunate opportunity to stay in Arizona with tattoo artists Long Jon, Pinky Pancake, and George. We could never thank them enough for their generosity—they put us up for damn near a week, and took us on a two-wheeled tour of the area down there. On top of that, they were instrumental in helping us assemble this very book, and you'll see plenty of their stuff here as well.

We spent a night in George's new studio, where the air was still foggy, and shot some pictures. A single question

on the meaning of one tattoo led to another set of these wild stories, and I fired up the tape recorder in hopes of salvaging a clear memory of these tales. The first tattoo in question is on the back of George's head. Here it is.

—Chad Lemme

Sara: "What's this little tattoo on the back of your head about?"

George: "Well, one night Mike and I were down at the Banana River Drive in Florida having a few too many beers and decided to split. We were tear-assin' around, headin' to a friend's place. On the way was this whole fuckin' SWAT team out on the street that had assembled to kick the doors in on this Chinese store. They were going in to [inaudible], it was a drug bust. So when Mike and I rode past, haulin' ass and makin' all kinds of noise and peelin' the fuck out of there, the people in the place looked out to see what all the noise was about, and saw the cops ready to kick their fuckin' door in. So they all split or something [inaudible], and the fuckin' cops took off after *us* instead! Well, we fuckin' hit it, and we were flyin' through people's yards and runnin' over mailboxes and garden gnomes and shit, and Mike went straight to the end of the pier and locked it up and fuckin' swan dived over the bars and into the canal, and he fuckin' swam away! [inaudible], called it in stolen once he got home and went and picked his bike up from the bastards the next day! But I refused to leave my bike, so I split off from him and went to the friend's house [inaudible]. They were all laughing. I parked my bike behind the house and everyone was sitting on the porch laughing and shit, and the SWAT team came in in full force and fuckin' tackled me ... I don't know ... they either kicked me in the head or I passed out, or something. I woke up in jail with a terrible headache and blood and shit. Anyway,

I had all kinds of charges pending for this particular arrest, so they never even got to the fact that I was fuckin' hammered drunk. Forgot all about it!

So, I went to this friend of mine who was a lawyer and he looked everything over and said [inaudible] the bastards wanted to get me for evading, so he told them, 'Well, I see here you've charged him with riding without a mirror, so he never saw you.' Then they said that they had their sirens on, and he said, 'I see you've charged him with "loud exhaust," so, naturally, he couldn't hear you.' And on and on it goes ... So I got out of everything. But then there was this problem of having no money to pay the lawyer, and I didn't know what I was going to do about that, but he died a week later, so I got out of that too! [laughter] Anyway, when the cops showed up at my friend's place and I got arrested, the cop pistol-whipped me in the back of the head, so I got this tattoo to mark the occasion." [laughter]

Sara: "So how about the VIN numbers?"

George: "Well, my bike was completely disassembled ... [inaudible], so the bike was in a million pieces and I was vulnerable at the time and this guy offered me forty-five hundred dollars for the fucker—cash. So, I told him to come pick it up in the morning and I started rounding up all the pieces and shit, and when he showed up the next day, I told him, 'I owe ya forty bucks.' He said, 'For what?' And I showed him that tattoo [the VIN number] that I went and got after he left. [inaudible] I couldn't sell it, and I still have it ... [inaudible] never get rid of it."

Sara: "And the Roman numerals?"

George: "Well, that's how many miles I had put on it [the Leaky Latowski bike] when I destroyed my back in Florida and had laid immobile on Roadside [Marty]'s floor for what

seemed like a year [inaudible]. Yes, I had four hundred and twenty thousand miles on it at that point."

Sara : "Okay, how about the back?"

George: "I had the [inaudible] 'Don't Panic' from *The Hitchhiker's Guide to the Galaxy* [inaudible] yeah … that's my motor …"

Sara: "How long did it take to …"

George: "Three days. One weekend."

Me: "Holy shit! You did that all at once?!"

George: "Yup. Ten hours a day for three days. [laughter] They kept giving me painkillers and all kinds of shit, and I was like, 'Fuck, these aren't even *touching* the pain,' so I just sat through it and fuckin' did it. And the VIN number I put there because of my frequent run-ins with the law. See, when they ask me to prove that it's my bike … cause I never carry around any paperwork shit for it [inaudible], so when they ask me to prove it's mine, I just turn around and do this."

It's at this point that George turned around and bent over while dropping his pants, to reveal a large vehicle identification number right above his ass while simultaneously showing the world his fruit basket. It nearly blinded me, but at the same time, it solidified my decision to tattoo my ass, just so I could show my smelly, white ass to every asshole who asks to see it. It's always more than they bargained for, but I never feel bad for ruining their day. And I doubt George does either.

George the Painter's VIN tattoo is symbolic of his stature in the moto-culture and his dedication to biking and inking.

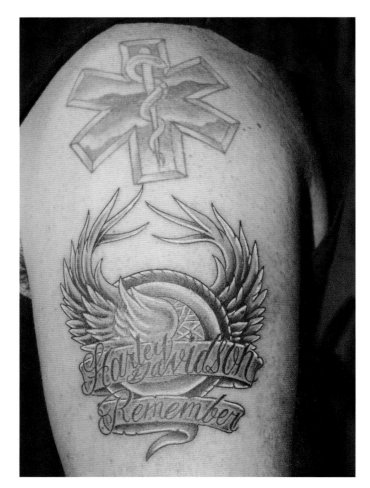

▲ Oh, the irony—a paramedic who becomes the victim of a crash! Vernon's tattoos tell a tale about his career in EMS as well as his motorcycle accidents.

▲ Above right: Lena, from Kissimmee, Florida, chose to have her motorcycle tattooed along with the names of her son and daughter. You can see where the motorcycle ranks in Lena's life—right up there with her children.

▶ Riding a motorcycle on a 90-degree wooden wall calls for a tattoo! Harry Bostard is a motorcycle stunt rider in California's Wall of Death. Most riders of the wall brand themselves with a tattoo of the accomplishment.

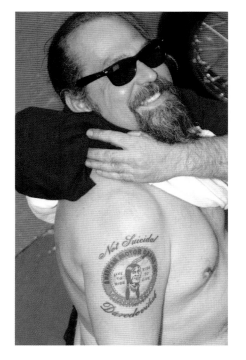

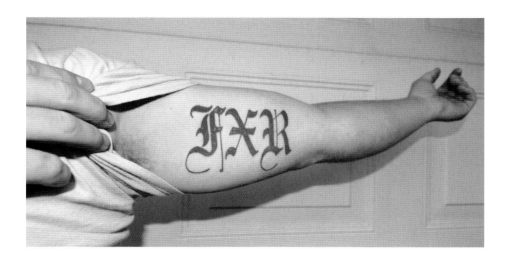

◄ If you have ever ridden an FXR, you might tattoo your arm as well. The FXR is the most favored Harley chassis by hardcore riding enthusiasts.

▼ A day before a bike accident, Jennifer got a tattoo of a panhead with wings; sounds a little like an intro to one of those unsolved mystery TV shows!

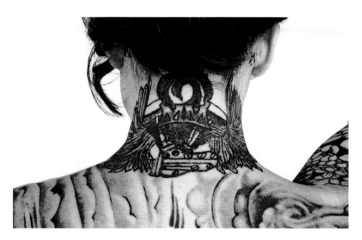

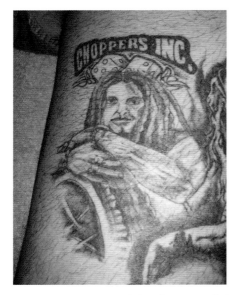
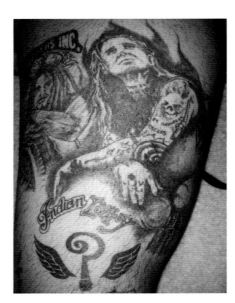
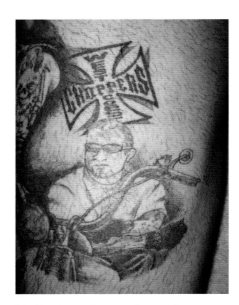

▲ We are pretty sure it is safe to say Chris Watkiss is fascinated by Billy Lane, Jesse James, and Indian Larry. Just an observation.

▲ Memorial tattoos are as popular as moto-culture tatts, like this one belonging to expert painter Robert Pradke, honoring his late father.

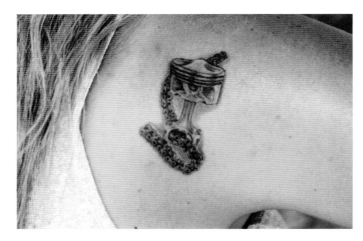

▲ Often referred to as the heart of the engine, this piston and chain is tattooed on Chris Gibbany's rear shoulder. Chris is passionate about power.

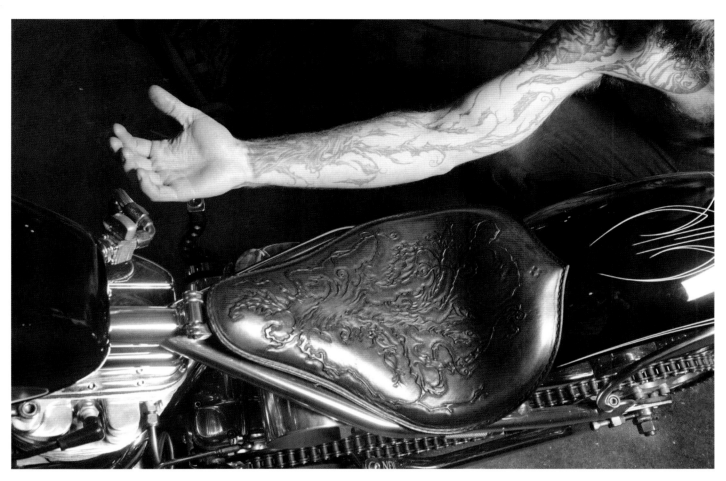

Iliya Hamovic is covered with ink that has a special purpose on his body— the tree on his arm is mirrored in the custom work on his motorcycle seat, which was hand-tooled by Paul Cox.

▲ ▲ Matthew Smith chose this tattoo as a constant reminder when he services his bike—"Don't forget the drain plug."

▲ Emotions surface when talking to someone about a memorial tattoo they have, but sometimes it's part of the healing process.

▶ Some tattoos are part of a promotion for a company (or radio station—Big Jim, 93.3 Classic Rock!). Money, products, or other types of compensation are usually the incentive for these tattoos.

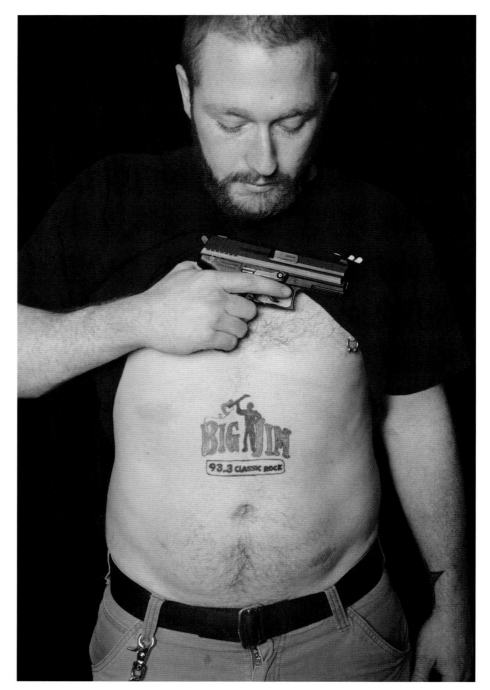

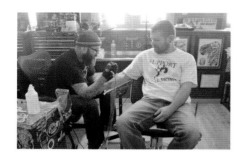
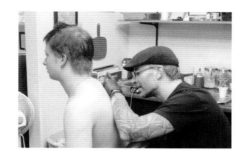

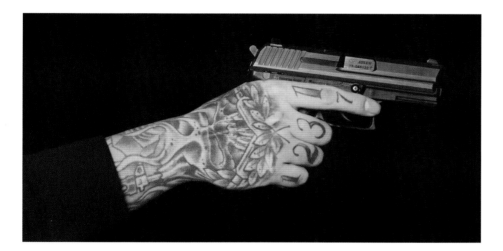

▲ Artist Darren McKeag works closely with clients to help transform their interests into permanent works of art, and a first tattoo always has a personal story attached to it. What would you put on your shoulder? What would your first tattoo be?

◄ The horrors of war are manifested on Chad Lemme's hand as a constant reminder of the great lengths man endures in order to survive, and the ironic disposition to destroy himself as well.

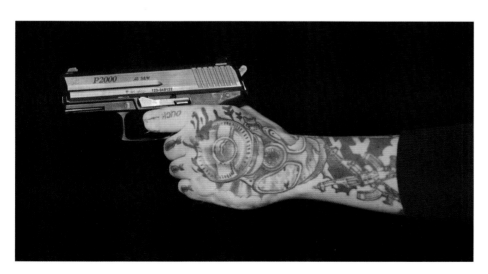

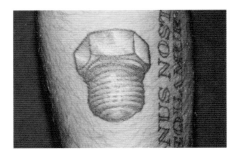

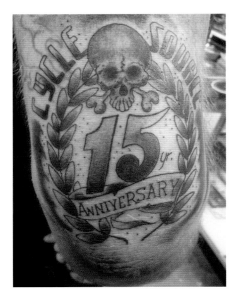

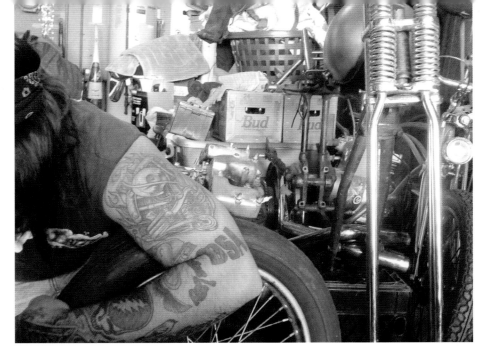

▲ This arm is full of personal stories, from a first bike and preferred engine to a favorite band (The Grateful Dead!). Tattoos can express so much without saying a word.

▲ ▲ Here's another drain plug tattoo—some people have a bad memory when it comes to remembering to put the drain plug back in.

▲ Some tattoos mark an anniversary, an important date, years of sobriety, or years committed to a certain occupation. These tattoos usually only have special meaning to the person who wears them.

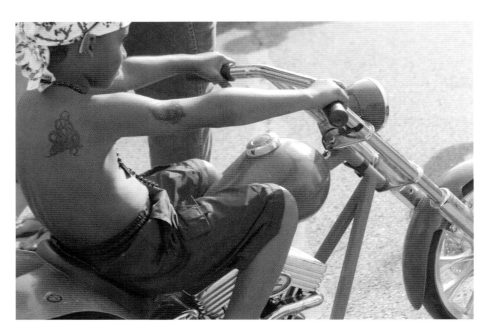

▲ Tattoos and motorcycles go hand-in-hand so well that this young guy had to get some temporary tattoos to match the chopper he was riding at Ohio Bike Week.

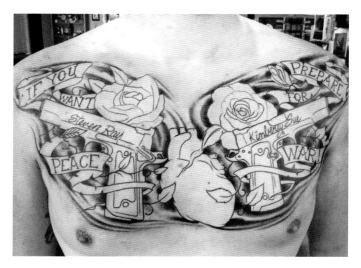

▲ This chest piece reads, "If You Want Peace, Prepare for War." There's no doubt that this phrase holds very personal meaning to the wearer.

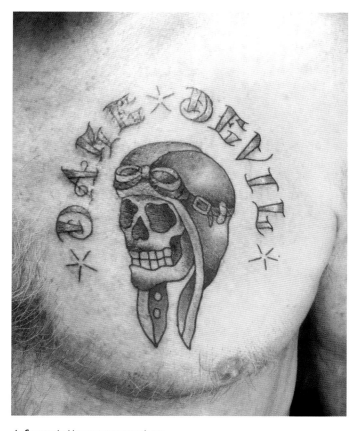

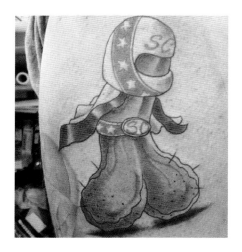

▲ Some tattoos represent an accomplishment or a milestone achieved. This tattoo belongs to Wahl E. Walker, motorcycle stunt rider of the American Motor Drome Company, who is no doubt a dare devil for riding his motorcycle on a 90-degree wooden wall.

◄ This is a stunt cock. In all honesty, I'm not so sure I want to know the personal story behind this tattoo.

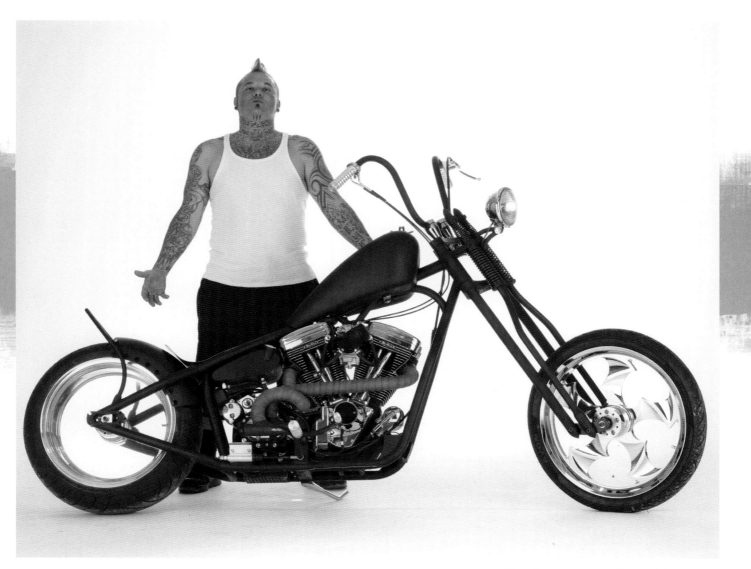

Terry has put more miles on his
bike and accumulated more stories
than anyone could ever dream
of being able to tell in a lifetime.
Terry Meyer

Terry "Rogue" Meyer

I woke up on the floor of Paul's shop, smelling like six different shades of shit and looking even worse. I gathered my effects and somewhat reassembled myself. And as I tried to make some sort of sense of the events of the night before, I heard talking through the office door. I had to investigate. But I never would have guessed what was about to transpire.

You meet people at really strange places in life, and most times you're not expecting it. Let's say— hypothetically, of course—that you had been hammered drunk for the past 48 hours on Mighty Whitey's Fightin' Fluid and all kinds of other Missouri moonshine.

Anyway, I was doing my best to stay upright while the world kept trying to buck me off. Trying to regain my sea legs, I walked smack into the middle of this amazing and wild story. Narrating the incredible tale was this dude with the word "Rogue" tattooed in big black script on the side of his skull. I found myself unable to get back to my hangover. I regret that I didn't walk in sooner to hear the rest of the story. How much did I miss? Who was this guy? He carried with him this confidence that I'd never seen in a human before, this middle-aged dude with a mohawk and the words "Ride to Die" tattooed on one side of his neck.

I couldn't tell if he was older than me or not. He looked like he had endured some seriously rough miles. And I never could have imagined exactly how rough those miles were. My mind was reeling just trying to keep up with this expeditious and incredible story. It was about his most recent running of the Hoka Hey Challenge, which is incredible in itself, but he went on to say that he had crashed something like 12 times, yet still finished near the front. But let me tell you about the Hoka Hey. In the Native Sioux language, spoken by Lakota Sioux tribes, "hoka hey" means "today is a good day to die." Many people think this was some sort of morbid battle cry, which is entirely false. What it really means is that you should live your life to its fullest potential every single day, as though it may be your last. The theory here is that every day would then be a good day to die.

The quest is an extraordinarily demanding series of miles that takes you through nearly all the states, and sometimes different countries. To stay ahead of the time limit and win this thing, you'd need to ride about 1,000 miles every 48 hours. In a nice comfy car on the interstate, that would be no problem. On a motorbike? Well, that's a horse of a different color. After that much riding for days on end, you start to see shit like colored horses and unicorns standing in the middle of the highway. Flying monkeys.

Terrible things.

I thought I heard that last year the grueling race consisted of most states for something just shy of ten thousand miles, and failing time was set at nine and a half days. You must be well rehearsed and well trained to prepare for that kind of bodily punishment. And most of these guys do it on quasi-comfortable bikes (with

suspension, no less). But not Terry. He does it on a damned hardtail. His competition bike is an entirely scratch-built, rigid FXR, created and fabricated by Paul Wideman at Bare Knuckle Choppers.

One thousand plus miles a day for a consecutive week and a half on a rigid—what a tough motherfucker!

But there was so much more I learned about Terry other than the travails of his racing. He told me how he'd raced with a catheter to save time from piss breaks, sometimes sitting in his own soggy piss for days at a time. He told me numerous stories about crashes, then showed me the scars from them. He told me about evading police, passing on the shoulder or the middle line doing well past 100 miles an hour for hours upon days. He told me about bouncing off guardrails, topping off his gas tank on the fly. But none of these stories compared to what I heard next when I asked the question sitting patiently in my mind: What exactly was meant by the tattoo across his throat, the one reading, "Live 2 Ride, Ride 2 Die"?

Only Terry can do his story justice—so buckle up, because here it comes, in his own words.

The lowest point of my life came when I was 37 years old. My parents had logged hundreds of thousands of miles together on several Harleys. They literally lived to ride, and rode together. That specific afternoon, they were out on their Fireman's Special, enjoying the Illinois countryside, when they were creamed by a dump truck. The driver wasn't paying attention and ran a stop sign, killing my dad instantly. My poor mother was kept on life support for four days, and when the doctors declared her brain dead, it was left up to me to pull the plug on her. It was the hardest thing I've ever done, and I'm sure that anything else in store for my future will pale in comparison to that. I felt like I was the one who was killing her. "Live 2 Ride, Ride 2 Die . . ." Those words never seemed more relevant to me.

I try to stay as positive as I possibly can through anything that life throws at me. Luckily I have a couple of great friends who didn't turn their backs on me, because this one brought me down, man—lower-than-whale-shit down. I went through a chopper-riding, whiskey/pill-slammin' stage, and lost the majority of my friends. Life can be strange. Getting tattooed became a way for me to kill the pain, so to speak. The booze and the drugs were just taking me down a real bad path. You'll never hear a success story like, "Bro, I drank so much Jack and ate so many OxyContin that I'm a fuckin' millionaire and couldn't ask for anything else out of life." I had to find another way to kill the pain.

I've got a chest piece with an angel and "Mom" and "Dad" that I get to see every time I look in the mirror. That piece is dedicated to them. Several of my tattoos are for them, as a matter of fact. Then I have others where, instead of getting shitfaced and high, I'd head to the shop and be like, "Please, just do something. Shovel that shit in there and make me feel it." I love my tattoos. People who don't get me will ask if I regret getting my cock or my face tattooed. I just smile and shake my head no, all the while thinking, "Dude, if you walked a mile in my shoes, you may very well set yourself on fire to beat the demons back."

Motorcycle racing is the only thing I know, and it's really the only thing I even *want* to know. I have no use for and no interest in anything that doesn't have to do with racing. If I meet somebody who seems cool, maybe somebody I could chill with—if you're not a racer or can't identify with my lifestyle, you're out. Same way with chicks, man. Try giving me a hard time at the track, or try to tell me that I read too many magazines or talk too much about racing, you'll find you and your shit out on the corner so quick it will make *my* head spin.

I've been racing since I was eight years old. I've won a lot of races, and I've lost some too. I've spent enough money to provide good lives for several families. I wouldn't do it any other way. I've never really considered myself a hardcore street rider. I will never log the kind of miles that my dad did—500,000 plus—wow. I had a hardtail that Bare Knuckle in Hawk Point, Missouri, built me that had about 25,000 on it. The one I have now has 20,000. I'm really just about the racing. I've ridden the Hoka Hey Challenge three years in a row for a total of 37,000 miles.

The first one I rode [I] was on my chopper for 9,000 miles. It was pretty brutal. That poor thing was trying to self-destruct. There was a lot of welding being done along the way. I'd have to say the second one was the most brutal of the three. The sleep deprivation alone was enough to make the average man quit. Throw in sitting in my own piss for days on end, sun poisoning on my mouth, getting run off the road several different times, and getting rear-ended by another competitor somewhere in Dixieland, among other things—yeah, the second one was an eye opener.

Crashes are a part of racing, you know? It really all depends how you can handle the mental part of it while you're physically healing. If you heal up great but are scared to death to get back at it, you're done. If you wind up a quadriplegic, but your mind's right and you'd do anything to get back on a bike, well, that might even be worse. I hope none of us ever have to find out that way.

I've broke my neck, both ankles, both wrists, fucked my back and hips up. I've actually been lucky. I see these poor guys at motocross races in electric wheelchairs and I instantly have the utmost respect for them. They love their sport and there's absolutely nothing that is going to keep them away from it. Strong-ass dudes in moto, for sure.

And that's where I'm at these days. I've been racing motocross since my late twenties. Rode the AMA Supermoto Nationals for five years, and now we're back to moto. Me and my homies will load up the kids and go anywhere in the country on any given weekend to ride motocross. We've ridden the most bitchin' tracks in the country with some of the fastest dudes in the world. My buddies' kids are going to be national champs and I'm proud to say that I'm going to be a part of their success.

Among the hundreds of tattoos that I've acquired, I've got "Live 2 Ride, Ride 2 Die" tattooed around my neck. That's how my parents lived, and that's the way I live. Quitting is not an option for me, period. And it wasn't for them, either. I'm going to ride 'til I die. I'm not saying I hope I can still be riding a motorcycle at a certain age, I'm saying if

you know me when I'm 95 plus, you're gonna be saying, "That crazy old tattooed motherfucker is *still* riding?!" I'll turn, give you the finger, and respond, "You're goddamn right, I am." My eyes are open. "Live 2 Ride. Ride 2 Die."

Stop and ask yourself: out of all of these people I know, how many are really, truly not afraid to die? Do you know anybody who loves riding enough to stay on a bike for weeks at a time? Literally? No sleep, no food, piss-soaked pants, sunburned skin, windburned mouth, bleeding eyes?

How many people rack up 37,000 miles in only three rides? How many do you know who actually ride to die?

When I learned what that phrase meant to him, I had chills crawling up my spine, and that lump-in-the-throat feeling mixed with bewilderment. I know many people who claim to have a friend, or know someone, or even be the most hardcore rider out there, and some of their stories are impressive. But this guy is on a whole other planet that most couldn't even comprehend—Terry redefines the word "hardcore" for me.

—Chad Lemme

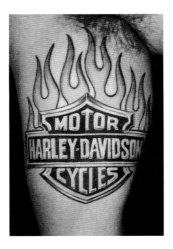

◄ "I've always loved bikes since as far back as I can remember," says Jason Cittro. "I bought my first Harley in '94, and the tattoo was just a natural progression for me—I thought a Harley Bar & Shield on the inside of my arm would just be bad ass and went for it." This tattoo was done by Chris Depinto, of Shotsie's Tattoo, in Wayne, New Jersey.

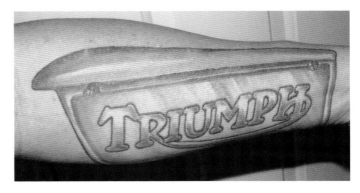

▲ "I got this tattoo because my '69 Triumph was the first bike I built, and it's also one of the reasons I quit drinking 13 years ago." —Nashville, Tennessee

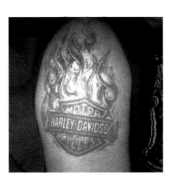

◄ "I live in Kitchener, Ontario, Canada. I got this tat because I really believe riding my Harley and going to Daytona Bike Week is my freedom from stress! It really is a true brotherhood. Biketoberfest in Daytona rocks! It is like a reunion every year bonding with my buddies!" —Ontario, Canada

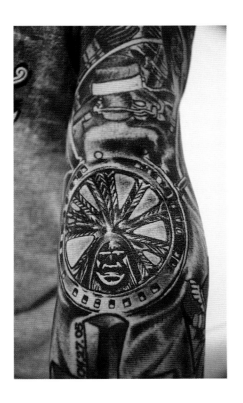

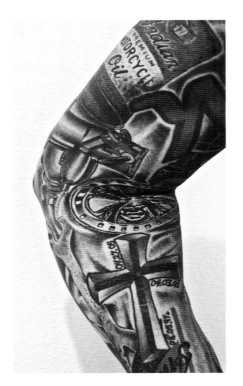

◄ "My first street motorcycle was a '47 Indian Chief that I bought as a basket case when I was 19. I restored it and still have it today. My first tattoo was when I was 21, and it was the laughing Indian. My next Indian was a 1938 that I started with a frame, then the motor, and piece-by-piece I built it. I still have it today. I love the styling of the 1938 Chief, so Darren and I decided to do the sleeve. It's very unique in that we did it part by part; we didn't lay the entire sleeve out beforehand. The sleeve just shows the passion I have for Indian motorcycles. And since I built the bike myself, it's a daily reminder of how hard work and passion for something pays off." —Jeff Kelderman, artwork by Darren McKeag of Slingin' Ink

▶ "All of my ink is due to something that was an unmistakable part of my life. The top ink is an EMS star of life. Although not biker-related, it was there first, and the second was put there on purpose. I worked for a lot of years in the back of an ambulance as a paramedic, so that is signifying the years of service and dedication to helping others. The lower tattoo, after riding many miles, was my first "branded logo" tattoo. That was after I had totaled my second motorcycle in my life when I thought that if I had ridden well over 100,000 miles on Harleys and survived—despite totaling two of them—there must be someone watching out for me. Plus, I think I had earned a 'Harley' tattoo by then. I have the angel wings, the wheel, H-D script, and the 'Remember' banner. We have to remember what we have done, where we have been, and what direction we are going. Otherwise, we are simply lost." —Vernon Schwarte

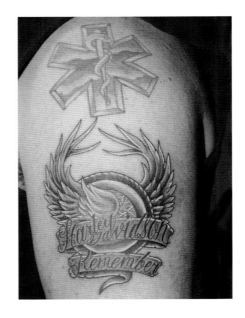

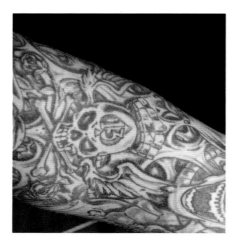

▲ "I added this to my sleeve design because I liked the design, and I love riding my chopper that was featured in *Cycle Source*, as I also enjoy the magazine the tattoo represents." —Wellsboro, Pennsylvania

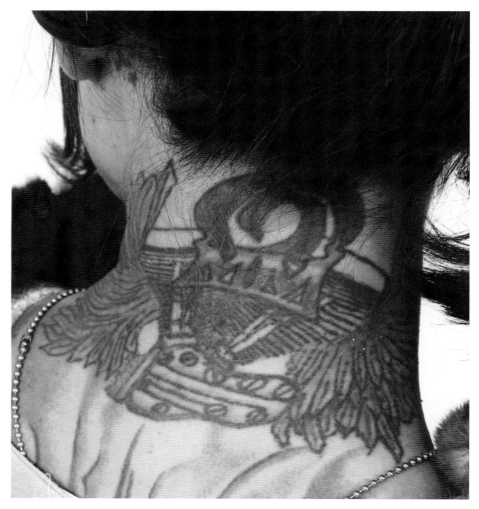

▲ "This tattoo was given to me by tattoo artist Seth Enslow for my birthday in 2005. He did this on the third of August in Costa Mesa, California. I arrived in Sturgis on my birthday, August fifth, and that night after our *Blood, Sweat, and Gears Tour* meeting/dinner, we all went for a ride—Billy Lane, Aaron Green, Paul Cox, Kendall Johnson, and Mondo Porras. I rode with Mondo. Well, Mondo and I ended up crashing! I later learned that you are supposed to get an engine with wings only after you have earned them by crashing and surviving. I was given this tattoo two days before my birthday, for my birthday, and I earned my wings that night on my big day. Mondo and I joke because I love my birthday road rash."—Jennifer Santolucito, Tattooed Songbird

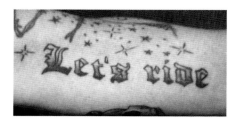

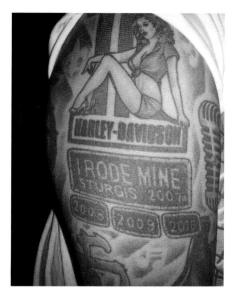

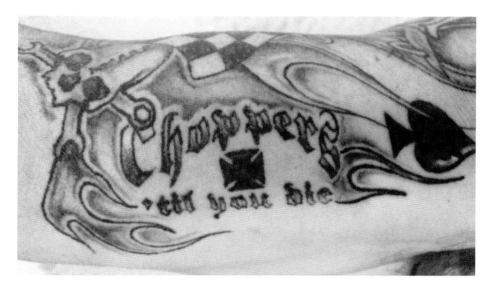

▲ "All of my tattoos relate to my life. I have Triumph choppers, and the 'CTyD' tat says it all. That is the only style bike for me. It comes from sewn patches and stickers that have been around since the seventies. 'Let's Ride' and 'Hold Fast' are, according to my friends, my slogans. Brian Jones is my tattoo artist." —Ontario, Canada

▲ "I just feel proud that I can and have ridden to Sturgis five times, and three of them were on a rigid. Luckily I'm close enough to ride just eight hours to get there. I've never gotten around to getting an 'I Rode Mine Sturgis 2011' tattoo yet, not enough space to tattoo near the others." —Denver, Colorado

▲ "I was on my first deployment while in the navy and we we're heading into our last port [Hawaii] after being out for six months. A group of about 10 of us all agreed that we'd get tattoos together and then take the town. After everything was done, only two of us ended up getting work done and we got screwed. I paid $120 BEFORE tip (I was told to tip by my buddies). Tattoo's on the outside of my left calf. It took him about 15 minutes and he had a shit-eating grin the whole time. Its supposed to be a surfer 'surfing the high seas of life'. My buddy paid over $300 for a tribal armband that barely went halfway around his arm."

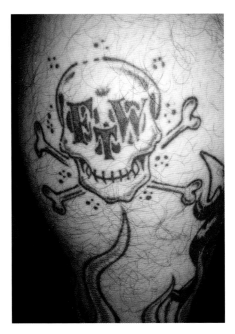

▲ "I am from New York City but have been living in Charleston, South Carolina for the past 12 years. When I first moved to South Carolina, tattooing was still not legalized yet. A few years went by and the laws passed, so I rode my bike to the local shop and wanted something to tell the world I like to ride fast and loud and I don't care what anyone else thinks. And what better way but to get a FTW tattoo across a skull and crossbones to show the evil behind me!"

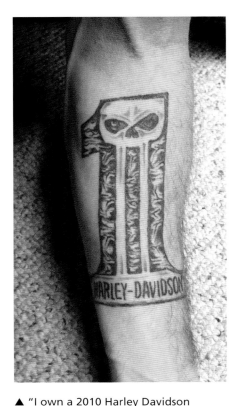

▲ "I own a 2010 Harley Davidson Sportster Forty-Eight that is fully customized. Show bike, but a daily rider. I got this tattoo because I love Harleys. I am 40 years old and love my Harley! My friend Paul Woolworth at Skin Addicts tattoo parlor did the work. He does all my tattoos. My bike is gonna get featured in *American Iron* magazine this coming summer."
—Jenison, Michigan

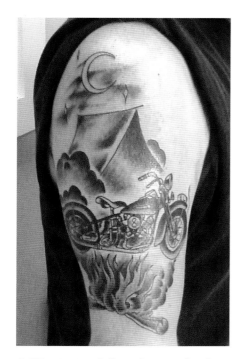

▲ "The tattoo defines the way that I like to ride. I don't enjoy riding with groups, especially on longer road trips. So this represents the way that I enjoy riding: just myself, my bike, and the outdoors. Of course I do take a bit of my wife with me; those are her initials on the front fender license plate. Some folks call me crazy as an eight-ball, so there is the eight on the air cleaner."

▲ "This is on my knee. It is a logo tattoo for the Hogs on the High Seas rally, which is a cruise/motorcycle rally done every year for kidney dialysis. Although a cruise, it is a rally all the same. Oh, and I won $500 that year for best HOHS rally tattoo!

The rally has since changed its name to the High Seas Rally. Harley-Davidson was trying to sue them for using the word 'Hogs' in their name. Fucking assbags . . ."

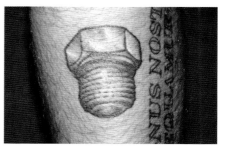

▲ "I got the tattoo because after changing my oil I went for a ride about 100 miles round-trip. Upon returning, I noticed oil pouring out of my bike. As I was cleaning up the oil in my driveway, my arm bumped the exhaust, leaving a beautiful scar. A couple minutes later, I realized I had only tightened the drain plug finger-tight. Lucky it didn't come out until I pulled into my driveway. The tattoo is a reminder to tighten the drain plug with a wrench."

Indian Larry "Question Everything" Question Mark Tattoo

Making our way from motorcycle rally to motorcycle rally over the last 15 years or so, we've seen one tattoo that has become increasingly popular. It's not a tattoo paying homage to a certain brand of motorcycle, or a tattoo screaming words of wisdom on two wheels. It's a tattoo about a philosophy, or a certain way to live life. That philosophy belongs to custom motorcycle builder Indian Larry.

Born Lawrence DeSmedt in New York on April 28, 1949, Indian Larry began working in motorcycle shops in New York City in the 1980s. For many years, Larry struggled with alcohol and drugs, but he maintained his focus on motorcycles and the moto hot rod culture, inspired by Ed Roth and Von Dutch during his years in California.

His bikes were popular in New York, and he had quite the reputation as a wild motorcycle rider, splittin' lanes and raising hell in the city streets. When the motorcycle magazines started featuring his creations, that's when things turned for Larry's career. The articles showed all the facets of Larry—the good, the bad, and all the ups and downs he

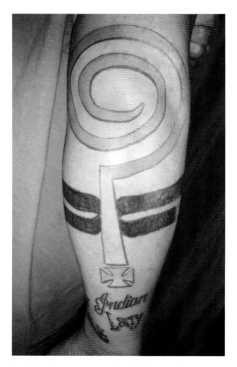

Bobby Heron proudly displays the Indian Larry Question Mark tattoo— a dedication to a legend.

had to overcome to get to a place where he could finally be comfortable with himself and his work.

Then in 2001, TV made its way into motorcycle culture and exploited the scene for all it was worth. This opportunity made the general public and motorcycle enthusiasts aware of Indian Larry. He was featured on *Motorcycle Mania II* and those *Biker Build-Off* programs. This led to more magazine articles and interviews, and gave Larry the chance to speak about his life and his philosophy. What he said made sense to fellow motorcycle enthusiasts, and he struck a chord with thousands of unknown brothers and sisters on wheels.

With all of this exposure, Larry was able to tour the country and attend many motorcycle rallies, showing off his creations and meeting his fans in person. People were always excited to meet Larry and catch a closeup glimpse of his creations, such as Daddy-O (known to most people as the Rat Fink bike), Wild Child, and Chain of Mystery. It would have been easier to handle the passing of a talented custom

builder if he had been a jerk in real life—Larry was anything but.

To this day, Larry's bikes have yet to be surpassed in terms of craftsmanship. One symbol Larry used over and over in his branding logo and on his paint jobs was a question mark. It represented his most prized rule of living life: "Question Everything." Why accept whatever's put in front of you? Question the shit out of it and enjoy the ride as much as you can.

Larry's way of life embodied everything the traveling moto-culture is about. Many of our friends have a similar tattoo, a mark of respect for Larry. "Question Everything," it reads.

If you see the Larry Question Mark tattoo on a fellow biker, you know that person has respect for Larry and all he stood for. It creates instant camaraderie between fellow bikers that share the question mark tattoo (and among others who don't, for that matter). Those who have the tattoo had a personal connection to Larry, either from working with him, or being in his family, or from traveling with him on the road. It would appear that anyone who was touched by Larry—anyone who spent time with him, and shared precious moments together—immortalized this legend by getting the question mark tattoo.

What's so great about this tattoo is that there is an unspoken respect for anyone who bears it. This tattoo carries meaning, and those who know of its meaning instantly respect the others marked with it. Practically every custom bike builder, pro or amateur, has this tattoo. We see it all the time at rallies and everyone is always happy to share their personal "Larry" story with you.

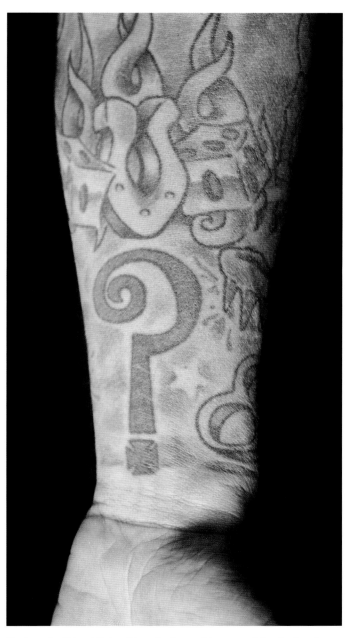

Custom builder Michael Lewis shows his respect for Indian Larry with the "Question Everything" tattoo beneath a flaming pair of dice and a lucky horseshoe.

◄ "Let's see, Larry has always been an inspiration for me, from the raw style of his bikes to the way he built them. Thankfully, I got to meet him before his passing. Let me tell you why I got the question mark tattoo: I always loved his logo for his shop, and with him being such an influence on me, I decided to have it done back in 2003 by a good friend of mine, Justin Hyde. He was apprenticing at the time at my friend's shop, Wild Zero Studios, and it was his first tattoo on anyone." —RJ Powell

▲ Anyone who met Indian Larry (center) was immediately impressed with his down-to-earth personality and sincerity. He was always happy to meet anyone who approached him just to shake hands.

▶ Jay Allen is a welcome face at many rallies, and has been a huge supporter of all the custom motorcycle builders over the years. His back piece has portraits of two famed builders who left us too early—Johnny Chop and Indian Larry.

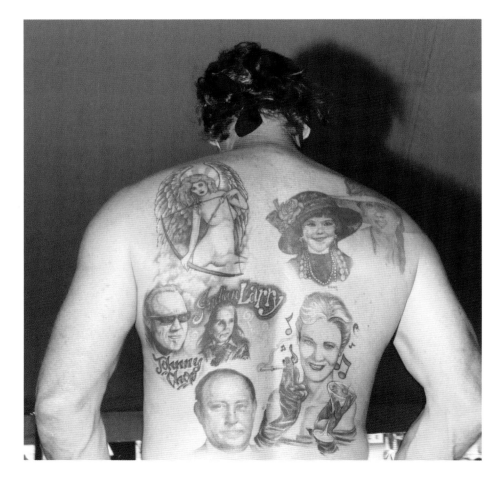

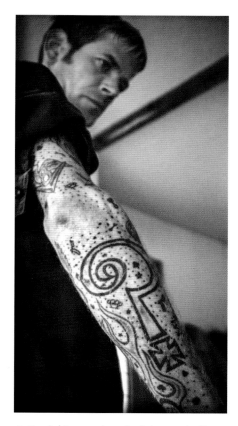

▲ Daniel is a custom builder, and after meeting Larry and spending time with him, Daniel developed a sincere appreciation for not only Larry's work, but his genuine persona as well. This inker's arm features another tribute to a motorcycle legend.

▶ Jeremy Pederson proudly displays a classic tribute to the custom moto-culture on his arm—Big Daddy Roth's bulging-eyed, ravenous critters are easy to spot, and an Indian Larry tattoo sits next to the mouse of mayhem. Jeremy slings paint and pin stripes at Relic Kustoms in Austin, Minnesota.

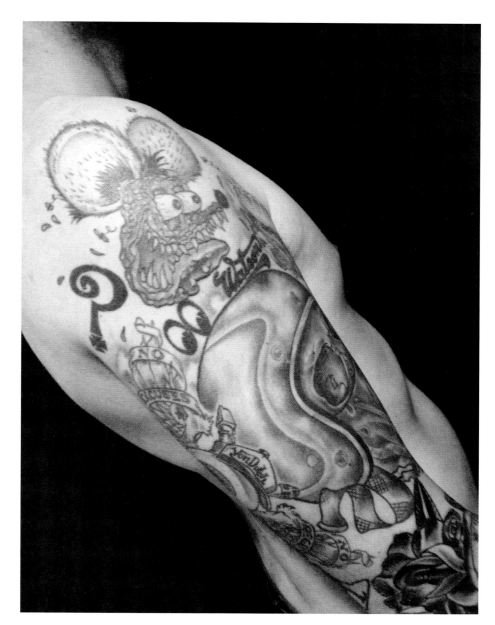

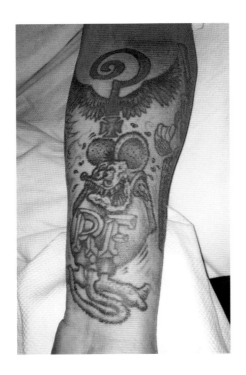

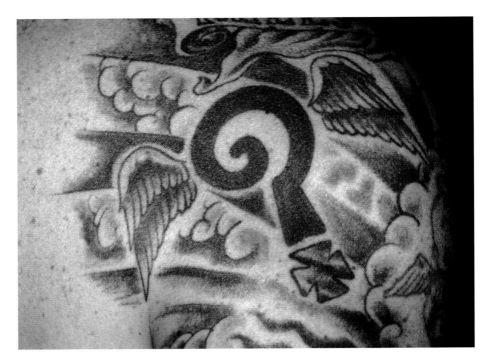

▲ Rob Lopez's forearm features another tribute in ink to Ed Roth with his grinning Rat Fink character, as well as a stylized "Question Everything" tattoo above it.

▲ Thick or thin, colored or black, Indian Larry tributes can be found in all shapes and sizes.

▲ While some just get the question mark tattooed by itself, others choose the version with wings—a tribute to a fallen builder, brother, and inspiration. A memorial to a legend.

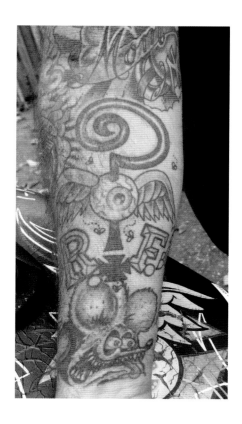

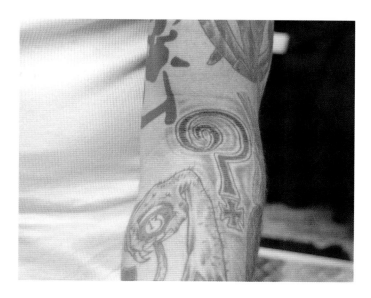

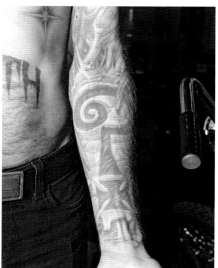

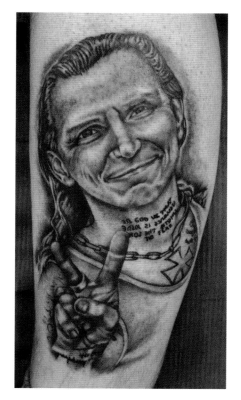

▲ The tributes to Indian Larry are literally all over the country and even around the world. This one was done by Joe Delbuono of Willie's Tropical Tattoo. *Bill Tinney*

◀◀ Above left: This forearm features another Larry and Rat Fink tattoo side by side, and this time they're in color. Larry was a huge fan of Ed Roth and Von Dutch.

◀ This is an amazing portrait of Indian Larry; the resemblance is incredible, and not just any artist can pull off a tattoo like this. Leave it to Richie Pan of Dark Star Tattoos to nail this one. *Bill Tinney*

◀◀ Below left: Custom builder Iliya Hamovic integrated his memorial for a legend on his full sleeve.

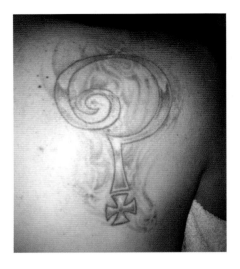

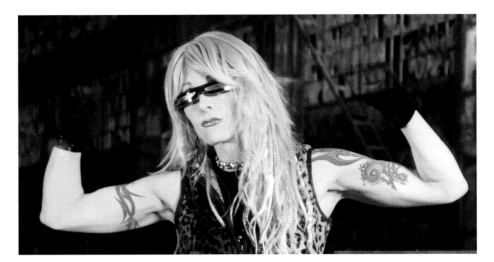

▲ This young lady shows her love for Indian Larry with his signature tattoo on her shoulder.

▲ Above right: Goth Girl spent many hours with Larry on the road, so this tattoo is much more than a tribute—it's a memory of the great times they spent together, of the great man he was, and all the wonderful things he shared with her. Goth holds this memorial tattoo in the highest regard.

▶ Robert Pradke (the best custom painter in the country) knew Larry well, and painted many projects for him. This tattoo carries much meaning for Robert.

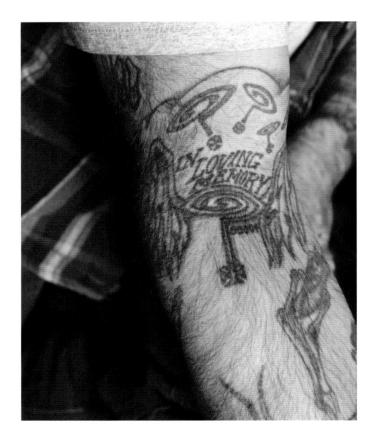

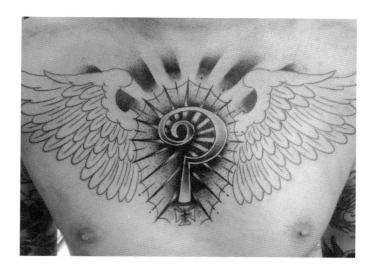

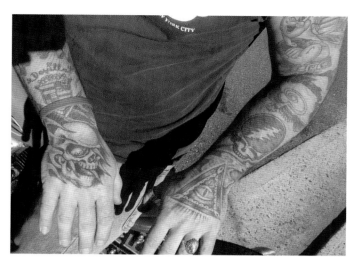

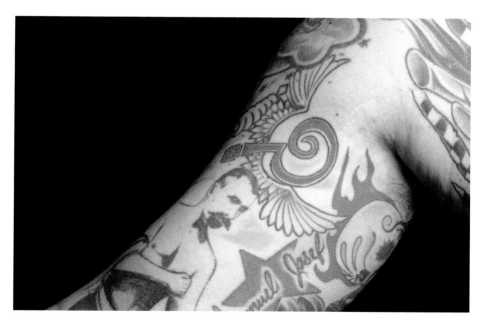

▲ Above left: It's hard to go much bigger than this—this fresh chest piece, emblazoned across this biker's heart, is an incredible memorial to Indian Larry.

▲ Larry Gregoire of Brooklyn, New York, knew Larry as a boy—they grew up in the same neighborhood. Sharing a love of motorcycles, Gregoire pays tribute to Larry's memory with a "Question Everything" tattoo, which rests comfortably between a smirking Popeye and another easily identifiable icon—the Grateful Dead skull.

◄ Paul Wideman of Bare Knuckle Choppers pays homage to an icon in the middle of an extremely detailed bicep.

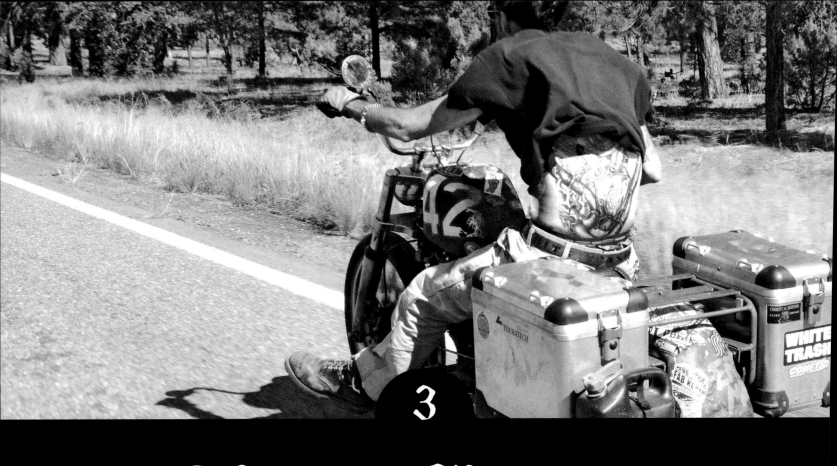

3

Back Pieces and Bodies

Some riders fall in love with an engine (panhead, shovelhead, etc.) and stay dedicated to that engine their entire life. A marriage in harmony and dedication—just as some people might tattoo their lover's name on their skin, some crazed lovers tattoo a complete engine on their back.

he back seems like a perfect place to spread a gigantic picture of life, or war, or *Star Wars*, or whatever. Only someone out of their mind would display the powerplant of their beloved motorbike . . . and many of these half-crazed motorcycle junkies are just the type of monster to do it.

The surface area of a person closely resembles the coastline of Norway: numerous fjords make up the largest coastline in the world, despite the rather small country it's attached to. Similarly, we have all kinds of square inches to cover with this or that, putting small pictures in our armpits and down our fingers and so forth. But the back is one vast, open area, the perfect place for a large, continuous masterpiece. And it's quite a thing of beauty when properly exploited.

Since truly hardcore motorcycle freaks love their scooters far more than any person, place, or time in history, they'll permanently affix things such as VIN numbers and words showing their love for the machine that matters most to them in life. This love really shines through when they go as far as placing a life-sized rendering of a Knuckle or a shovelhead beneath their dermis for all eternity. I know a few of these particular mutants, some of which are pictured here.

Speaking of freaks, let us examine the truly hideous of the sideshow. These mutant monsters have gone above and beyond the call of crazy and tattooed their skulls and faces, along with the rest of their colorful hides. Unfortunately, a sort of stigma has stuck to this narrow class of courageous characters willing and able to permanently alter their Mona Lisas. It used to be that a simple sleeve would guarantee inevitable stares. But nowadays, with tattooing an entire arm or two having become common practice, it takes a little more flare to attract the stares—a facial tattoo seems to fit the bill perfectly.

It's only natural that when you see someone wandering around with tattoos on their head or their neck or their face, you look. And you look because it's the natural thing to do in our censored corner of the world. Hell, *I* look. Some gawkers will ask questions, but most will just look, too nervous to inquire about the art at all. It's the people who are truly frightened—the ones who pretend not to look, repeatedly shooting quick glances out of the corner of their eye—who really crack me up. These people clearly should never play poker.

The ever-changing nature of history leads one to believe that someday the taboo behind the tattoo will vanish. Look at it from a historical perspective: people used to go to the circus and pay good money to check out the tattooed savages of Borneo, or whatever little primitive slice of Pacific island the conquistadors ransacked while expanding their empire. We may not do that anymore,

but the curiosity remains when it comes to tattoos on uncommon areas of the body.

I asked tattoo artist Darren McKeag of Slingin' Ink in Grinnell, Iowa, how he feels about the stares, since he's almost entirely covered in tattoos, including head, neck, hands, and face. Here's what he said:

"The funny thing is I've been covered in tattoos for so long that I don't even realize people stare at me unless I catch them really *staring*. Most instances, it's the people with me that notice people staring at me, and honestly I couldn't care less if they stare or not; it really doesn't bother me. The interesting part of all this is that the people who aren't tattooed are the ones concerned that I am tattooed.

The other night at a bar this lady with no tattoos (I know this because she told me) asked me if I cared that she wasn't tattooed. I told her nope, and she insisted that I care—that I must give a shit. I told her no again, and she was pissed that I didn't care to give her attention, or care that she was giving me attention. It might not help that I think most people are stupid."

—Sara Liberte

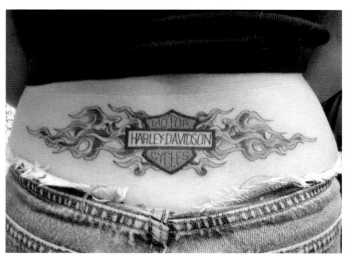

▲ A lot of ladies choose the lower back to display their artistic flare or passion; in this case, riding her Harley-Davidson is what inspires this young lady. She chose the classic Harley-Davidson Bar & Shield with hot rod–style flames to frame what is commonly referred to as a "tramp stamp."

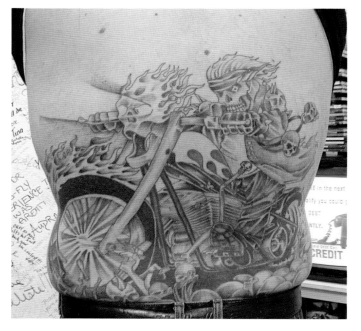

▲ Does it get any more righteous than a skeleton riding a rigid chopper? It does if you have this tattooed on your back! This ghostly rider rumbles atop the highway to hell, cruising over a road of bones and skulls. His bike features a flaming skull headlamp and bone jockey shifter.

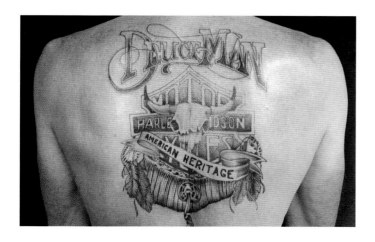

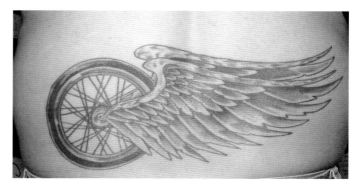

▲ For this rider, his motorcycle is part of his American heritage. This top back piece showcases not only the passion for the brand but a little more Americana with the steer skull and feathers. It's obvious this guy rides a Harley-Davidson Deuce model and is very proud of it.

▲ Above right: It appears to be the case for many motorcyclists that riding a motorcycle is as close to flying as they can get. It's very common to see images of wings with motorcycles or next to motorcycle parts, such as this laced wheel for this clean back piece depicting the limitless feeling of riding. Many people are unaware that the winged wheel was invented by the Nazis for their motorcycle corps (but don't make the mistake that the wearer is, in fact, a Nazi).

▶ Cards, whiskey, a smoke, and your rigid motorcycle—what more can a guy ask for? How about an amazing, beautiful tattoo artist wife who laid out this portrait of you riding your bike? This is the back piece of tattoo artist Long Jon Barwood of Sacred Skin Tattoo in Payson, Arizona, completed by artist Amanda "Pinky" Barwood.

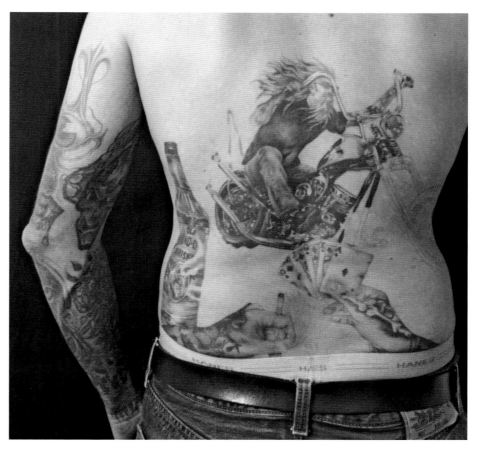

▶ Some riders fall in love with an engine (panhead, shovelhead, etc.) and stay dedicated to that engine their entire life. A marriage in harmony and dedication—just as some people might tattoo their lover's name on their skin, some crazed lovers tattoo a complete engine on their back. This is the back piece of *Moto* journalist George "the Painter" Frizzell. It was completed in three straight eight-hour days. Ouch! The art was done by Richie Pan, of Darkstar Tattoo Parlor, New Jersey.

▶▶ Iliya Hamovic, of Steel Born Choppers (New York), has one of the coolest back pieces we came across. Ominous skeletal vertebrae snake from his hips to his medulla oblongata.

▶ Tattoo artists usually have the most detailed back pieces, and this guy is no different. A sinister, smoking skull overwhelms everything else.

▶▶ This girl sports a set of wings in progress as she rests at one of the motorcycle rallies. *Tom Tobin*

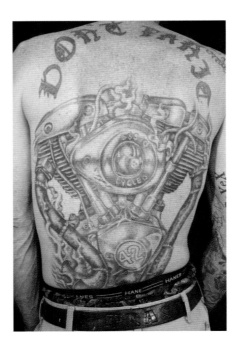

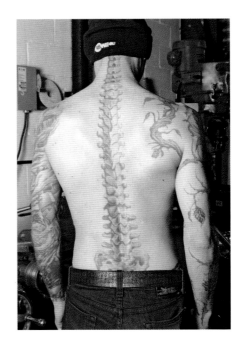

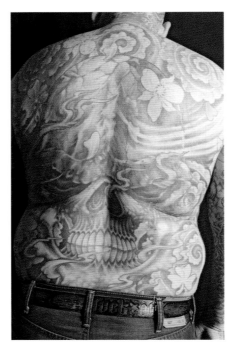

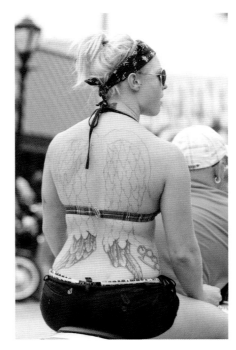

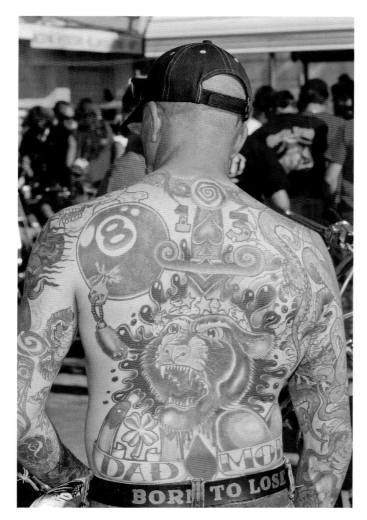

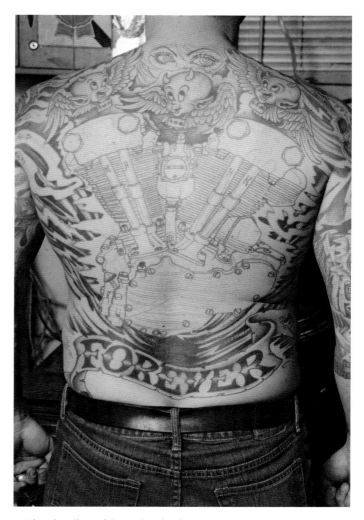

▲ From this back piece, a panther explodes, a magic eight-ball predicts the future, lucky (or unlucky?) 13 sees over all, an octopus tentacles his right arm, while a tribute to Mom and Dad sits on his waistline. Do you think this guy was really "Born to Lose?" *Tom Tobin*

▲ The detail on this engine back piece is simply insane. A bedeviled Porky Pig is sitting pretty atop an intricate V-twin knucklehead. The "Knuckleheads Forever" artwork is by Josh Arment of Aloha Monkey Tattoo in Burnsville, Minnesota.

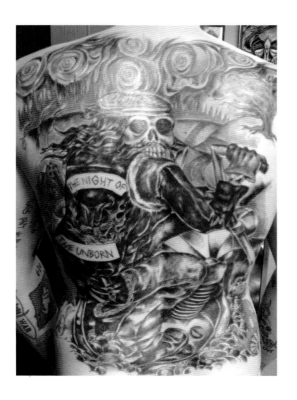

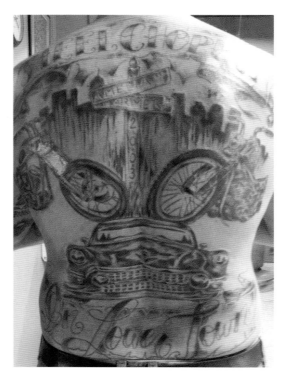

◀◀ Latricia Horstman is the artist behind this full back piece. This demon rolls toward a purple witch-tree horizon as "The Night of the Unborn" passes by.

◀ A couple of cool bikes and a chopped Chevy say much about this rider's lifestyle. This piece was also done by Latricia Horstman.

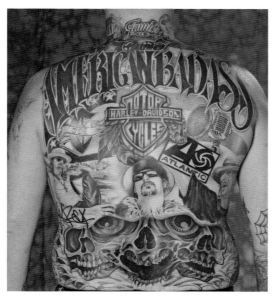

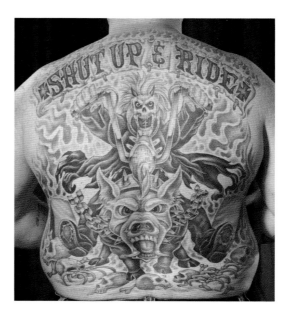

◀◀ This guy has a thing for Kid Rock, who ranks up there with Harley-Davidson; he gave his entire back to them. *Bill Tinney*

◀ This bold back piece makes quite a statement. "Shut Up and Ride" with a skeleton riding a hog. *Bill Tinney*

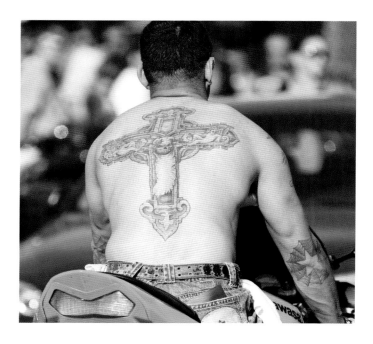

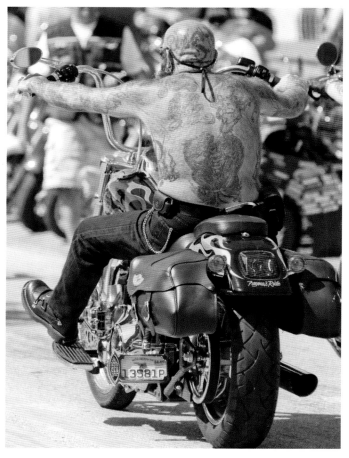

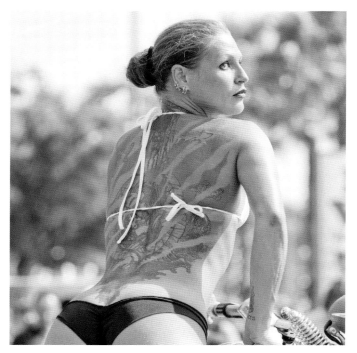

▲ Many scattered pieces fill this guy's back, arms, and skull. For some riders, no piece of skin can be wasted—it's an open canvass! *Tom Tobin*

▲ Above left: A detailed cross with a skull in the middle creates an ambiguous aura around this mysterious rider. *Tom Tobin*

◄ Yamma hamma! This girl is dressed well to show off her massive underwater scene—a manta ray, jellyfish, and hammerhead shark patrol her shoulders, while more sinister creatures lurk below. *Tom Tobin*

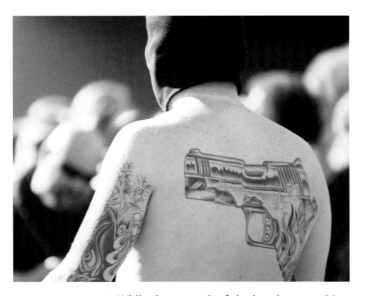

▲ While the artwork of the handgun on this back piece is amazing, I'm more interested in knowing if he always wears a black cap over his face! *Tom Tobin*

▶ Everyone with butt tattoos welds naked, right? Lemme's "HE-MAN" and "Beaver patrol" tatoos were the result of a FREE TATTOO FRIDAY at Slingin' Ink, where if he accepted a free tattoo, he couldn't know what the artist was going to tattoo on him.

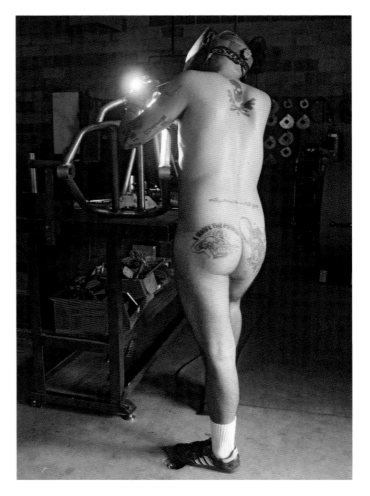

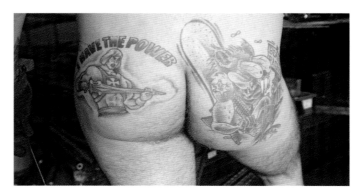

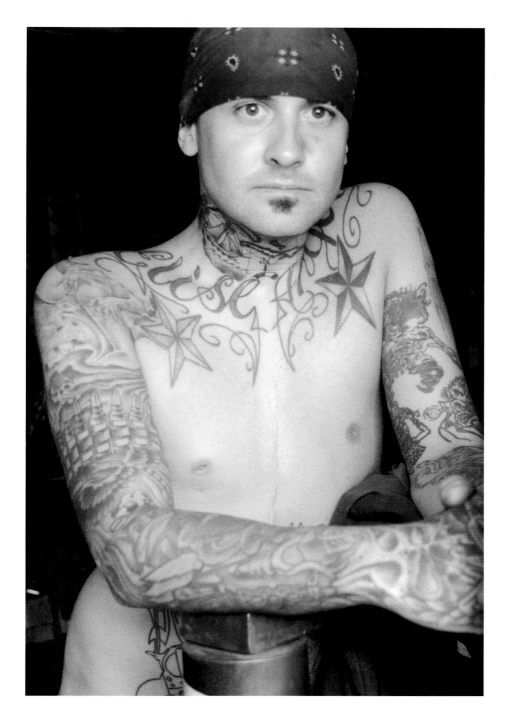

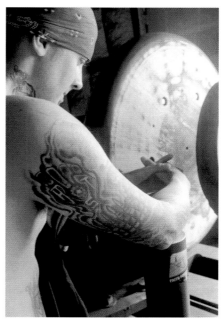

▲ If the writing in this book doesn't tell you that author Chad Lemme (pictured) is no doubt a Gonzo fan, perhaps this tattoo will signify it.

◄ So we have a full sleeve, a neck bone, a necklace, patchy arm work all around, two hand bones, and a stomach piece. That's some serious time under the needle.

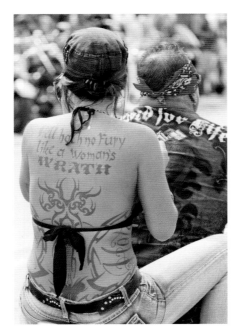

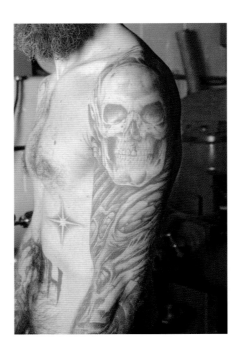

◀ A grinning skull fits perfectly on this rider's shoulder. The depth of the rest of his arm is amazing; done well, black and gray tattoos are sights to behold.

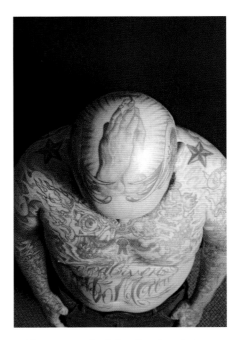

▲ "Hell hath no fury," Shakespeare wrote, "like a woman scorned." Who said bikers don't read? *Tom Tobin*

▶ I love the location of the connecting rod on the elbow in this full sleeve.

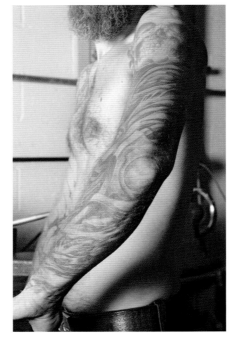

▲ Not a spare inch is missed on tattoo artist Darren McKeag's body. Tattoo artists always have the most amazing full body ink.

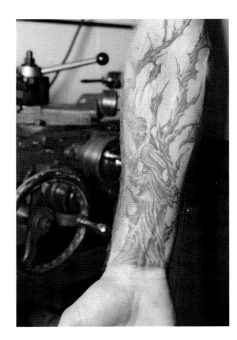

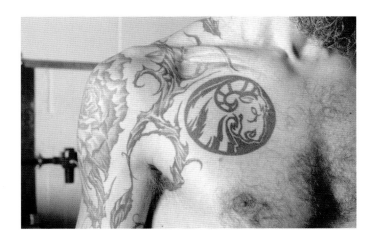

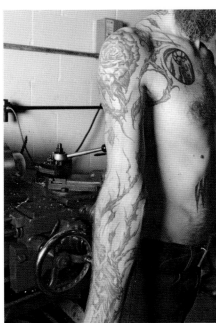

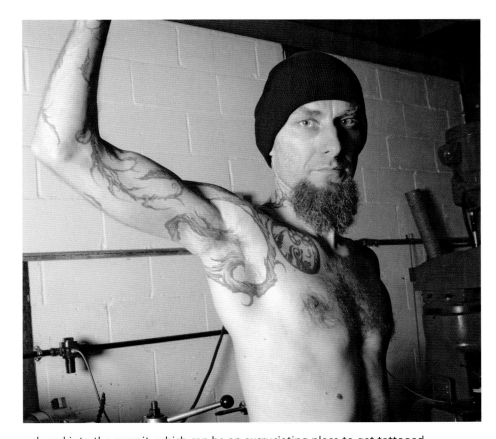

The thorns of this shoulder rose creep up, around, and into the armpit, which can be an excruciating place to get tattooed.

▶ This entire body is themed around Route 66, which must be loaded with personal memories of amazing trips. *Bill Tinney*

▲ Tattoo Duke is a tattoo artist with many years under his belt and almost as many tattoos on his body. He is a great guy and a blast to hang with—if you ever run across him at a rally, be sure to say hi.

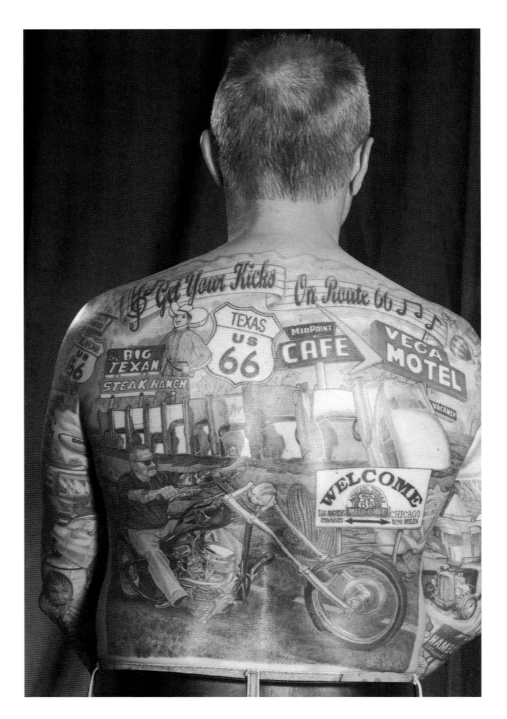

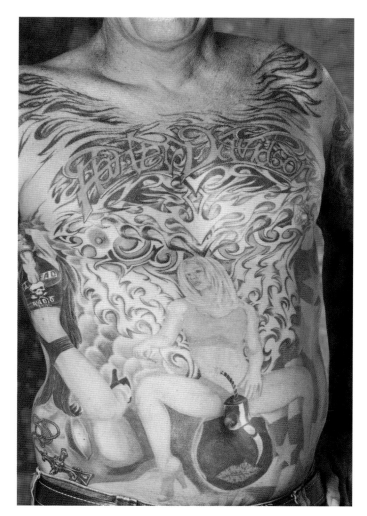

▲ Girls and Harleys fill up this guy's body of work. *Bill Tinney*

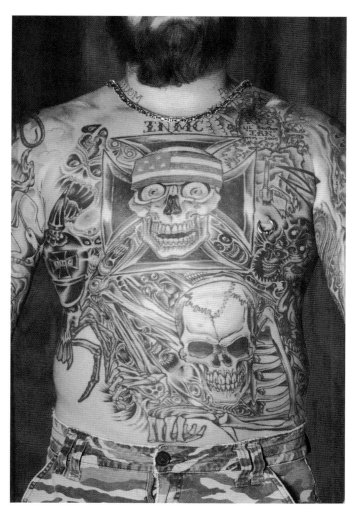

▲ There's so much to look at on this guy, but I still see some empty real estate. I'm sure he has plans for those small areas. *Bill Tinney*

▼ Charlie the Nomad is fully decorated with traditional color tattoos, two arm sleeves, and a full chest piece filled with personal mantras and symbols.

▼ You have to think about the adventurous life these guys must have have lived to have so many amazing memories and moments worthy to be permanently inked on their body. *Bill Tinney*

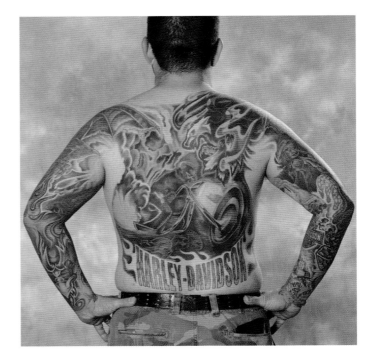

▶ Guess which one is Tattoo Duke. He sports traditional, full color body tattoos as far as the eye can see.

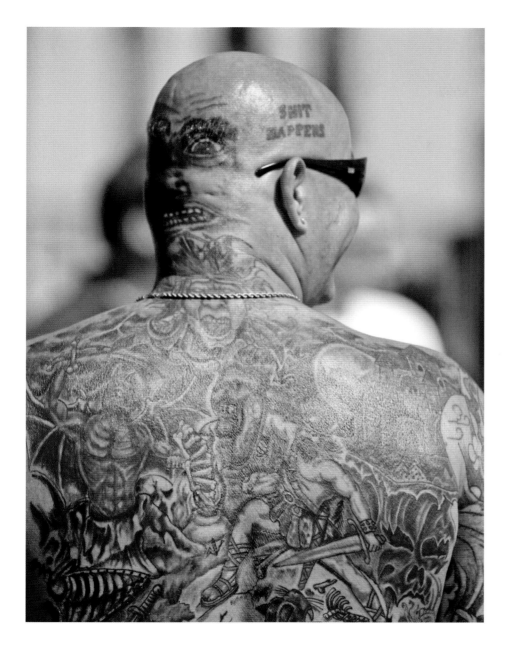

◀ Covered in tatts, his old body nothing but a memory, one wonders when he decided to proclaim "Shit Happens" for all eternity above his temple. *Tom Tobin*

▲ These guys sport a little bit of everything on their fully covered, colorful torsos. They're sharing a story outside Willie's Tropical Tattoo in Florida. *Tom Tobin*

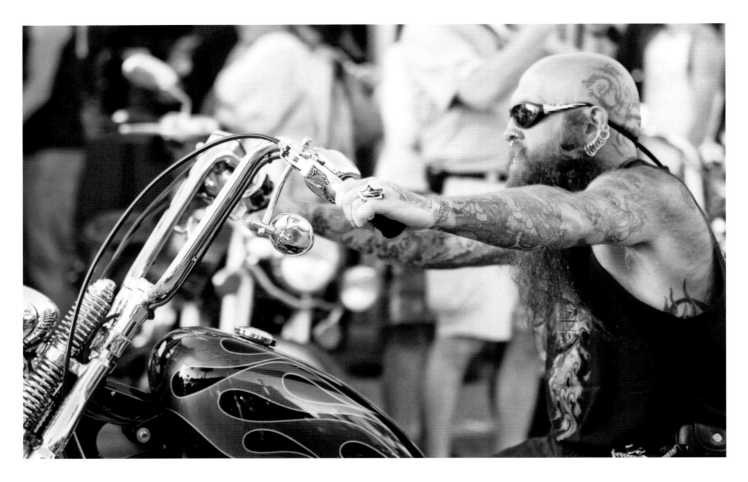

▲ Some people might be scared shitless seeing a guy like this tearing down the road, but chances are he's one of the coolest cats you could ever party with. *Tom Tobin*

▶ According to Chad Lemme (pictured), the sea monster on his jaw was more painful than the neck bone and necklace tattoos.

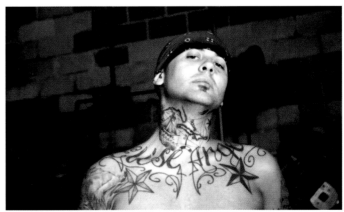

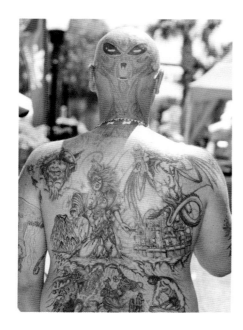

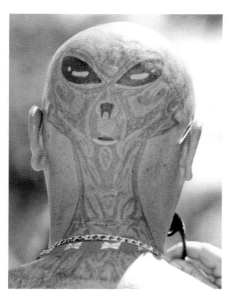

▲ From an alien to fierce pirate babes, dragons, and more, this guy's back and head tells quite a tale (I'm just not sure what it is). *Tom Tobin*

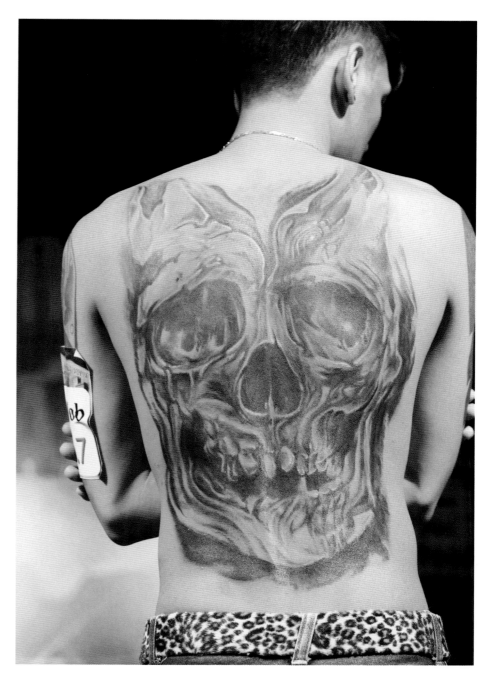

▲ Another back piece in a tattoo competition at a rally around the country. *Shutterstock*

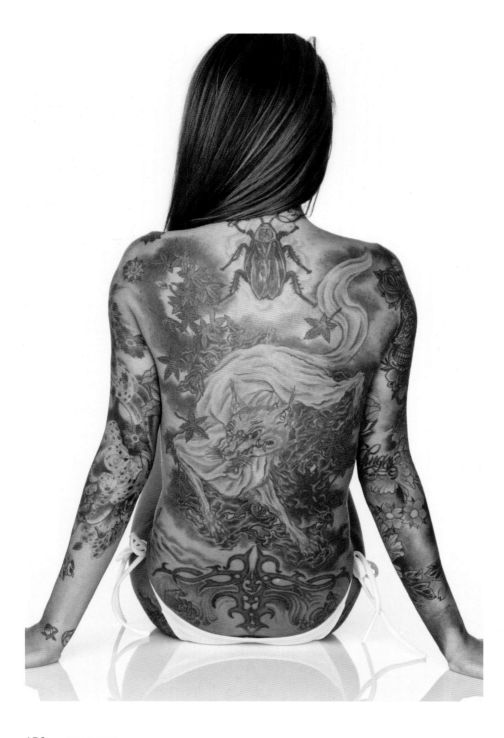

◄ This woman incorporates many traditional and contemporary forms on her back mural; how many different images can you spot? *iStock*

▼ This guy is well on his way toward a body full of tatts. The Chevy adorns his chest, "Rider Life" sits above his belt buckle. A few demonic skulls lurk on one sleeve, while a shifty trickster haunts the other. Even his hat looks like a Big Daddy Roth tribute—well done, sir! *Tom Tobin*

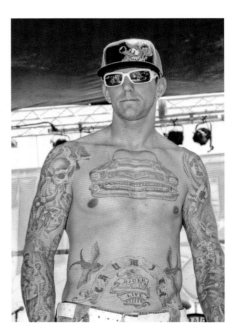

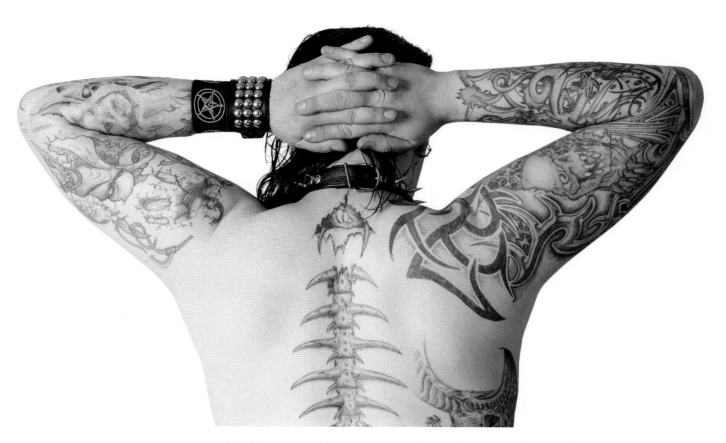

▲ A sinister spine of spikes anchors this biker's tattoos. *Shutterstock*

Famous Tattooed Bikers

When the Discovery Channel started exploiting the motorcycle industry with its "reality" shows, custom motorcycle builders quickly became household names. Guys that were craftsmen in their own right at metal fabrication, engine building, bodywork, and paintwork were now overnight celebrities. These guys were just minding their business when the fat cats at the television networks dangled the dollars in front of them, and they gave chase like an ass in perpetual, hot pursuit of that proverbial carrot on a stick. For some, it paid off big (if you're okay living the rest of your life without a soul, anyway).

Those rotten TV execs were ready to cash in on the biker image to grab the interest of the masses. Even if it was exploited for all the wrong reasons, the long hair, the tattoos, the cool motorcycles, the burnouts, the parties— it still made for great television, and it launched the motorcycle scene into money-making madness, if only for a while. Suddenly, custom motorcycle building seemed to be a glamorous lifestyle; these guys were rock stars with blowtorches. All the televised appearances, magazine coverage, and meet-and-greets at motorcycle shows made it look like these guys were living the life.

Naturally all this media attention paved the way for the thousands of wannabes suddenly crawling out of the woodwork. It took time to weed out the posers, but anyone with a trained eye could tell the real builders from the hacks without a second glance. Over years of working in this industry, we have had the opportunity to work with many of these builders. We saw many of them come and go, and we remain friends with the right ones still to this day. I collected images of some of the guys I considered to be true craftsmen, and as I'm sure you guessed, they all have tattoos.

—Sara Liberte

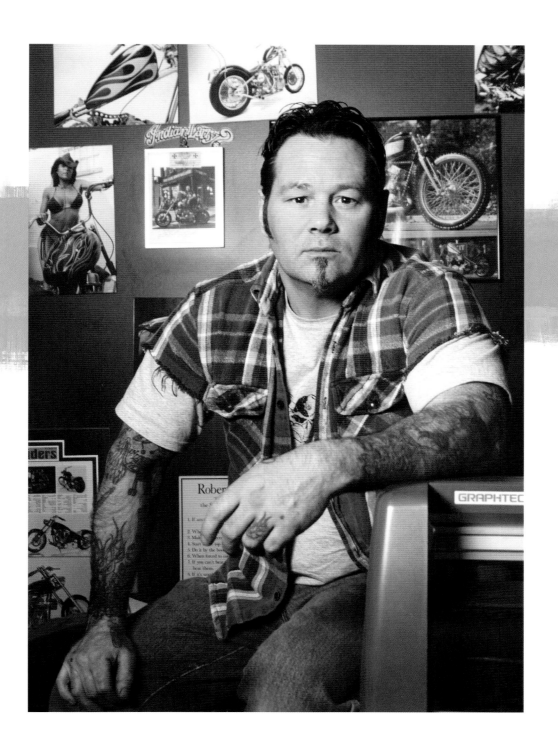

Jason Grimes

Maine is home to this particular craftsman, owner, and operator of Northeast Chop Shop in Windham, Maine. Jason is one of those guys who can do it all. He's completely immersed in every aspect of the custom culture, from fabrication work to bodywork, from welding to painting, all the way down to folding and hammering different combinations of steel for his Damascus parts. Having a soft spot for early Harley-Davidsons, he has his arms loaded with tattoos depicting parts from early bikes, including a very cool cutaway of an early external valve train H-D engine. The rest, consisting of camshafts, early carbs, and a springer front end, is like a historic motorcycle museum tattooed right on his arm.

—Sara Liberte

Jason had some great tattoos to share with us, and I liked them all. But I liked the stuff in his shop just as much, and as a result, we wound up spending the better part of a day there, which would become a recurring event for us throughout this book. I remember seeing this short and narrow Ironhead with mags wrapped in knobies, and a shortened 39mm out front. This thing looked like it would be a fucking *blast* to ride. Short, extremely narrow, light—the perfect recipe for high-speed insanity.

After the extensive tour of the shop (with Jason sharing his version of the Damascus process), and a perusal of his painter's outstanding pinstriping, we set up the backdrop and Sara began photographing his favorite tattoos. We heard stories about them, ogled over them for a while, then hit the road in the twilight hours, which had snuck up on us. On our way out, Jason left us with an armful of T-shirts, hoodies, and other swag, and we can't thank him enough for it.

—Chad Lemme

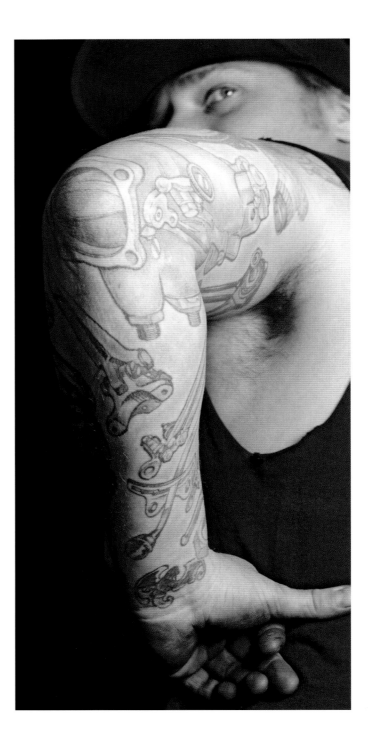

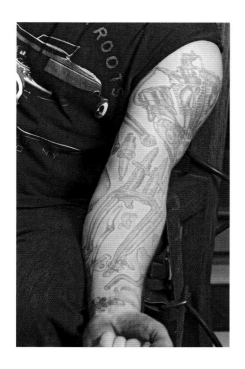

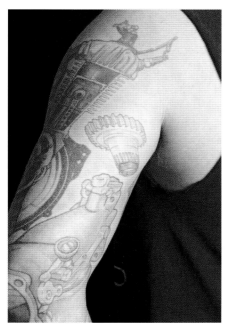

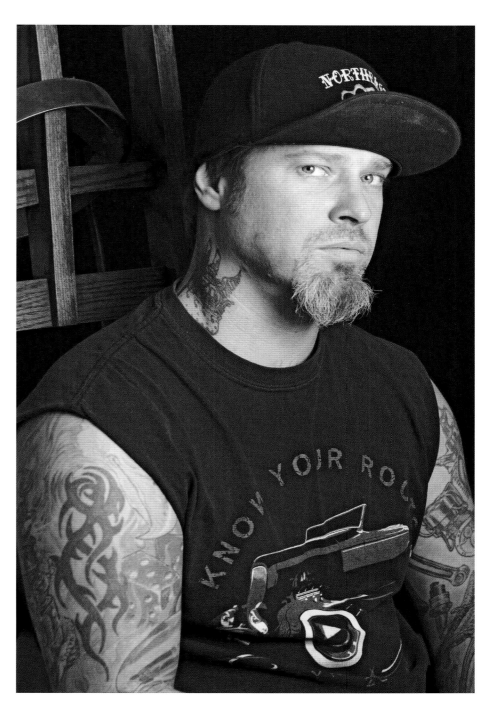

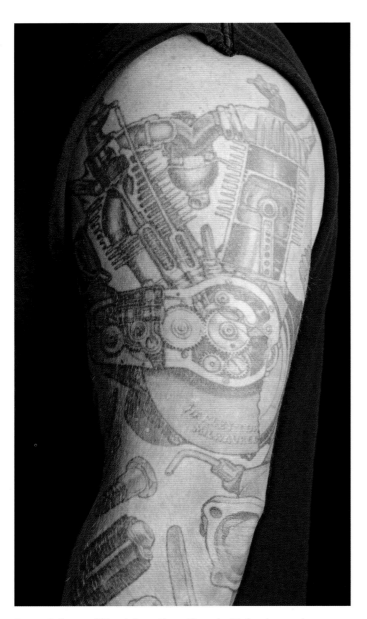

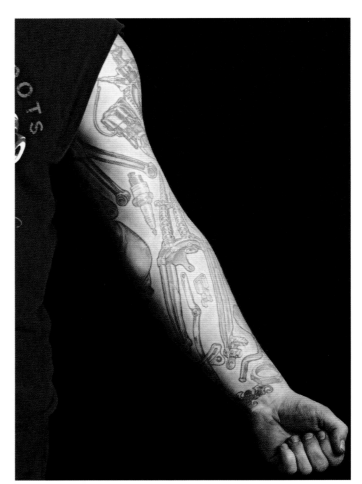

Jason Grimes of NorthEast Chop Shop in Maine has a sleeve full of motorcycle parts and components. His left arm sports exploded views of a V-twin engine, as well as many lugs, bolts, and other parts of the engine, and his right arm is more dedicated to various symbols of his biker lifestyle.

Dave Perewitz

Dave is one of the builders who's garnered the most TV airtime. From it, he earned the title "King of Flames" for his custom flamed paintwork. Dave currently resides in Massachusetts, and has been building bikes for a few decades now. This guy has been putting time in on bikes longer than some of the younger builders out there have been alive, all the while amassing myriad tattoos, just the same as his never-ending collection of bikes and parts. Acquiring two full sleeves and several pieces on his legs, Dave has enjoyed the time he's spent in the chair with Gabe and Nolan at Acme Tattoo, and looks forward to more time in the hot seat.

His customs have been through many fads and styles, from the early rail digger–style chops of the early 1970s; to the fat tire, stretched out, pro-street fad of the 1990s; to the big front wheel bagger phase of recent times. On top of it all, he also keeps up with what the younger builders of today are doing, with the stripped-down bobbers and skinny stuff. Bikes and tattoos run in the Perewitz family: Dave's daughter, Jody, has stepped up to the plate to run the business. She's also building an array of her own inspired customs, and even putting in time on the salt flats of Bonneville. Jody's interest in bikes seems to be growing rapidly, just the same as her interest in tattoos. She now sports a full sleeve, and when we saw her last, she was just getting started on the other arm. She's proud to be using the same tattoo artist as her father.

—Sara Liberte

I had never met Dave and Jody until heading to their shop to photograph them for this book, but I certainly knew who they were. As they sat around reminiscing about days past and other worldly shit, I simply wandered off to gaze at all the motorbikes adorning their showroom floor.

(This was another case of the motor-induced ADD I get in such situations.)

But they came and found me, and after shaking me out of my motorbike-induced trance, Dave showed us around his entire shop, regaling us with stories about

every last thing in the place. We met all of his many employees, who were nice and inviting. He showed us his projects in the works at the time, showed us where each differential step of the builds took place, and brought us through back rooms where personal projects were coming together.

It's always a good time, wandering through others' shops and enjoying every little bit of them. Of course, we shot some pictures of Dave and Jody before we headed on our way, and we must thank them for their help here as well. It was truly a pleasure meeting them both.

—Chad Lemme

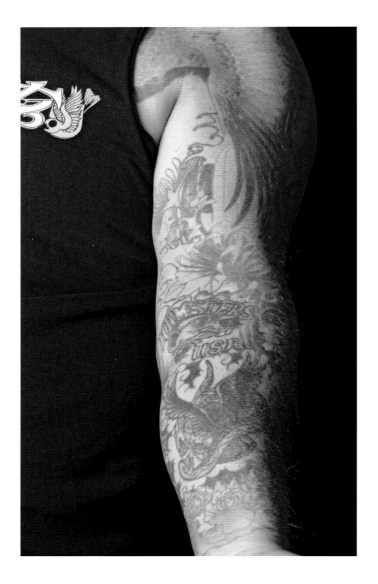

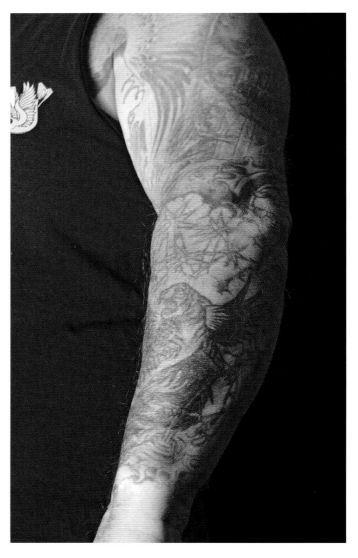

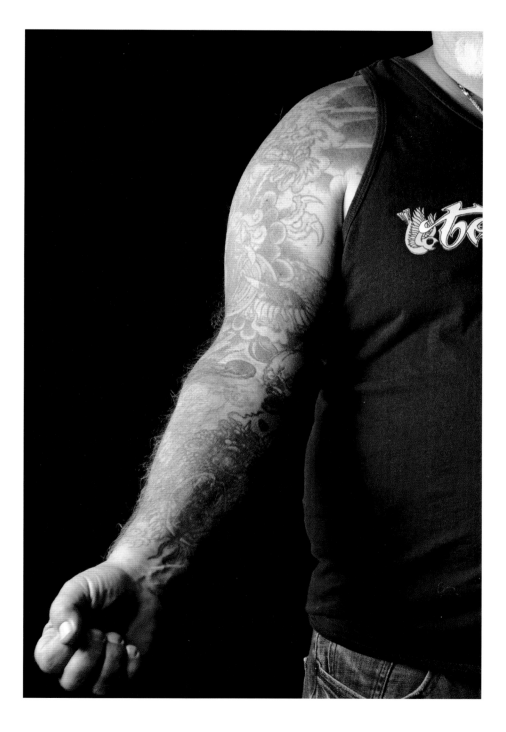

Known as the "King of Flames" and an artist himself, it's no surprise that custom bike builder Dave Perewtiz has a full sleeve of artwork.

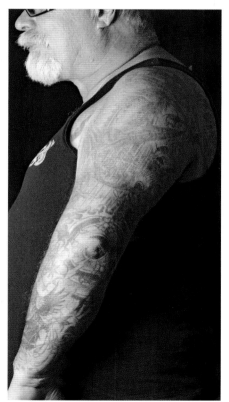

Robert Pradke

Robert Pradke is another guy who was able to cash in on the early televised success of the biker build-offs.

Working alone in his Connecticut shop, Robert is so highly sought after for his flawless and detailed custom paintwork that he stays beyond busy year-round. Like most body guys, Robert was influenced by the real-deal rodders, the guys who can do all the work themselves. From metal shaping to fabrication, from bodywork to paint, from drawing designs to pinstriping and gold leaf, he is a master. And while he can work in any imaginable style or design, it's apparent that he was influenced by the custom scene of the early 1950s. It should go without saying that his tattoos are geared toward these influences, and all have a very important personal meaning, including a tribute to his late father.

Visiting Robert's place in Eastford is more like walking through a museum filled with his amazing work, collectibles, art, and memorabilia, rather than a paint booth. The walls of his office and showroom are riddled with photos of the amazing people who Robert had the pleasure of working with over the years. The space is filled with inspirations and special moments in his career. And his personality is reflected in his work. He is a truthful and genuine person—no bullshit from this guy.

We could have listened to the stories of his numerous *Biker Build Off* appearances for days on end. Robert spent hours invested into so many bikes that have become important icons in the motorcycle world. We

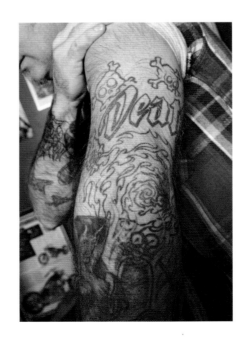

looked at photos and artwork on the walls and listened to the stories that went with them. We looked at Robert's tattoos, and just the same as the photos on his walls, each tattoo had a special story to go with it. We shouldn't have expected anything less from such an amazing artist as Robert Pradke.

—Sara Liberte

Robert's place was the one place that I *really* had a hard time leaving. There was so much to look at, and all of it was rich with history, stories, and legends. There were things built by Indian Larry, pictures and more pictures of *Biker Build-Off* work he had done, and with so many of the top people in the industry. There were projects in the works, and all of them were unbelievably amazing in their own right. The flawless perfection in every little detail of his work, the immeasurable consistency of his stripes, the mirror finish of the clear—all of it was executed with a professional perfection rivaled by none.

He sent us off with a pile of T-shirts and other things, and it's impossible to show our appreciation not only for his generosity and good conversation, but for his craftsmanship as well. It was truly an honor to have been invited in and shown around his shop. I've kept up with his work for years and years, and always held him in the highest regard as a painter. And after hanging out and talking with him, I only have *more* respect for him.

—Chad Lemme

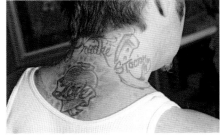

Robert Pradke's reputation precedes him; as one of the best painters in the country, he proudly displays his many tattoos. "Death" is stylized in gothic script near his left shoulder, sitting above a nightmare whirlpool of flame; below that, a fiery she-devil bares her breasts. On his arm, a gothic money symbol is skewered by a dripping blade, possibly to protect the names of his father and mother, seen above on both sides of his neck, his love for them both evident near the top of his spine.

Iliya Hamovic

Iliya is an anomaly. And not because he's from Croatia, but because he's very different from any person you'll run into almost anywhere in this country.

It seems that most of the people I know (and everyone I don't know) boast that they don't care what people think of them, but Iliya is the only one who means it: he *truly* doesn't give a good fuck what anyone else has to say. He does what he likes and he enjoys every minute of it, as though he were sitting in the corner laughing at us all having a pissin' contest over who's less insecure.

He's tougher than a coffin nail. This guy grew up brandishing an assault rifle while waging war against the Serbs. He's got the war wounds to remind him every day that it could always be worse. It seems that most of us, in our overly censored and sanitized upbringings, were raised to believe that the world is beautiful and that peace can work, which obviously limits us to little more than a childish nature later in life. But when you grow up in the midst of war, where you're forced to fight for your life on a constant basis, you gain a certain appreciation for the little things. You may say that it's unfortunate to be brought up in a rough time and place, or to have to endure the real and the evil face of the world, but it does seem to mold respectable and appreciative people in the end.

You'll never catch Iliya bitching about how tough he has it, and I truly admire this about him. I've had the good fortune to share a nice dinner with him and his lovely girl, Chrissy, and believe me when I say that they have very good taste. Not only that, but it's extremely difficult to pay the bill before him.

Iliya and Chrissy don't take much for granted, and they'll always have my infinite respect for that. And on top of it all, he is a fucking phenomenal builder. Nothing he does is short of perfection. He fits in that very high echelon of builders like Paul Cox, Indian Larry, and Keino Sasaki, in the way that every last detail is the highest quality possible; he would almost rather make a little less money than to cut a corner for a customer.

It's always fun hanging out with Iliya, because on top of being well versed in many different facets of life, he can execute a politically or morally based conversation without a flaw, all the while leaving the rest of the group in hysterical laughter. I don't know many people who can lay out a solid debate riddled with humor and still make an entirely valid point. He's an astute observer of the finer things in this crazy life, yet he still makes damn sure that he'll enjoy every last bit of it. And with that in mind, let's examine his tattoos, and hear the stories of a few of them.

Now, how anyone can live in a city is beyond me, especially bigger ones like New York City, which is right where Iliya's shop, Steelborn Choppers, is located, in the middle of a mortal mess they call Brooklyn. Each borough in the Big Apple just kind of turns into the next one, with no breathing room in between; it seems like the human interaction never ends. I get claustrophobic in places like this, but I was raised a hundred miles beyond the middle of nowhere—same planet, different worlds.

But Iliya seems to like it there, and more importantly, he's in the midst of some of the best builders in the world, and it shows. That sense of perfection shared between the top few builders is something you simply cannot find in other places (not in such close proximity, anyway). When we arrived at his shop to shoot some photos, I was distracted by all of the really cool shit in his place. I think I studied the piece he was working on for almost an hour, completely unaware that I was holding up the photography!

Iliya's shop is mind-boggling. He has the biggest, most fantastic lathe I've ever seen. And it was one of those

things that you know for sure made parts for the Allied war machine back in World War II—I just wanted to start turning something down in it, just to be able to stand in the same place and run the same machine as some American Allied victory worker back in 1943.

After a good hour-long break from reality, I finally made my way over to the camera and heard some really interesting things about his tattoos. For instance, the skull on his left shoulder is actually an x-ray of his own skull. The wild part is that in the x-ray photo, you can see pieces of shrapnel embedded in the bone, separating his brains from the atmosphere and high explosives. Try to imagine it: this guy has a head full of explosive fragments left over from fighting a war while still in his teenage years! That type of shit makes for one hell of a tough human being. The tattoo shows the shrapnel just as the x-ray does, and you can also

see the screws spun deep into his skull; these are holding his top front teeth in their designated places, just as it appears on the x-ray. Now *that* shit is tough, in every sense of the word.

On top of dodging 120mm antipersonnel mortars and Soviet-designed bullets, he started working on and riding motorbikes before the age of 12, and was a professional drummer for 20 years. But in his humble nature, he would never bring any of this up, nor talk about himself in with any pretention.

So it was left up to Sara and me to pry that info from him and share it with the free world. He's too kind to go on talking about himself and much more tough, both mentally and physically, than any of us will ever be, and he has my eternal respect, for all the right reasons.

—Chad Lemme

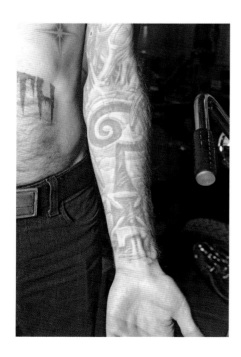
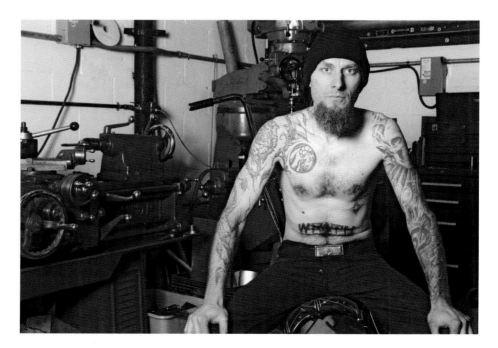

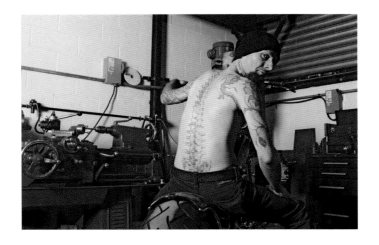

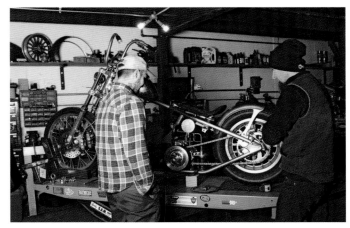

Iliya Hamovic, of Steelborn Choppers, New York City, has an eclectic collection of tattoos. Like most craftsmen, Iliya thought long and hard into the art and location of his work. A skeletal backbone reminds him that good work doesn't come easy; his left arm pays tribute to Indian Larry, a friend and inspiration; and the filigreed scrollwork of his right arm matches the intricate leatherwork of a favorite custom motorcycle.

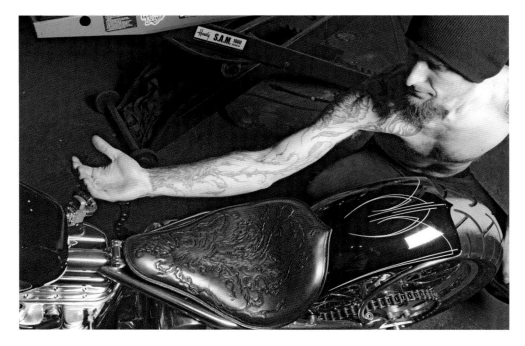

Billy Lane

Billy is another builder who is extremely well known for his incredible fabrication abilities, as well as his stints on various TV shows. Over the years, he was able to make some really nice parts available to the free world and beyond as Choppers INC., and he enjoyed his success for several years. His dreadlocks and tattoos were his trademark look, and they gained him tons of attention from female fans in the motorcycle scene. Traditional black and gray tattoos fill Billy's arms.

In the summer of 2006, while traveling the motorcycle rallies, I got to spend a bunch of time with Billy. He was doing his Blood Sweat and Gears tour, and I was traveling with Samantha Morgan of the American Motor Drome Co. We seemed to be set up at all the same spots, and Billy spent some time inside the drome with us. Samantha taught Billy how to ride the go-kart on the 90-degree wooden wall of the motor drome, and I was lucky enough to be there and share the moment.

Billy loved listening to Sam's stories of the early wall days, as we all did. We especially liked the ones about the Pelequin family having a lion as part of the act—that's right, a fucking *lion* rode along in a side hack on the wall of death. We loved hearing these stories and looking at her early photos. Billy was impressed with Sam, and always supported her and the American Motor Drome crew. I captured the moments we shared inside the wall with Sam and I hold these moments close to my heart. Samantha passed away a few years ago, and there's not a day goes by that I don't think of her. One of the best memories is of her teaching Billy Lane how to ride the Wall of Death.

—Sara Liberte

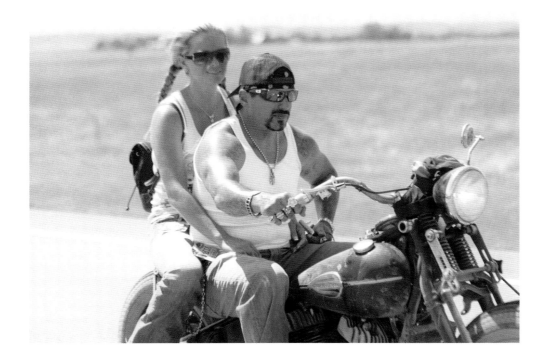

Billy Lane, of Choppers Inc., in Melbourne Florida, has quite the collection of tattoos. Here is a great photo of Billy with a pretty lady cruising the beautiful landscape of Sturgis.

Paul Wideman

Paul is one of the coolest cats I've ever met, and I'm truly honored to call him my brother. I've had the fortunate opportunity to work beside Paul on and off for the last year and a half or so. I can honestly say that I've enjoyed every last minute of it—despite the high-speed madness, and the complete lack of any good help, we seem to have been able to wring some fun out of almost every day spent whittling away at a mountain of orders.

On top of it all, Paul has the greatest family on the face of the planet, and they have welcomed me in and made me part of that outstanding clan. No words could possibly explain these people. They constantly help each other out; they always strive to be the best humans that they can possibly be; they appreciate the finer things in life and take nothing for granted; they have more moral fiber than Lao Tzu on a wicker swing set; they live by their values; they're the last of the true, patriotic Americans; and they live this lifestyle with a relentless, common sense of humor rivaled by few and imitated by many.

It quickly became apparent that comedy comes first in that little slice of heaven down there in Missouri. It seems like you're constantly laughing about something, and these words from Paul are a testament to that. When I asked him to write something about his tattoos, he decided instead to make some fun of the part-time "bikers" who try, and try, and try, but just can't seem to get it figured out. And with that, here's Paul!

So, I got the killer work on my hands a few years ago 'cause I knew it'd look badass and my street cred would go up. One of them is a panhead, 'cause my uncle had one in the 1970s. It was the longest chop in Little Rock! I forgot what the other one is, and I honestly couldn't even tell you which

one is the panhead. I just know my uncle swore by those transmissions.

I got my Mongo tattoo as a way to conquer my fear of huge, drunken, homosexual mariners, or the "Sexy Sailor," as they are known in some circles. It was done by an unknown artist at a bike night at the Hustler Club in Jackson, Mississippi. The artist converted his Yugo into a half-car, half-RV kind of thing, and the RV end is where he tattooed. When he got real busy, he'd open up the second station in the front seat.

I got my "Throttle Junkies" tattoo after watching *Choppertown*. Me and a few brothers decided it'd be cool to start our own chopper club, but not an MC, cause we didn't want to have to drink and ride, or be around drugs, or ever have to stand up and fight for anything. Unfortunately, our interest didn't last nearly as long as it took to outline the tattoo, which is why it's still unfinished.

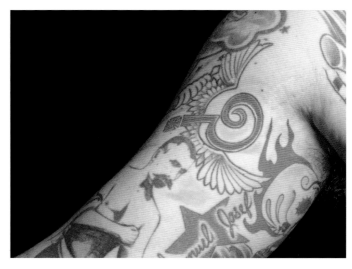

Paul Wideman of Bare Knuckle Choppers has many tattoos with personal meaning. From bike parts to the Indian Larry Question Mark tattoo, each one has a special meaning for Paul.

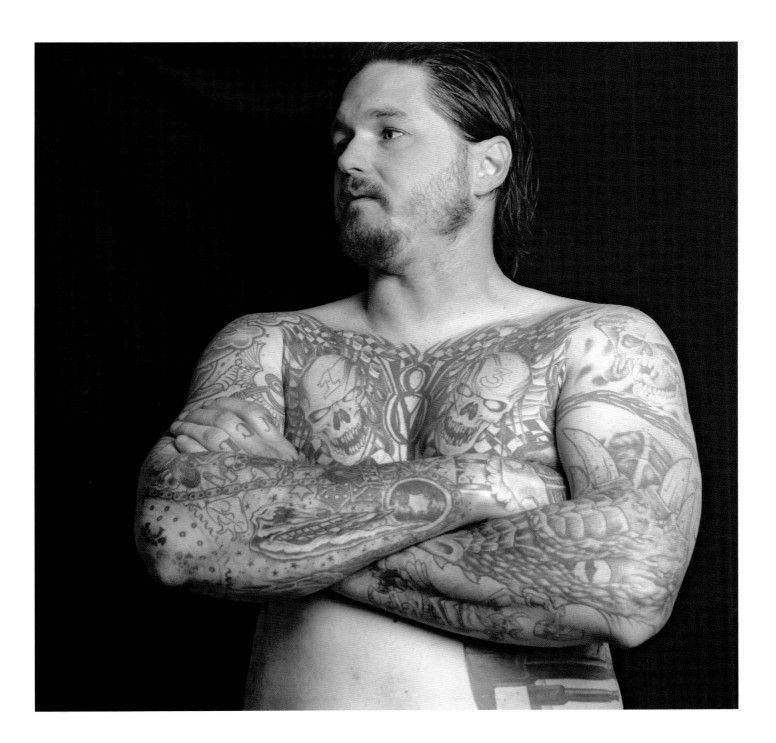

My chest piece started as a drawing I did when I was in rehab for huffing porta-john chemicals in 1998. My art was the only way for me to express myself and to keep from going crazy, but in 2002 I lost it in a late-night bingo game to a Puerto Rican gambler named Suzie. I met Suzie again in the jail at Myrtle Beach Bike Week, and he gave me back my

art. He was finally in AA, and one of the 12 steps was making amends for old stuff.

Thanks,

Paul Wideman

Bare Knuckle Choppers

—Chad Lemme

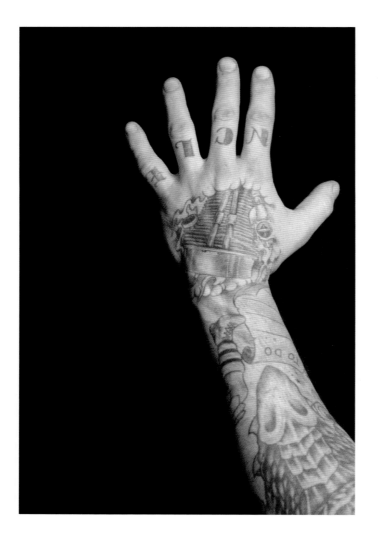 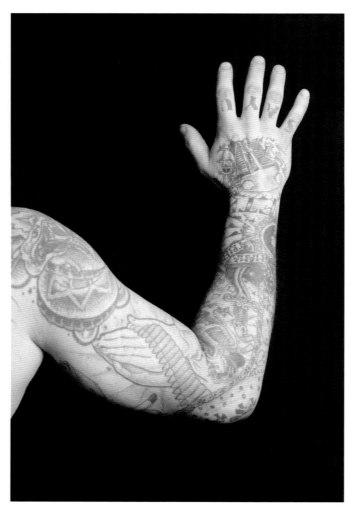

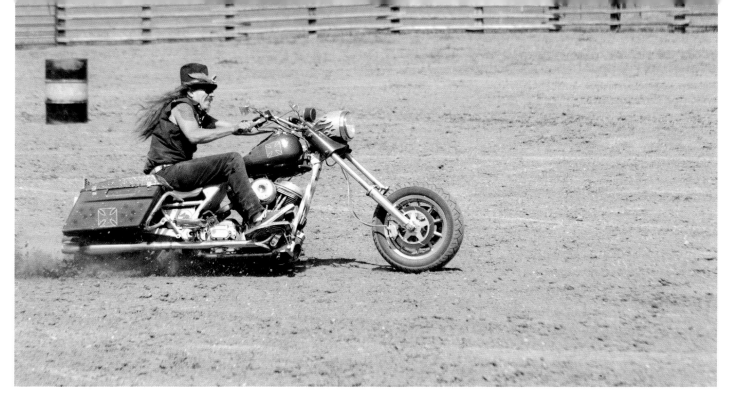

Riding at Sturgis, "Motorcycle Gypsy" Bean're boasts a broad deltoid tattoo.

Kevin Bean're

This motorcycle gypsy set out to make himself popular for being a motorcycle nomad, and it worked. He was featured on a few TV shows and received plenty of media coverage in magazines for literally being at every motorcycle rally, every year. He's got a tattoo, which solidifies his biker persona. He even has a book out about his motorcycle travels.

To be honest, I can't remember the first time I met Bean're, it's like I've known the guy all along, and I've always enjoyed the time spent with him. Bean're is one of those guys whose outlook on life is that it's way too short to worry about little things. He knows that tomorrow is not guaranteed, so he'd better get out there and make the most of today. And I guess that's probably why he's so much fun to hang out with. He's never worried about

anything, and he remains focused on how to make a great day out of today.

When I travel to different rallies, I try to seize the opportunity to do what's unique to the area, and ask myself "what can I do here that I can't do anywhere else?" I remember one year at the Ohio Bike Week I was determined to go to Cedar Point amusement park, because there's no other rally anywhere close to an amusement park with roller coasters as big as the ones at Cedar Point. Bean're was up for it, and we hit the gates running. The funny part is that the rest of the guys with us were too fat to get on any of the coasters! They literally couldn't buckle the seatbelts and had to get off the rides. But Bean're and I rode every coaster in sight that day, and never stopped laughing for even a moment.

—Sara Liberte

Kevin "Teach" Bass

Teach is one of those great humans I was talking about earlier: one of only a select few who shine as a beacon of hope, restoring faith in humanity and far too humble to ever be proud of it; a paradigm of goodness to model if we want to push humanity forward in a fine direction. Hell, by the time we finally left his place, we had an armful of T-shirts, stickers, a hoodie, and some CNC wood-burning art to boot.

I think we got ahold of him only a few hours before we landed on his doorstep, and he welcomed us in to his home and shop like we were family coming home. We sat and talked about everything and nothing, snapped a few photos, and once again, I found myself entirely shut off from the outside world by a blinding case of motorbike-induced ADD. There was so much cool shit in his place, and Teach happily went through and showed us every last bit of it.

On top of readily welcoming us and showing us around (as well as the gifts), we left there with some really cool photos of him and his tattoos, with his amazing shop serving as the perfect backdrop. But the tattoos were something to behold in and of themselves. All work was done by Josh Arment at Aloha Monkey Tattoo in Burnsville, Minnesota.

—Chad Lemme

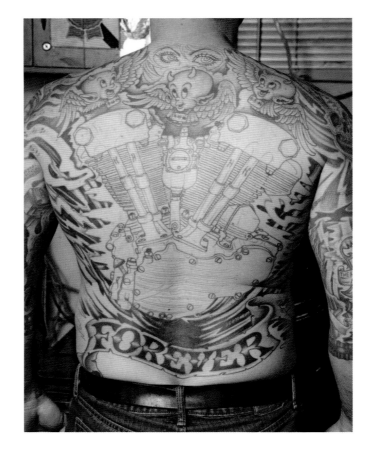

Kevin Bass is loaded with motorcycle tattoos, including that amazing full knucklehead back piece. Notice the cool tattooed pig fetus trophy he won at a bike show—how many people do you know have a tattooed pig fetus?

Jason Kangas

I remember the first time I met J. I went in to inquire about a possible painting position, but was hired as a chassis fabricator that same day. He brought me inside to show me around real quick, and there were people *everywhere!* It looked like a party, and there were cameramen following Jason and fellow crew member Kai Morrison through the necessary steps of building what was to become the Shovelhead Kill Machine, and the eventual winner of the Biker Build-Off on the Discovery Channel.

Back in 2008, when the idiots in the top tier of this country fraudulently wasted the economy for us all, scores of hacks and television-motivated "builders" started to fold. Only the select few, true professionals weathered the storm, and they are the same people who were on the summit of the custom motorcycle world before then. Twisted Choppers was one of those few shops.

But they had an extra, special bonus: the two dumbass pencil jockeys in charge of their books and billing were defrauding the shop in the same way those rotten bastards on Wall Street were stealing from the country. It took years to rebuild after that. Jason and Kai sold all their shit, got regular jobs, and put in the hours at night just to keep it going.

But the shop is up and running strong again, just like it used to, for the last couple years. The only difference is that Jason and Kai have parted ways to each concentrate on their own thing, and I wish the best for both of them. If not for these two, I wouldn't even be here writing this book, and I wouldn't be sitting next to Sara right now. So I guess I owe them a rather substantial "thank you!"

—Chad Lemme

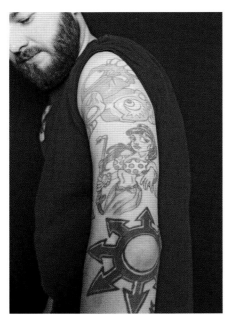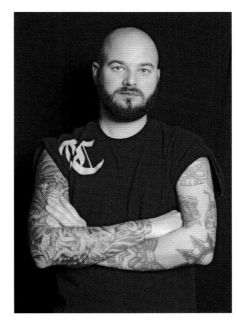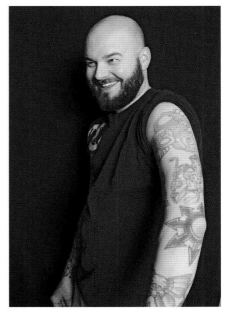

Full-color tattoos cover the arms of Jason Kangas of Twisted Choppers (Sioux Falls, South Dakota). The artwork is by Darren McKeag of Slingin' Ink.

Kai Morrison

Kai is a custom motorcycle–building extraordinaire, and professional hair farmer, and he was my boss for the longest time. But he never saw it that way. As far as he was concerned, we were just a bunch of idiots helping each other build motorbikes for fun. I guess he looked at it like he was just another employee and operated on the same level as all of us.

Kai is also humble in the way he enjoys other people's stuff and is never afraid to say how other professionals have influenced him. Billy Lane is one for sure, as you can see in some of Kai's fuel tanks. But he's got his own interpretation of things, and proudly makes the internal strength and rigidity of the bike his number one goal. That focus shows in his work with heavy-duty parts, solid mounting and bracketing, and in his use of the best products on the market.

Kai is on his own and has a shop in Sioux Falls where he continues his art of custom building. His shop is Kai's Kustoms, and it's already piled up with work. And I can't *wait* to see what comes out of that place in the near future.

—Chad Lemme.

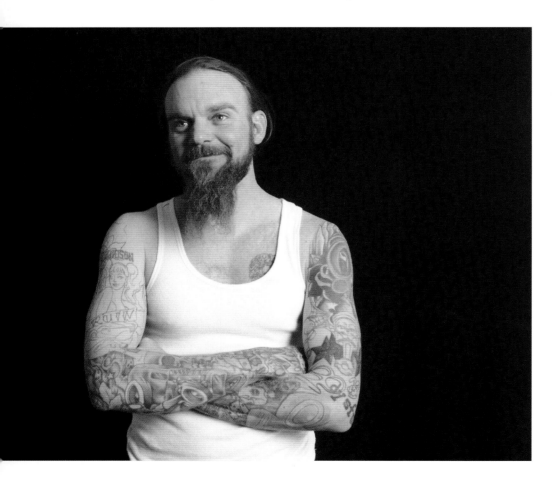

Custom bike builder Kai Morrison smirks while displaying his full-sleeve tattoos, replete with motorbike and hot rod culture up and down both arms (and on his chest too).

Johnny Chop

Johnny Chop was an extremely talented builder, one of the few who could do all the work involved on his own. From engine work, to fab work, to body and paint, this guy was one of the true gems of the motorcycle builders. And Johnny was not just a builder—he was also a true artist, and he enjoyed everything related to art and tattooing. Johnny was covered in traditional, colored, hot rod culture tattoos. Full sleeves, hand tattoos, neck tattoos—Johnny's ink was part of his look, and because of it many labeled him as the stereotypical tough guy and tattooed biker. But, as someone lucky enough to get close to Johnny, I can tell you that he was farthest from it. He had a heart of gold, and I enjoyed any time spent with him. Johnny passed away in 2006 from heart complications.

Hanging with Johnny was like hanging with someone you grew up with. You never ran out of things to talk about, and you never felt that you had to have useless, bullshit conversations just to fill in some awkward silence. We talked about things we enjoyed, like motorbikes, cars, artwork, photography, dogs, and making fun of people. I'm not ashamed to say we made fun of people walking around at bike-related events. Hell, I think everyone does. People love going to Main Street at a rally to make fun of everyone wandering around in all their craziness. No one wants to admit it, but I will. And the best part was that we didn't give a shit. I still don't give a shit, and I know if Johnny was still around, we'd still meet up, talk about mutually interesting things, and then find a bike or some crazy get-up to laugh at!

—Sara Liberte

▶ A personal friend taken from us too soon, a genuine artist, and a craftsman with much to offer, Johnny Chop had some very cool tattoos with equally cool stories.

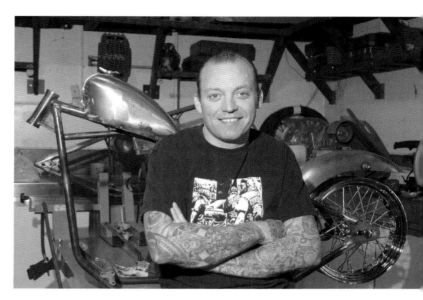

▲ The late Johnny Chop, taken too early in life, was one of the most innovative builders in the industry; he was a true craftsman. *Bill Tinney*

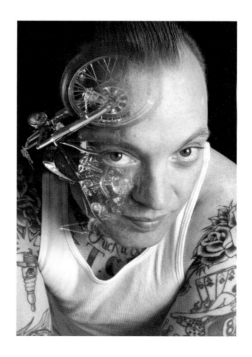

Russell Mitchell

Russell hails from England, but he made his way to California where he created, owns, and operates Exile Cycles. His minimalist, stripped-down black bikes took hold of the motorcycle scene and helped curb the fat-tire, Easter egg, custom fad that prevailed during the late 1980s through the 1990s. Usually sporting a bleached mohawk and covered in traditional Japanese-style colored tattoos, Russell Mitchell is always noticed; he's been featured in magazines along with a bunch of television shows. Russell is still working out of California, and Exile is still going strong.

I remember the first time I met Russell. We were both at the Corbin press party in Sturgis around 2004. I had some artwork hanging up during the party, and he was staring at a piece from my *Woman and Machine* series. It has a woman's body with a motorbike running through it. But the bike had an Exile Sprotor, and he didn't think I knew that it was his parts on the bike in my image. So he introduced himself and began to tell me all about his parts. I told him that I already knew that it was his part on the bike because not only was I the photographer, but I built the bike as well. We struck up a friendship right away, and he later invited me out to California to photograph him for my builder and machine series.

—Sara Liberte

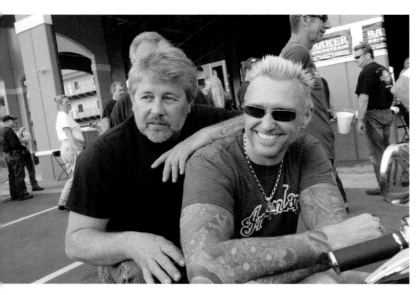

▲ Russ Mitchell and Russ Marlow, both known for building beautiful custom motorcycles, relax on a bike in Daytona.

▼ From Exile Cycles in California, Russ Mitchell is covered in traditional Japanese-style tattoos. This is another highly stylized shot from the author Sara Liberte's collection.

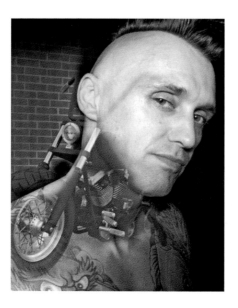

Jeff Cochran

I don't look up to very many of the builders in our industry, but Jeff Cochran is one of them. The best example of his talent is the swing-arm bike that he piloted in Daytona. It must have been Bikefest 2012. I've never really seen a plain swing-arm, external suspension, shovelhead chassis that I truly liked (save for the FXR, of course). There's something weird about how square the back half of the frame is, and how it seems to abruptly stop right after the trans.

But this thing was entirely different. I mean, it stood up nicely, looked and felt comfortable and agile, and it ran like a champ. It was short and narrow, and, most importantly, it looked like it would be a blast to ride. And Jeff so effortlessly nailed the aesthetics on top of it all, like it's just some sort of byproduct of a solid and reliable vehicle. This is the difference between the amateurs and the master craftsman.

Since then, I've wanted to build another bike for myself modeled off of that fine piece of machinery he had in Daytona. The real kick in the face is that he apparently built the thing in something like eight days, only to load it up and head for the beach.

But the best part about Jeff is that he's such a genuinely kind person. He's helped me a few times before, always willing to answer my questions when I'm stumped, and that is a *far* cry from the majority of assholes in the world, who would just tell you to get fucked. He's also one of the few of our generation who weathered the economic storm several years ago. The recession really weeded out the hacks from the pros, who took their livelihoods much more seriously, and the true professionals persevered.

In all sincerity, I must thank him for the great photos and the help with this book. He's one hell of a photographer. Let's just assume he's good at everything, and sit back and enjoy his fantastic work.

—Chad Lemme

Bike builder, photographer, and all-around skilled artist, Jeff Cochran has some great tattoo artwork. Here, he cruises through Sturgis.

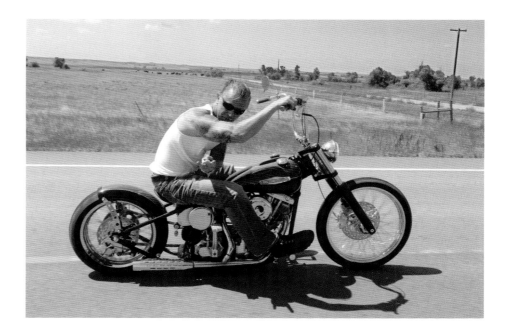

Rogue

Not many motorcyclists today actually live the true biker lifestyle, riding all over the country, putting on miles and miles, and standing up for bikers' rights along the way. But motorcycle photographer and journalist Rogue does, and he has been not just for a few years, but for a few decades.

This guy is the real-deal biker. Working for *Easyriders* magazine over the years, Rogue has built a solid reputation as a freedom fighter, standing up for bikers' rights and going all the way to Washington for the fight. His "Freedom Fighter Hall of Fame" tattoo is his badge of honor, and he proudly displays it on his bicep to remind him that all the hard work he put into fighting for bikers rights' over the years has been fought for good reason. Later, his work was

acknowledged when he was admitted into the biker hall of fame in Sturgis, South Dakota.

If you have an interest in motorbikes, or the corresponding lifestyle, you know who Rogue is. You've seen his photos here and there, and you've read about his crusades over the years. When I was first introduced to Rogue, I was extremely humbled to discover that he was aware of my work as a moto-journalist. I couldn't believe it! During the V-Twin Expo in Cincinnati, we spent hours talking and getting drunk together. Many talented people in the motorcycle industry surrounded us, and it was all kind of surreal.

He told me tales of the political fights back in the 1970s; he told me about his efforts to get helmet laws repealed; he told me several crazy and wild stories about his journeys riding motorbikes across the country. I distinctly remember him sharing his insight on the people in this industry with me, and advising me not be discouraged when the inevitable backstabbing happens. I always thought those words of advice were kind of weird, and that no one in the motorbike world would stab me in the back. I remember thinking this was a community of people who valued their word, valued their friendships, and most importantly, valued their brotherhood.

His words came reeling back on the first stabbing. Unfortunately, those words keep echoing in my head as the years fly by, filled with more and more frequent stabbings. As a result, I'm no longer even surprised when this happens. I'm not sure there is such a thing as brotherhood. Regardless, I've sincerely appreciated Rogue looking out for me over the years, and sharing all his infinite wisdom to boot. This is what a true inspiration does for you.

—Sara Liberte

Freedom fighter for bikers' rights since the '70s, Rogue is one biker who demands respect. He's a true biker in every sense of the word.

Billy Tinney

When I started this project, I knew I couldn't do a biker tattoo book without getting in touch with photographer Billy Tinney. Billy has been with *Easyriders* magazine for 41 years. His career started in the early 1960s after he traded a sawed-off shotgun for a 35mm camera. When he noticed an ad in the magazine looking for an avid biker and photographer, he jumped on that grenade without a thought. Billy was ready to submit his photographs to the publication.

He rode to Daytona, shot 100 rolls of film, and left the entire *Easyriders* staff in complete awe as to how he didn't get killed capturing some of the images he did, *especially* because of who some of the riders in the photos were.

This started the relationship between Billy and *Easyriders*. Over the years, Billy focused on shooting bikes, girls, and tattoos. Fast-forward to 1976, Houston, Texas, for the first world tattoo convention, comprised of names like Dave Yurkew, Mr. Tramp, Randy Adams, and Crazy Ace. All of these people helped Billy merge his motorcycle career with his love of tattoos. Later, in 1980, *Tattoo* magazine was born, and half of the publication consisted of Billy's images. The magazine was a little too cutting edge for its time, and because of that, it didn't really have a place on the newsstands. The right to the publication name *Tattoo* was lost, but a guy named Bob Bitchen ran nine issues with it. It wasn't long before *Easyriders* bought back the title, and *Tattoo* magazine was finally on its way.

Over the years, Billy hung out with some of the best and most widely known biker tattoo artists, such as Gil Monty and Brian Everett. At every event in Daytona, these guys set up an underground tattoo shop across the street from the Boothill Saloon. Billy often built a makeshift studio down there to shoot the work these guys were putting out.

Four decades and a lifetime of work later, Billy can say that he has been with *Easyriders* magazine the longest. As well as being a staff photographer, he is also editor in chief of *Tattoo* magazine, which celebrated its 25th anniversary in 2012. He is also one hell of an awesome guy and an inspiration to someone like me.

—Sara Liberte

Photographer Billy Tinney has been a longtime contributor to the biker culture. He's lost none of his touch (nor his hair!), and we're proud to feature him in *1,000 Biker Tattoos*.

I have no idea who this man is, but he just had a great "rider" look to him—this guy would never drag his chopper behind on a trailer to a rally halfway across the country.

Other Tattooed Bikers

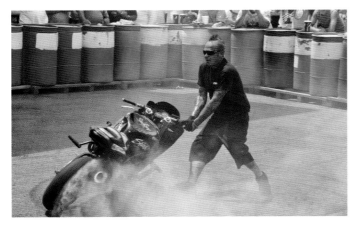

▲ Charlie is a long-haired stunt rider in the American Motor Drome (and it's hard to spot his tattoos as he whips by!).

◄ Above left and left: Motorcycle stunt riders the Starr Boyz are tattooed daredevils.

Keeping the famous name alive, Bobby Seeger owns Indian Larry Motorcycles.

▼ Tattoo Duke rests under a tent with Goth Girl at a motorcycle rally.

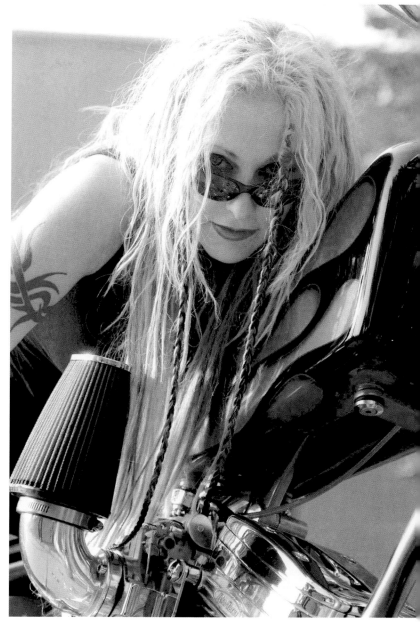

▲ Featured in the Discovery Channel's *Motorcycle Women*, Goth Girl has some amazing ink. She sports an Indian Larry tribute tattoo, as she was a close friend to Larry.

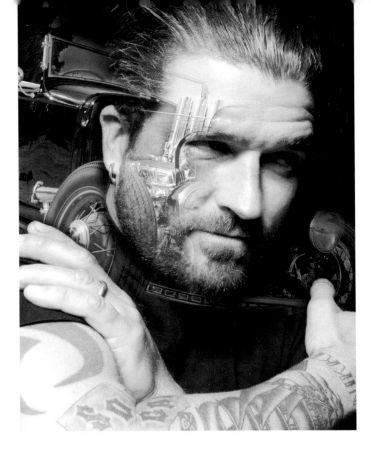

▲ From SoCal Speed Shop, Jimmy Shine has plenty of tattoos with personal meaning. This stylized shot is from the author Sara Liberte's personal art studio.

▲ Above right: Jerry Covington is a custom bike builder and tattoo fan. Check out the winking skull on his forearm.

▶ Riding in Sturgis, Bill Dodge of Bling's Cycles cruises down the road.

▶ Scott Webster sends some love with a full sleeve of tattoos as he chills with pre-tattoo sleeve Jody Perewitz during Daytona Bike Week a few years ago.

▼ Bike builder, designer, leather worker, writer, and incredible artist, author Chad Lemme is adorned with some amazing ink. Anything less than amazing is not an option for this perfectionist.

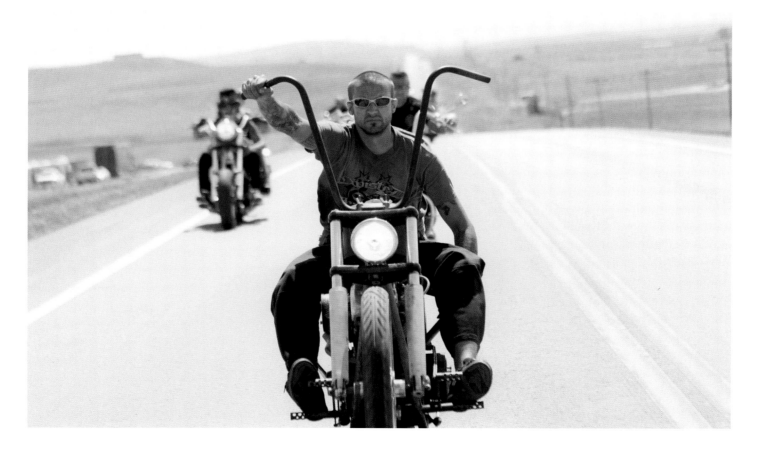

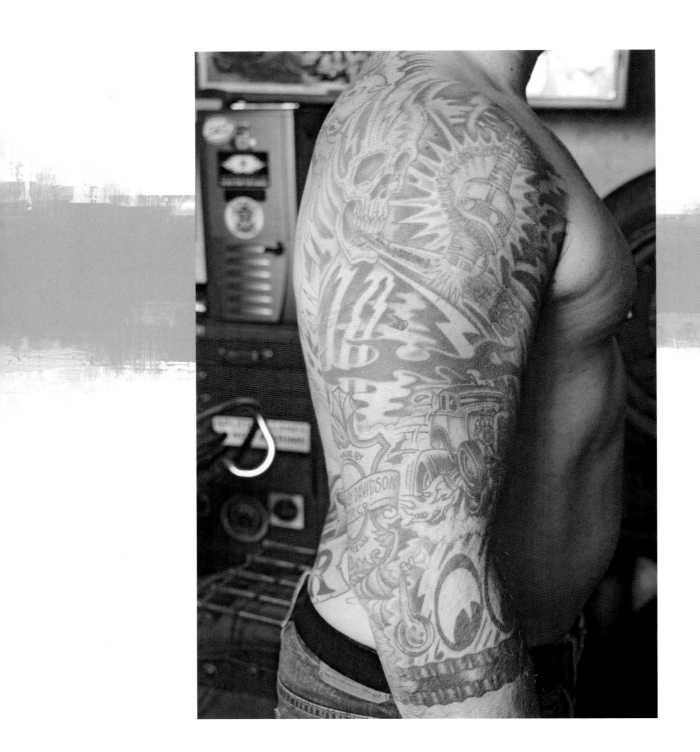

Unusual Tattoos, Murals, and More

As we were hanging out one night discussing full-sleeve tattoos (along with neck and hand tattoos), we noticed a rant about this exact topic on Facebook from a mutual friend of ours. We contacted him and asked him if we could include his thoughts in this book; it was too perfect not to share with everyone. Jed went off, jabbering on about the exact shit we were talking about at that moment, and it basically hit home with everyone we interviewed. From tattooed people, to tattoo artists, and everyone in between, they all pretty much shared the same sentiments as Jed. Here he is.

Maybe I'm just getting old, but I keep seeing these damn kids—and grown-ass men as well, I suppose—getting tattooed ass backwards. Starting with a huge neck/throat piece, then they do their fucking hands up. So, you see these dudes with a flannel buttoned up, and they look fully tattooed. Then they take off the shirt, and they don't have a single piece on 'em. What the fuck? I'm all for tattooing the shit out of yourself, but come on, guys! That shit is weak as hell.

When I was growing up, the neck and hands were usually the last things you got done once you had a good amount of ink. Now it seems like it's all up front. The shit's so watered down. Getting a huge piece on your throat or neck, and every inch of your hands, doesn't mean shit. It's not about the art or meaning of the tattoo anymore, it's about covering your real estate as fast as possible. Maybe it's the evolution of the art form or some shit, but when I got my first tattoo it was important to me. In fact, every one of my tattoos tells a story or represents a memory from my life so far.

I just don't see how these young kids can slap down Mom's credit card, or hit the trust fund to get their fucking full sleeves done in one or two sittings! It doesn't mean anything to 'em! Do they bring in a magazine and tell the artist, "I want it just like this, but different?" All the personal time spent thinking out each piece, and really figuring out what you want to be on you forever, is long gone. Man, now it's just cool to get covered as fast as possible, starting with the spots you're most likely to regret, or catch hell for later in life. I don't regret a single tattoo, but that doesn't mean that I don't have a few ghetto ones.

But that used to be part of the process—getting a homemade or impulsive tattoo when it meant everything to you. Now, I'll admit, if I had a disposable income, rich folks, or a trust fund of some sort, I'd have a lot more tattoos than I do now. One thing that I have noticed is the quality of work out there has gotten way better. These artists today are unbelievably talented, and are pushing the envelope and raising the bar every day. The tattoos look better, but the meaning is so much less than it used to be. Now, the guy at the party with no ink is the one standing out; he's the one looking different. It's a strange evolution.

I remember back when it was almost impossible to find a shop that would do facial tattoos. Even hands and the high neck area were a big deal. It was a major decision. Oh well, I'm done with my rant.

But I must say, get tattooed. Get drilled on. Cover yourself head to fucking toe if you want! But for fuck's sake, think about the meaning behind the tattoos. Do they tell a story? Do they tell the story of your life? Do they show your experience and the things that make you a unique person? Or are you just getting work done to shock people? Or are you getting tattoos because it's cool, and cool kids have tattoos? Too many cool kids doing the same shit fucks up a cool thing by definition.

—Jed Kemsley
Heavily Tattooed in
Port Townsend, Washington

—Sara Liberte

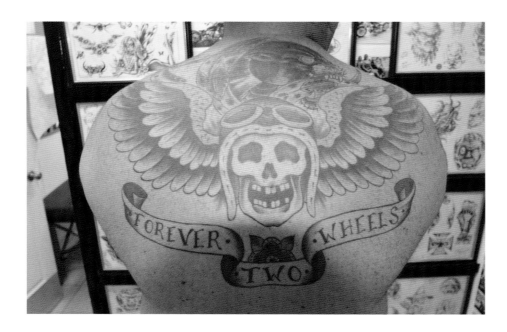

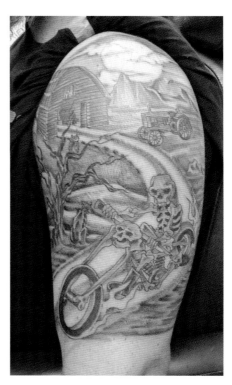

▲ *Forever Two Wheels;* diehard enthusiasts live by this moto. Here, it's scrolled across the back with a wicked, winged skull and riding cap.

▶ A home-based garage usually looks something like this—parts everywhere, and the owner/mechanic covered in tattoos.

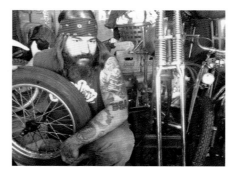

▲ This hellrider burns away the past as he rockets down a country road. You can tell this biker is far from home, but that it probably rests easy in his heart.

▶ Jody Perewitz, known now for setting land speed records on the Bonneville Salt Flats, has put in many hours creating this full sleeve.

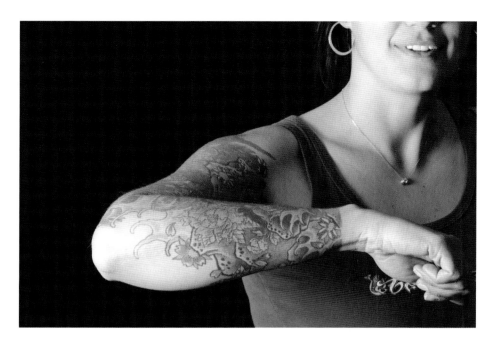

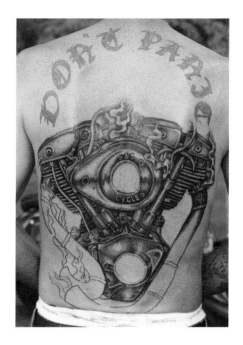

▲ George the Painter's amazing back piece is a closeup shovelhead engine. The artwork was done by Rickie Pan. Another adoring fan stands nearby.

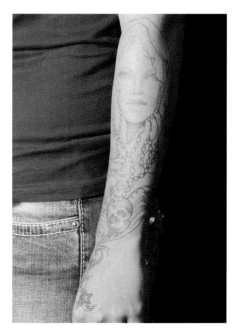

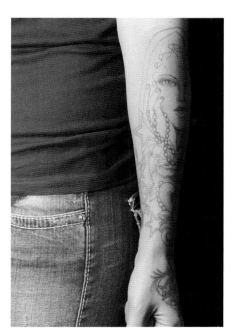

▲ Jody has begun work on her other arm, stenciling in a gypsy-like companion.

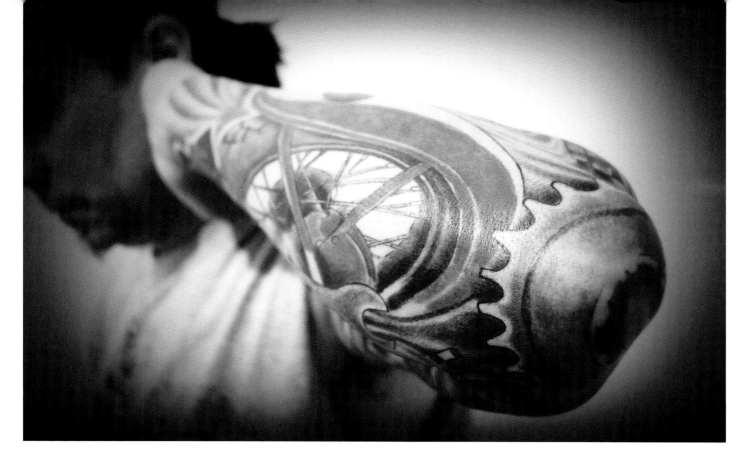

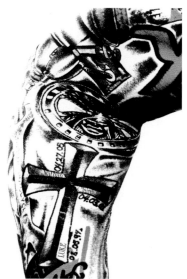

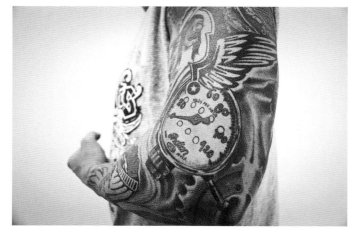

Jeff Kelderman had this entire sleeve done in tribute to early Indian motorcycles, some of his very first bikes. The artwork is by Darren McKeag of Slingin' Ink. *Crazy Asian Photography*

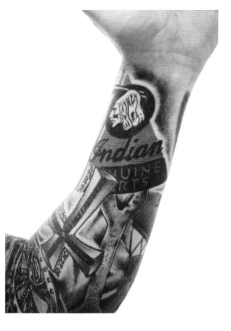

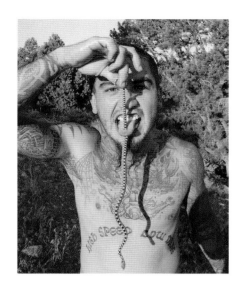

◄ This chest piece mural is awesome—High Speed, Log Drag—but damn, I can't help but look at the snake through Charlie the Nomad's tongue piercing hole. Wow.

▼ No snake here, but it's easier to see Charlie's spark plugs and wrenches.

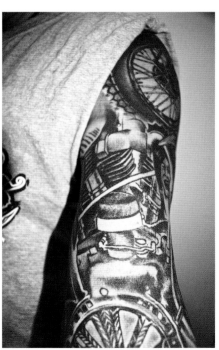

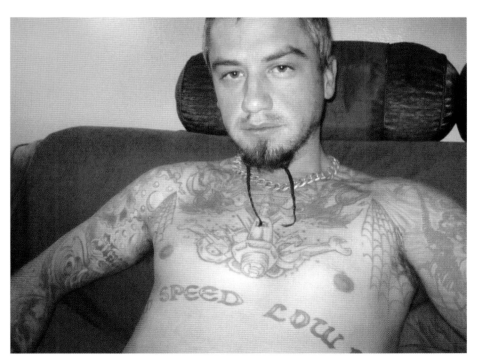

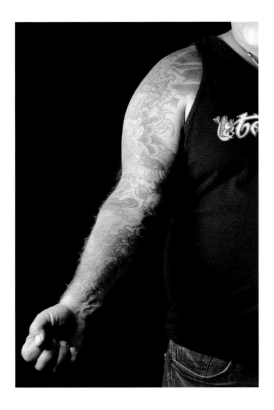

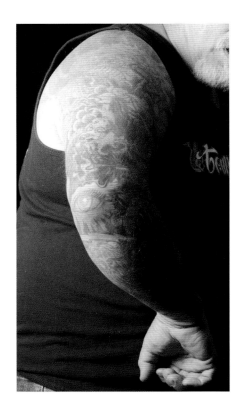

▲ Custom bike builder Dave Perewitz has tattoos on this full sleeve dating many years back. No matter how far you cast back, tattoos and moto-culture are inextricably entwined.

▶ Dave's leg has some ink with an aquatic mural showcasing his love for the sea life.

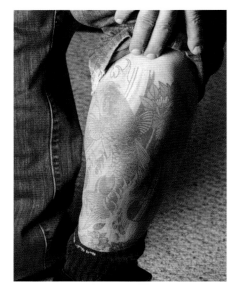

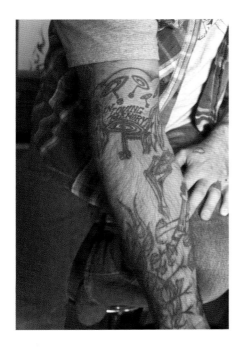
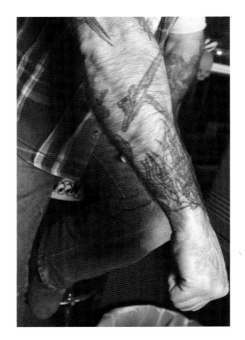
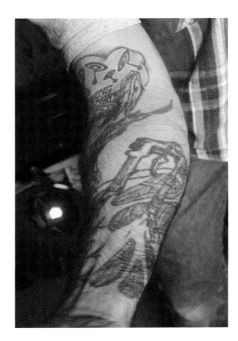
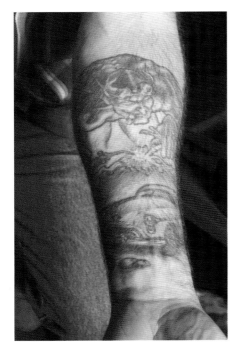
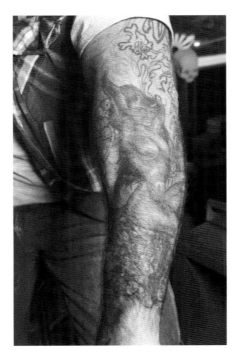

Custom painter Robert Pradke has an arm filled with objects with special meaning: an airbrush, some hot rods, flames, and a tribute to Indian Larry, a true inspiration to all craftsmen. His other arm features a grinning devil, and a tempting mistress!

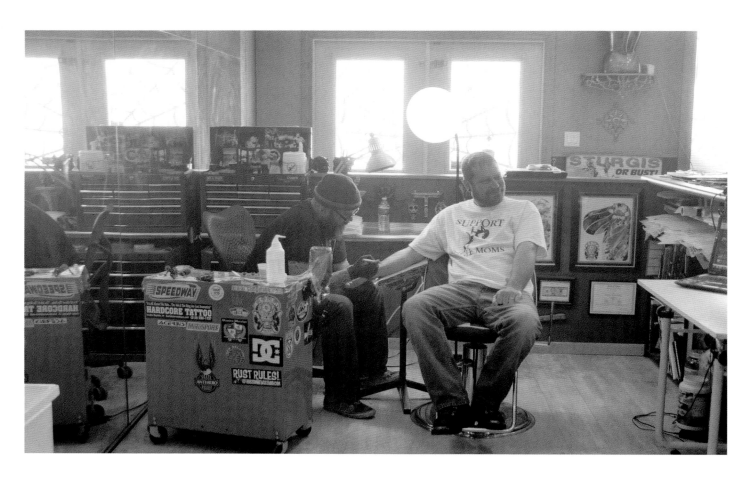

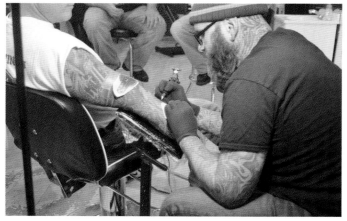

▲ Darren McKeag lays out some artwork for a mural all about engine parts.

◄ Many people bring friends along for the ride as they sit in the chair for a new tattoo. Sometimes friends provide moral support, but more often they're just there to have someone to talk to. If the artist is talented, maybe they'll have gained another customer.

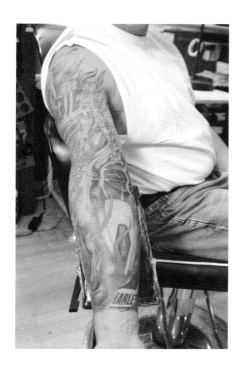

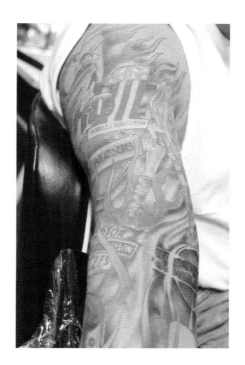

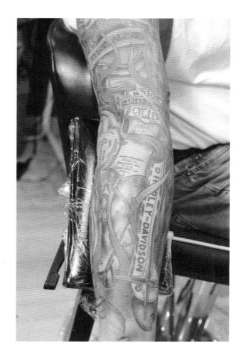

Now *this* is a motorbike mural—the entire arm is covered in H-D logos, flames, and other symbols.

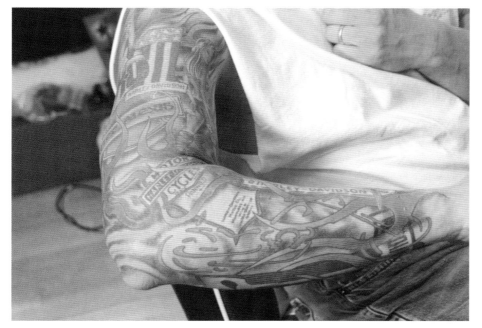

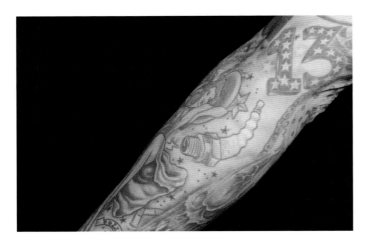

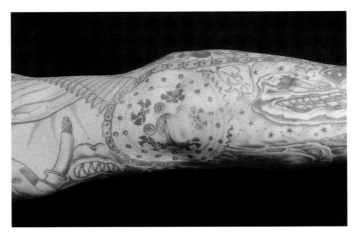

▲ I like this mural—it's got all kinds of surprises scattered throughout, including a spark plug, a chain, some shells, skulls, and more.

▲ Above right: I like the placement of the sprocket around the elbow with the motorcycle chain leading back up the arm—very cool and inspired mural work.

▶ Find the magneto on this arm could prove challenging, as it's wedged in the middle of many other intriguing components.

▶ ▶ How cool is a skull top piston? I'd say it's totally awesome, and it's a killer piece in this arm mural.

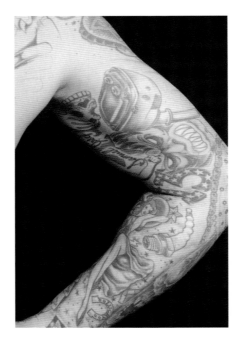

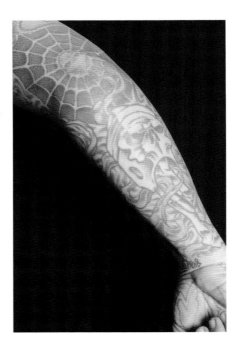

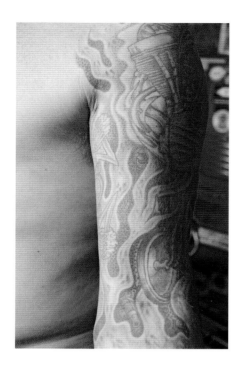

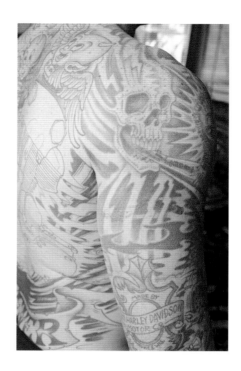

This mural is loaded with lots of motorbike goodies, including engines, logos, flames, hot rods, lightning bolts, spark plugs, and a bedeviled Porky Pig. This mural literally has it all.

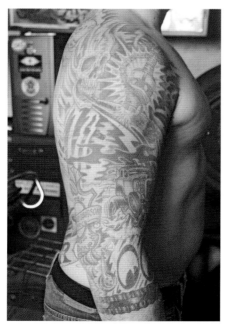

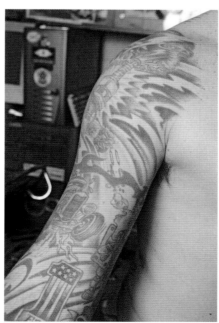

This mural features traditional coloring and typical motorcycle themes, including pistons, wings, flames, hot rods, and skulls. The fine line detail work is amazing, and the coloring makes this an outstanding full sleeve. It was done by Darren McKeag of Slingin' Ink.

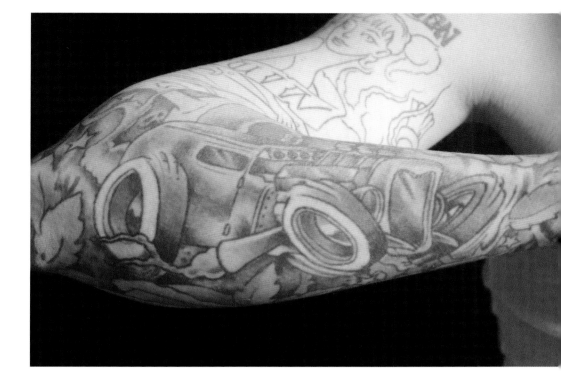

▶ A very cool rat 'rod is perfect for this forearm mural.

▼ This hand bone mural features a cool split rocker shovel.

▼ Below right: like the creepy green skull with the red hot devil lady intertwined on this mural piece. Skulls and women go together well on a biker's arm!

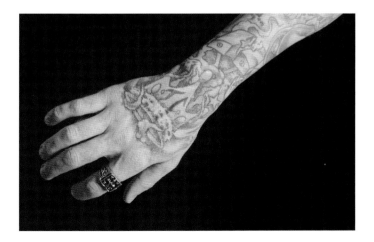

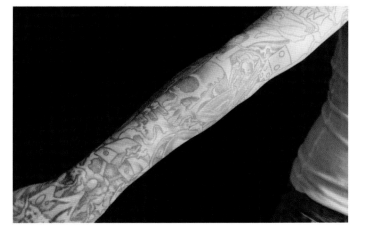

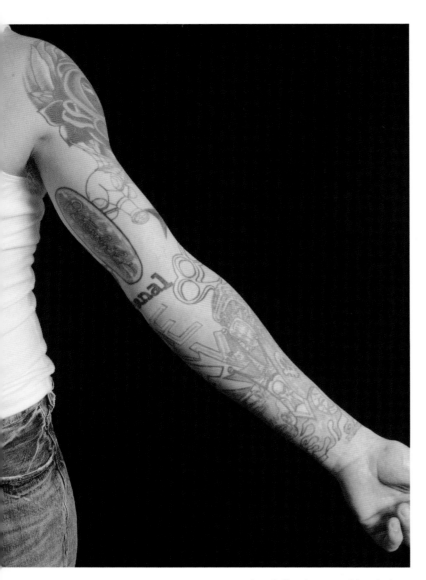
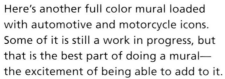
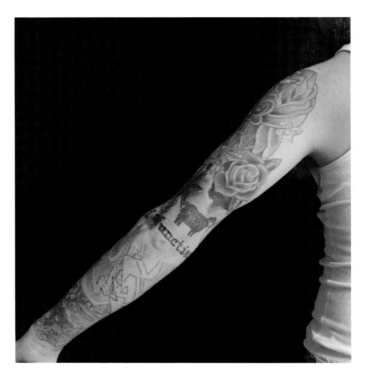
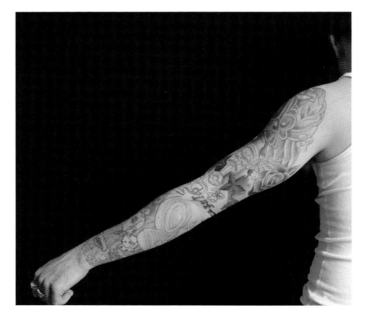

Here's another full color mural loaded with automotive and motorcycle icons. Some of it is still a work in progress, but that is the best part of doing a mural—the excitement of being able to add to it.

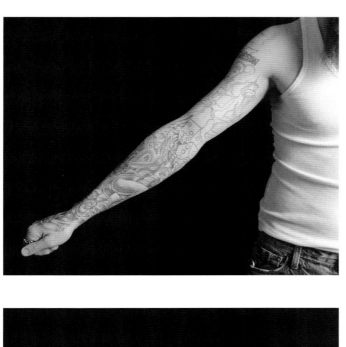

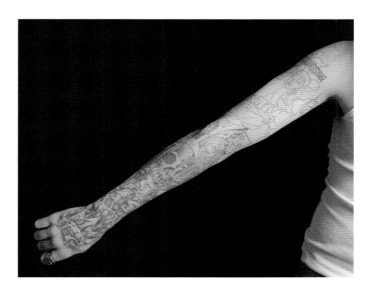

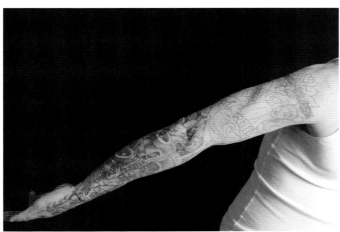

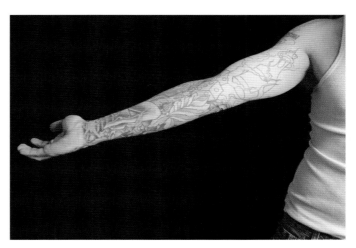

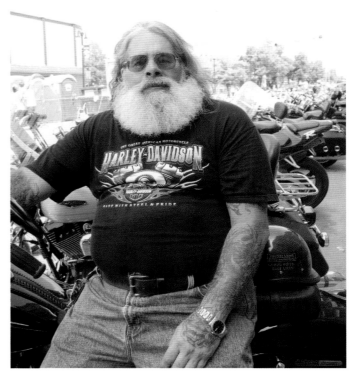

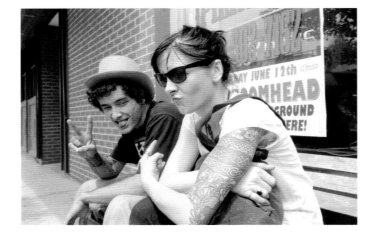

▲ ▲ Neck tattoos are becoming more popular; years ago, you never would have seen a waiter or waitress covered in tattoos. In many of today's coffee shops, bistros, pizza parlors, and more, much of the staff are sporting tattoos.

▲ Many young people today sport mural tattoos. They may not ride, but they certainly enjoy the ink.

▶ Bright and colorful, this young lady stands out at Daytona Bike Week for her super bright mural artwork.

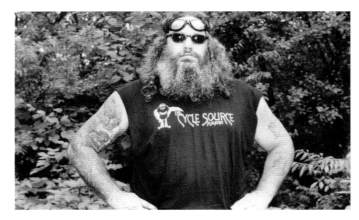

▲ ▲ Usually feared by those who don't know, "graybeards" with tattoos are more times often than not the most awesome, kind, and caring bikers of them all.

▲ I don't know what's more impressive—this guy's full sleeve or his full beard.

▲ Tattoo artist Latricia Horstman has a rockin' full sleeve tattoo. Here, she hangs with good friends in Sturgis, South Dakota.

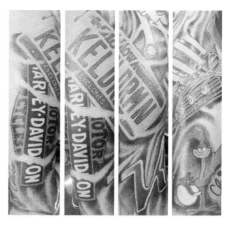

▲ One of the coolest mural pieces we have come across belongs to Jeff Kelderman. This one was done by Darren McKeag of Slingin' Ink.

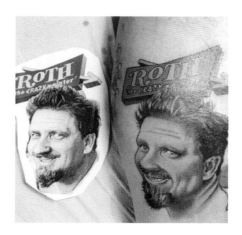

▲ This is a great portrait of Ed Roth, and features amazing detail work by Darren McKeag.

▲ Two full tattoo sleeves, a yellow street glide, and a matching yellow python: just another day at Ohio Bike Week.

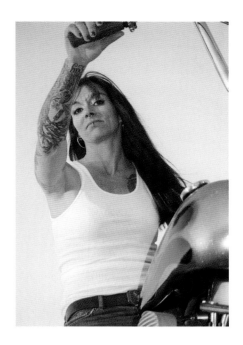

◀ Left and below: Girls with full sleeves and panheads are extremely popular with the biker boys!

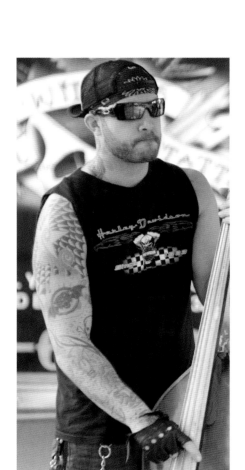

▲ Rockabilly music is huge at motorcycle rallies, and the musicians are usually motorcycle riders themselves, often covered in tattoos.

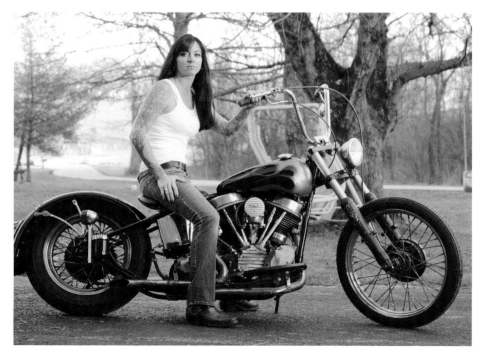

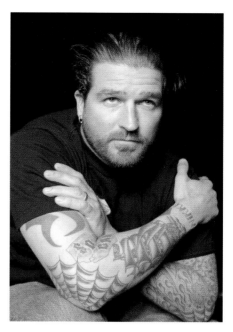

Jimmy Shine of So-Cal Speed Shop has some cool murals on his arms.

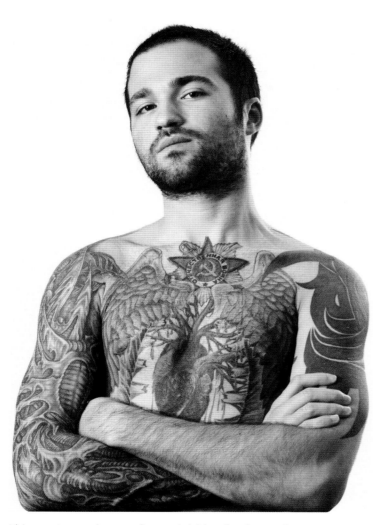

This was too cool not to feature! A bleeding heart gives way to veins and arteries branching into a symbol of freedom—the eagle's wings—before the mural continues in the flesh, sinews, and bones of his right arm. *Shutterstock*

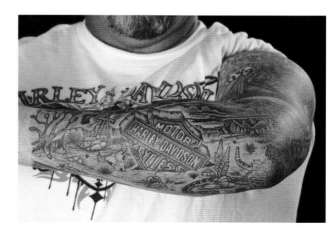

Here's another full sleeve loaded with cool things to explore. *Bill Tinney*

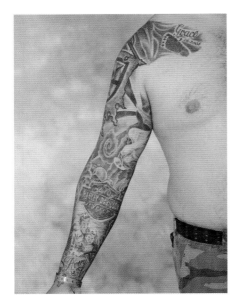

▲ It looks like many personal memories fill this full sleeve. *Bill Tinney*

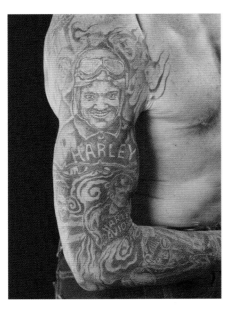

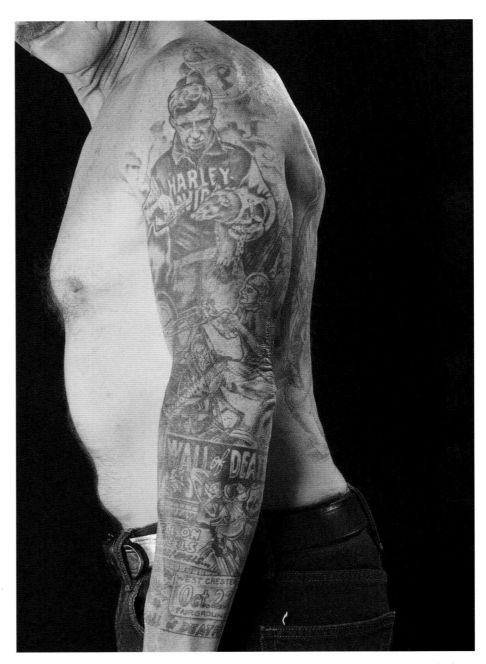

▲ It's always great to really check out a full sleeve, to find all the small details, and to listen to the personal stories that go with the art. *Bill Tinney*

▼ I love the black, gray, and red ink on this full sleeve dedicated to the moto culture. *Bill Tinney*

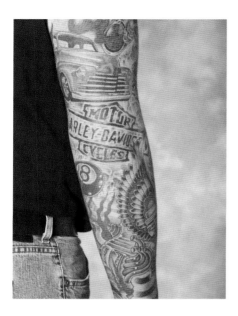

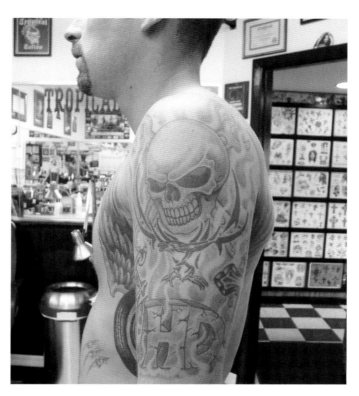

▲ Artist D.C. of Willie's Tropical Tattoo put some hours into the start of this full sleeve.

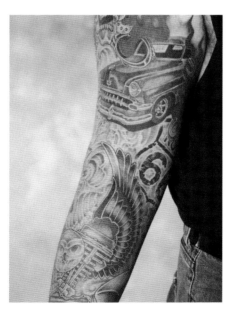

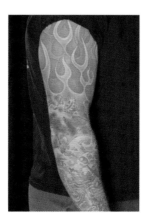 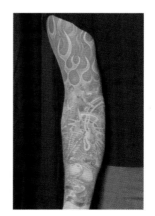 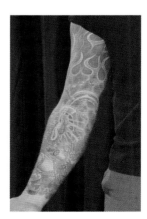

▲ This is a cool mural of an engine blowing up with parts flying everywhere and lots of flames. *Bill Tinney*

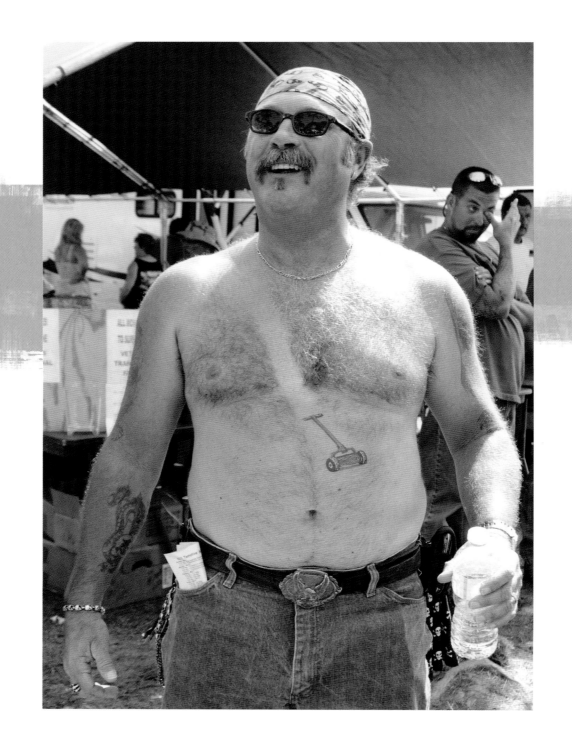

Tattoo Regret

When you hang out at many of the motorcycle events across the country, you're in the perfect position to see thousands and thousands of tattoos. In some instances you'll find some truly amazing work—possibly the best you've ever seen. But you'll most certainly find some of the worst too! And sometimes you sit and you wonder, "what in the fuck was that guy thinking when he got that?"

First on the list of reasons for tattoo regret is the artist. More often than not, the client chooses a shitty artist based on price. And it goes without saying—you get what you pay for. This couldn't be any truer than when it applies to tattooing. You most *certainly* get what you pay for in this field.

The second foul face of tattoo regret is shown on the customers themselves. For example, he or she—often in a drunken stupor—chose some dreadful design to have tattooed on their hides, thinking they were ready to take on the world. And even if they weren't drunk, it was probably still a spur-of-the-moment thing. Tattoo regret often appears on a bicep or leg as the name of a fling the client thought they were in love with at some point or another.

On the arms, legs, and backs of many misled clients, we've seen twisted and warped bikes with three legs, some with five legs, and motorcycles so out of proportion they look like a child's rendition of a Hot Wheels set. The worst thing about this part of tattooing is just how many mislabeled "artists" have no shame for their lack of talent, and no remorse for permanently fucking up some poor guy's real estate.

—Sara Liberte

I look up to a very small niche of artists, and I constantly study their work. I try to learn as much as I can from them, and I distinctly remember my brother Darren, upset about a second *really* bad tattoo that he had to fix that same day, going off to several of us hanging around his shop. He is often saddened when hacks are allowed to ruin people's skin—people like the rotten bastards who earn their apprenticeship in prison using ashes and a guitar string from atop a cell shitter.

Even worse yet is the fact that local people often go to these neighborhood shops because there's absolutely nothing good to compare them to; they base their assessment of tattooing on the crap displayed. Making matters worse is all of these tattooing shows on TV giving the no-talent shitbags the awful idea of setting up shop and raking in the money in the first place. No education, no talent, and nothing good to come of it.

My brother Willie in Daytona used to run the only place in the area to get a tattoo. Shows start airing on TV and suddenly there's dozens of shops all crammed into one area, and they all do shit work for cheap. Now not only are the true professionals fucked, but worst of all, these bastards are giving the entire industry a bad name.

Some tattoo regret stories are hilarious, though. Think of the idiot tattoo artist tattooing an idiot client who can't spell, or when either one or the other of the idiots is drunk. Imagine some misfortunate cretin wandering into a tattoo shop, wanting the name of his new wife (who he just met in Vegas last night) tattooed on his *face*.

A motorcycle rally is the perfect place to gather all of these tattooed and sun-soaked sasquatches with no more intelligence than a shovelhead. And if you look in the right direction, at the right time, with a heavily trained eye, you're certain to see *something* ridiculous.

Sometimes I wonder how many of them regret the whole thing. It's nearly impossible to pinpoint who's to blame for some of this shit. Of course, *nobody* wants to take the blame. So what often happens is the 'squatch blames the "artist" and the "artist" blames the 'squatch.

For some, the only way to avoid tattoo regret is to *not get a tattoo*. Here's some food for thought along those lines.

—Chad Lemme

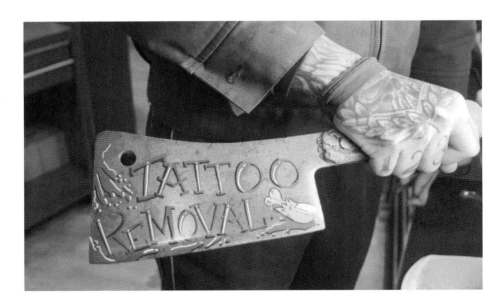

▲ Hanging out at Slingin' Ink (Grinnell Iowa) is the perfect remedy for tattoo regret.

▲ I think this is supposed to be a tattoo of Ace Freeley of KISS, provided Ace were a woman.

◄ Never tattoo someone's name on yourself. This guy learned his lesson the hard way—Elizabeth is his ex-wife. Fortunately, it's not *too* noticeable . . . right?

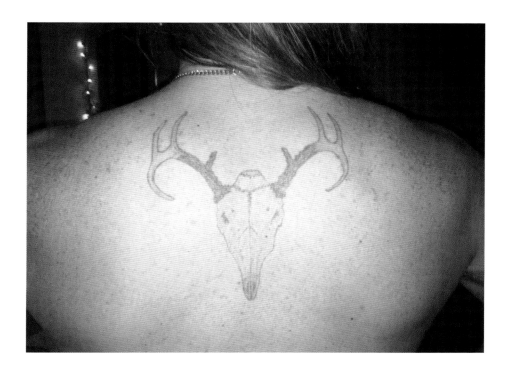

◀ What is that on top of the deer skull? A yarmulke?

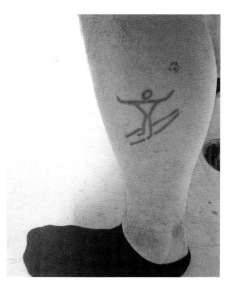

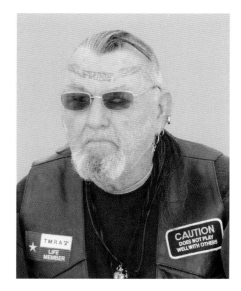

◀◀ Nothing like a tattoo to commemorate the time you got drunk, hit the pavement, got pulled over, then failed the "walk the line" test.

◀ Sometimes a tattoo seems like a great idea at the moment, but the decision often turns into tattoo regret. Is that thing even symmetrical?

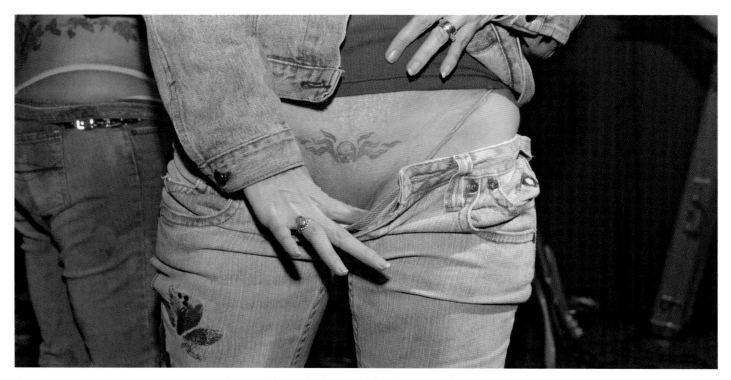

▲ Usually the tramp stamp goes on the *back* of the body. Do you think she simply forgot to turn over?

 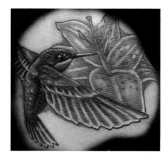 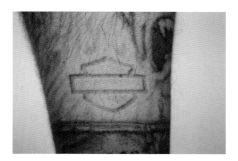

▲ The only redemption from tattoo regret is if you find a great coverup artist who can remedy your mistake.

▲ Sometimes going small is a good way to be conservative if you're not sure you want to commit to something very big. But it's better to go through with it than to half-ass it, as this guy did!

A tramp stamp usually screams "I like to party," and some guys get a huge kick out of these wherever they can find them. Many women enjoy them when they're young, but good luck getting that thing removed later.

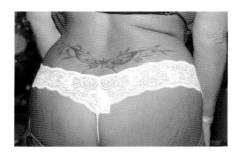

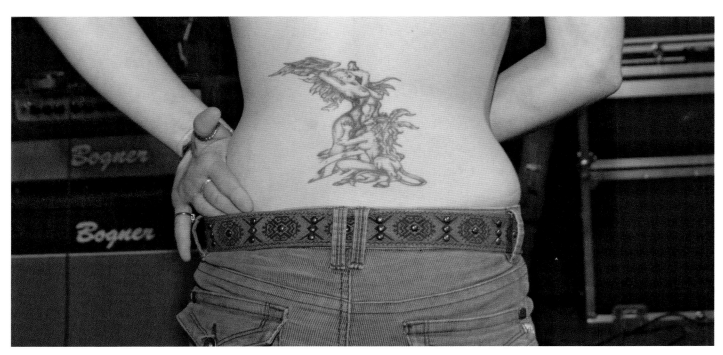

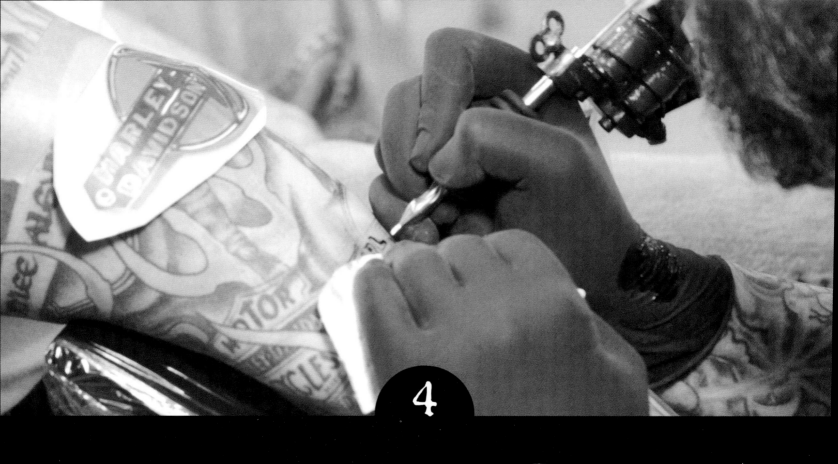

4

Tattoo Art

Tattooing always exposes you to a huge variety of people from all professions and lifestyles. You hear the most fantastic and unbelievable stories, sometimes without even asking. People really trust in you and open up about their lives. You can make friends for life.

Tattoo Artists

any tattoo artists specialize in "biker" tattoos, but only a select few are truly sought out by bikers. This is mostly due to word of mouth, as compared to mainstream media advertising. If one of your brothers recommends a tattoo artist, you're much more apt to go to that artist. It's common practice to take the word of your best biker brother over just blindly picking out an artist on your own when it comes to having something permanently embedded in your skin.

When trying to find the best of the best in a tattoo artist, you must first consider what your idea or design will be. Some artists are best at portraits, some are best at lettering, and some are best at freehand designs. And even if some are the best at what they do, some bikers use several tattoo artists to embroider their bodies. For example, they would have one artist solely for portraits, and one who's better at the freehand stuff for other art. If you find a talented artist in all venues, book early—jack-of-

all-ink artists have incredibly long waiting periods, often over a year out.

We spoke with many bikers and artists to find out who the most sought-after tattoo artist is among bikers today. We couldn't narrow the list down to just one name, since too many people were repeatedly being mentioned. So we compiled a list of artists with the best reputations among bikers today, and here they are.

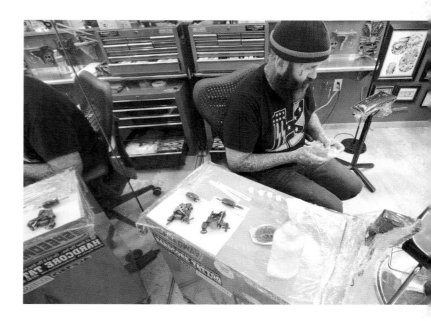

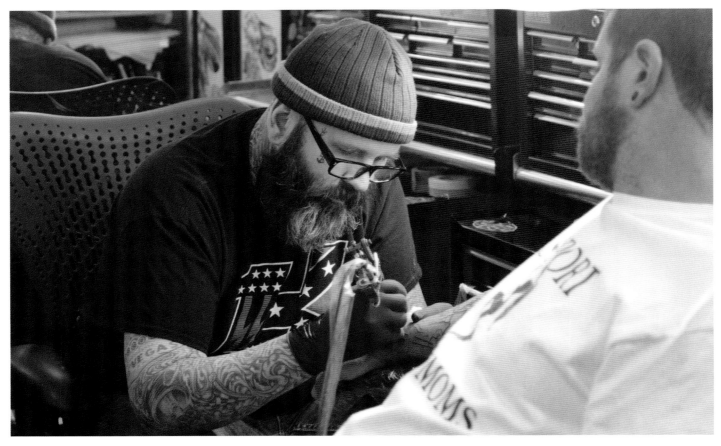

Darren McKeag lays down some color on this arm piece.

Darren McKeag,
Slingin' Ink Tattoo
Grinnell, Iowa

Darren is the kind of guy who volunteers to dive headfirst into underground tunnels with nothing more than a flashlight and a .45 to hunt down and eliminate the remaining Viet Cong forces burrowed deep inside whatever hill they had just shelled or scorched with napalm. He's the guy who audibly farts in the middle of a wedding service, just for something to laugh about, and still goes home with

a bridesmaid. Hanging out with him is always a story in and of itself, and if I were to share a few of them, I'm sure we could land ourselves in jail for quite a stretch.

I remember going to a swap meet just down the road from Darren's place on a Sunday afternoon with the hopes of securing a random part or two. We wound up in this massive bar brawl a few hours later, blind drunk, and not a single part to go home with. Dozens of people, some we had only met an hour or two before this, just fucking demolishing the place. There were three or four women in

◀ Other artists working in the shop occasionally swing by to check on a tattoo in progress.

▼ Artist Darren McKeag (right) is always a welcome sight at a motorcycle rally. *Bart Alan*

▲ A first-aid kit is never far at a tattoo parlor. Where do you think this one's from?

◀ When visiting a tattoo shop for the first time, look for awards, recognitions, magazine articles, and other accolades—these all show the shop has good credentials with talented artists.

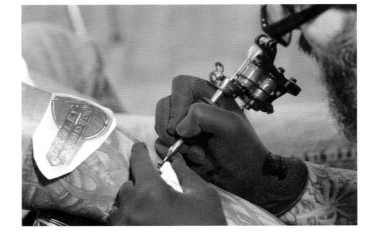

▶ Settling into a groove, Darren plugs away at this tattoo with his reference taped to the arm for visual guide.

▼ Darren McKeag begins the first step in creating an original tattoo—the drawing phase.

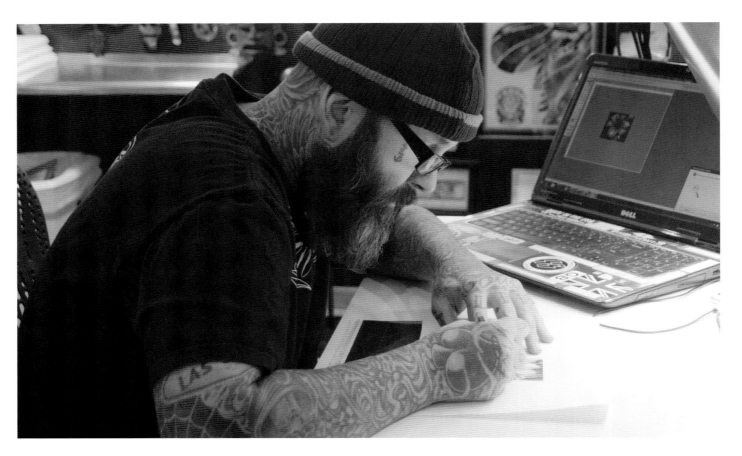

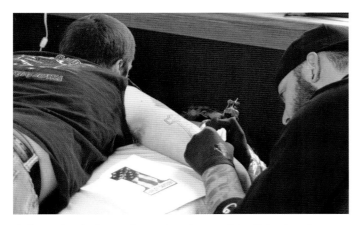

▲ Once the design and template is complete, it is placed on the intended body area, and if the placement is good to go, the inking process begins.

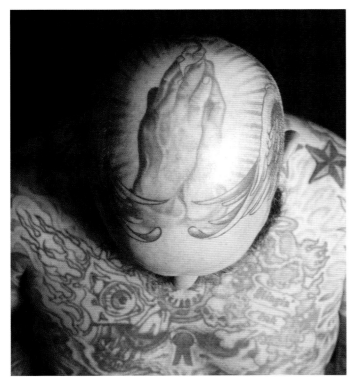

▲ Darren McKeag is renowned for his amazing detail work.

the mix! One took off after me with a fucking Taser while I was teeing off on her husband, and some random arm came flying out of left field and knocked her out cold just a split second before she blasted me with hundreds of thousands of volts of pissed-off electricity. The last time I got thrashed with one of those things, I lost control of my bowels and couldn't use my right leg for almost a week.

But this is what happens when you hang out with Darren. It's inevitable. I remember heaving what might've been a motorcycle over the side of a bridge on A1A in Daytona one morning. We stripped down naked and walked in front of Willie's surveillance cameras like a couple of bareassed Sasquatch, only to find there were fucking alligators wandering around the area that night. Later, we came under heavy fire while cruising the back roads of Pensacola, searching for a baby alligator to bring home. This was all within 48 hours! And it goes on and on and on, every damn time.

But, aside from operating motorcycles far beyond the manufacturers' specified recommendations (or just outright blowing the poor things up), and aside from breaking things that were supposed to remain intact, and burning things that were supposed to remain unburnt, and unclothing people who should forever remain clothed, Darren is one hell of an artist. He can pinstripe and paint with the best of 'em, but it's his tattoo work that's a marvel to behold. I've always looked up to him as an artist, as well as a person, and have spent days of my life studying his work. I could only dream of being as good as he is.

Many people work hard for an entire lifetime and still pale in comparison to him. And there's clear proof of this with every new tattoo he rolls out at his shop. I feel very fortunate that I get to call him my true brother; it's an honor to simply know him. He's the real deal. He's not one of these assholes who pretends to be a tough guy or boasts

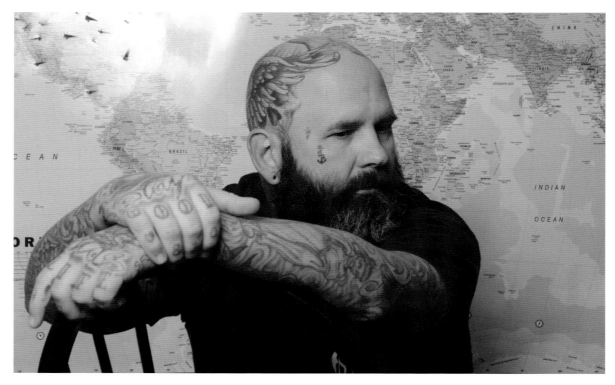

▲ Darren McKeag is the highly sought owner of Slingin' Ink, in Grinnell, Iowa. He is renowned for his amazing detail work.

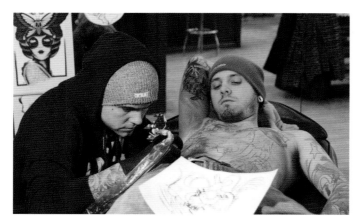

▲ Artist Alex Vance of Slingin' Ink works on a full stomach piece.

▲ Scott Bruggeman of Slingin' Ink draws a tattoo for his next client. This is often the first step for many artists.

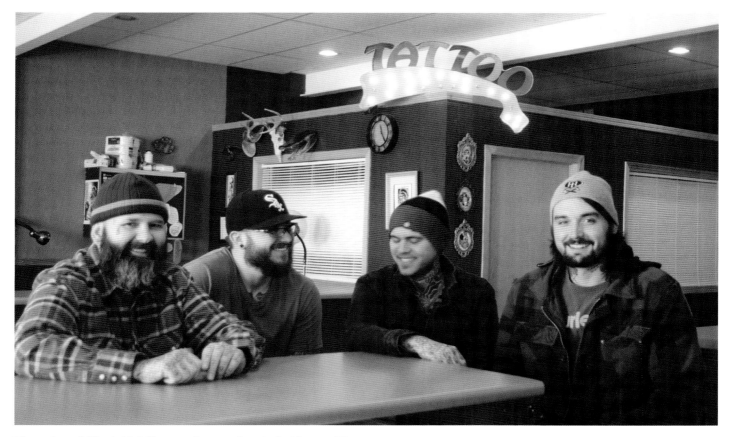

The artists of Slingin' Ink Tattoo—Darren, Scottie B, Alex, and Dan.

about his miles—he runs a beefed-up chop 110 miles an hour the entire way, blasting through traffic like a fuckin' squirrel shot out of an industrial-sized water balloon launcher.

He lives in a garage and on the road. He brings a feeling of envious bewilderment to weekend warriors. He lives the life every dude dreams about, and if given the opportunity to try it, these guys claiming to be all hardcore and tough as .50 barrels would fold after only a few days, if that. He lives it. If you set your sights on insanity, and damn the torpedoes, you just might find him, haulin' ass through destruction, 'cause he came to offend and destroy.

—Chad Lemme

Long Jon and Pinky

Sacred Skin Tattoo

Payson, Arizona

One of the first shops we visited to start work on this project was Sacred Skin Tattoo in Payson, Arizona. Sacred Skin is run by husband-and-wife duo Amanda "Pinky" and Jon "Long Jon" Barwood. Both of these artists ride motorcycles and even travel to motorcycle rallies with a kickass mobile tattoo studio/trailer. They've built a solid reputation based on amazing artwork within the motorcycle/tattoo scene. This talented couple walks the walk. They live the lifestyle that they cater to, and are true artists of their craft, and it's an honor to call them friends. They welcomed us with open arms to not only their shop, but also to their home. These two are in the upper echelon of the few great humans left on this earth.

We asked Pinky to tell us about her life (one that many dream of living). And in her humble way, she shared this with us.

One of the best parts of my life is my job. I don't think many people would say that, but for me it's very true. I decided to become a tattoo artist about seven years ago; I have always been an artist, so it was a logical choice for me, given my love for art, people, and cultures on the fringe of society. I also love being tattooed, and having the opportunity to tattoo others is a real gift.

My husband, Long Jon, is a tattoo artist as well, and we met when I was seeking an apprenticeship at Sacred Skin Tattoo. He chose to mentor me, and teach me what I needed to know to become a tattoo artist. It took about a year and a half to complete my apprenticeship, at which time I began my professional tattooing career.

About three years after I started working for Sacred Skin, Long Jon and I decided to take the show on the road. We remodeled a new fifth-wheel into a tattoo studio, complete with living quarters. For two summers, we traveled all across the country doing tattoos. We worked at family reunions, full-scale bike rallies, and everything in between. We found our niche with the biker events.

Not only do we tattoo, but we ride motorcycles as well. It just made sense. As much fun as it is to travel, tattoo, hear the bands, and see the madness that tends to ensue, there is a lot of pressure being on the road. The clients can be less than clean, having slept in the dirt. Not to mention the drinking! Drunken people are unavoidable in some situations and are extremely difficult to work with.

The tattoos we do on the road tend to be more of a novelty to commemorate an experience, or small enough to do in one sitting. We were often so overwhelmed with business that we would miss whole events without coming out of the trailer, and before we knew it, it was time to leave for the next event. All that being said, there is no way to describe

Amanda "Pinky" Barwood of Sacred Skin Tattoo in Payson, Arizona, whips up a custom creation for a client at her drawing desk.

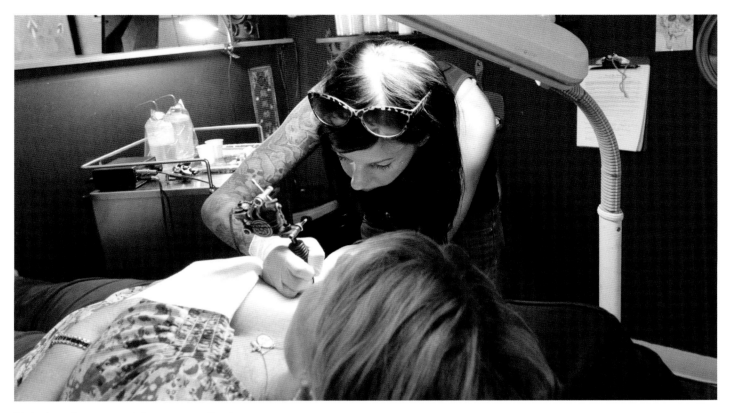

Pinky lays down some ink on a new client.

the world that opened up to us because of our trade and our choice to travel.

Tattooing always exposes you to a huge variety of people from all professions and lifestyles. You hear the most fantastic and unbelievable stories, sometimes without even asking. People really trust in you and open up about their lives. You can make friends for life. We got to know so many people who ride, or build motorcycles. Some make custom goods, or art. Some are performers, photographers, or journalists. Some were just attending the event and would never see us again, but made an impression in their own way. To this day, we can go

almost anywhere and find a friend who is willing to entertain us or put us up for the night.

But, as much fun as we had on the road, the two of us wanted a slower pace. We wanted to be able to spend more time with our clients , working on larger custom artwork. We also wanted to be able to travel for recreation so that we could actually spend some time with all of the great folks we met. As a result, we opened Sacred Skin in Payson, Arizona.

We love living in a small town and having the opportunity to ride out of here when we need a change of pace. Now that we have been in our home studio for a while, I have had time to focus on doing

▼ Long Jon takes a rest before the next client arrives for her new custom ink.

▶ Long Jon Barwood of Sacred Skin Tattoo in Payson, Arizona, does some research in his office for a client's custom tattoo.

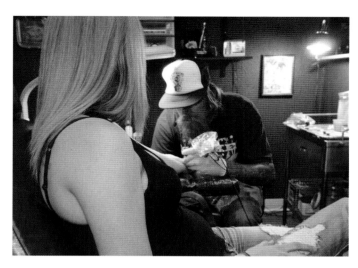

art that I love. I really enjoy doing portrait-style tattoos, large custom neo-traditional tattoos, and anything to do with nature. I like experimenting with really bright colors and flow patterns with a lot of movement.

In my free time, I try to paint and draw as much as I can, or do something creative every day. There is no greater satisfaction than loving what you do for a living. Being able to get out there and actually *live* your life is priceless.

Pinky is one of those people you can't help but admire. Not only because of the life she leads, but also because she's "aware" of it. She enjoys the moment and appreciates it all. She's not bogged down by the humdrum worries that society so easily places on people trying to get ahead in the rat race. She's an amazing artist and even more amazing person.

Of course we wanted to hear Long Jon's take on how he got to be where he is as a highly sought-after tattoo artist. He has an outstanding reputation among bikers as

a great tattooist and an even greater reputation as a solid, stand-up guy. Here's what he has to say:

I am a biker, and I'm proud to use that term. I am also a tattoo artist. I earned the right to call myself that by serving a proper, traditional tattoo apprenticeship almost twenty years ago. Choppers and ink have been the focus of the entirety of my adult life, and they're both attributes that my parents fucking *hate*. To them, it's a loud, raucous, rebellious, dirt-encrusted lifestyle; to me, those are the aspects that so perfectly illustrate *freedom*. If you don't automatically know what I'm talking about, you are reading the wrong book.

I wasn't always Mr. Artist Person, or Mr. Biker Dude, for that matter. In fact, I grew up quite the opposite. But somehow, I "morphed" into a tattoo artist and a biker, allowing life to lead me down the road.

I scored my first bike in the late 1980s and have never been without at least one since. Harley panhead choppers are my idea of the perfect

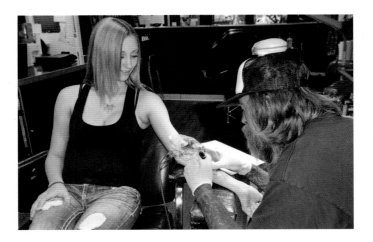

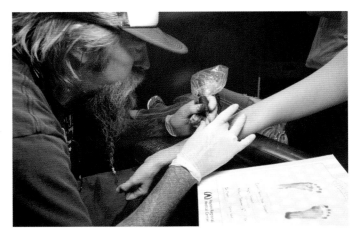

collision of function and form. I went to college in Southern California and majored in magazine journalism. I was lucky enough to write for various tattoo and motorcycle lifestyle magazines throughout the 1990s.

I stumbled upon the chance to take a tattoo apprenticeship in the middle of back-woods Tennessee in 1995. Since learning my trade, it's the only thing I've done for a living, and I've worked literally all over the country while owning/operating several tattoo studios throughout the years.

Currently, I hang my hat in a little mountain town called Payson, Arizona, where I live with my beautiful tattoo artist wife, Pinky, three dogs, a stable of motorcycles and cars, and a cat named Jesco. We operate Sacred Skin Tattoo Studio and absolutely love it. We have a mobile tattoo studio also, and have spent summers past traveling our beautiful country and tattooing on the road to finance our adventures.

I have had the good fortune to live like others vacation, and that to me is quality of life. I owe virtually all of the quality in my life to tattoos and motorcycles in some very basic manner.

Like we said, these two are the real deal, living the life and enjoying every minute of it, and never taking one second for granted. We got to experience watching people come into Sacred Skin and get tattooed, and it was an incredible experience—you can almost feel the good intent and positive vibes behind the efforts of both Pinky and Long Jon. We enjoyed speaking with their clients, who were all completely stoked about the new art they just received.

Long Jon and Pinky are incredible people, and we're definitely honored to call them our friends. They have an outlook on life that we rarely see; you could try a lifetime to be as humble and as positive as they are, and never come close. They have our eternal respect, and we can't thank them enough for their kindness.

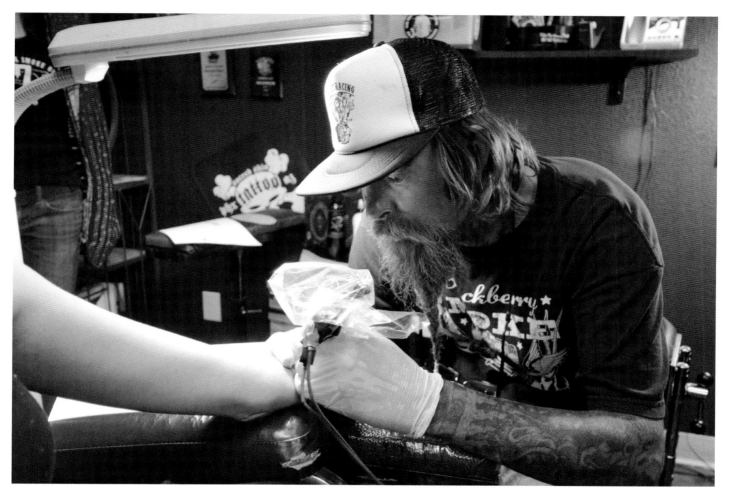

Long Jons lays down the gun and applies some fresh ink on this young girl. Most times clients come in with an idea, then it's then up to the artist to turn it into a design that will look as good or better on the fresh canvas of skin.

Tim Jewell & Chad Kirschenmann
Ink & Iron Tattoo
Sioux Falls, South Dakota

▲Tim Jewell of Ink & Iron Tattoo
(Sioux Falls, South Dakota) lays down
some work.

► Chad Kirschenmann, owner of
Ink & Iron, works on some original
tattoo designs.

►► A chilly day at Ink & Iron Tattoos
in Sioux Falls, South Dakota.

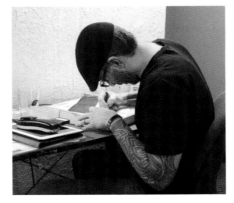

Richie Pan

Dark Star Tattoo
Toms River, New Jersey

Rich Panarra, aka Richie Pan, was born in July of 1965, in Elizabeth, New Jersey, across the water from New York City. Richie told me that his art career started at a young age. "I was never good with school, so I turned to art. Then, motorcycles became my second passion when I figured out that I wasn't making any of the sports teams," he said.

Near the age of 10, Richie had a neighbor nicknamed "Spider." "Spider was a dirty old biker with tattoos," he said, "who built bikes and hot rods in his garage. I would make it a point to find my way over to his house as often as I could. He had a large impact on my lifestyle. It was also this time when I got turned on to biker artist David Mann, who I would say is another influence on me, between my art and my bikes."

In 1978, Richie's parents moved the family out of Elizabeth and into a town in the suburbs named Howell. "I had to say goodbye to Spider, who turned me on to bikes and hot rods, and I ended up saying hello to my new neighbor, Danny Wolf. Lucky for me, I wound up with a new, cool neighbor."

Danny was the owner of Wolf's Den Tattoo Shop and was the person Richie would have to thank for getting him turned on to tattoos. "Other than my great-grandfather, who was a sailor during the first war, his [Wolf's] tattoos were the first I ever remember seeing. It was funny how two neighbors had such an impact on me: Spider got me hooked on bikes, and Danny got me hooked on tattoos."

It wouldn't take long for Richie to start riding bikes. "I started riding bikes when I was 17, but didn't own a Harley until I was 21. My first bike was a 1980 Sportster, and the next thing I know, I'm into panheads, and I never looked

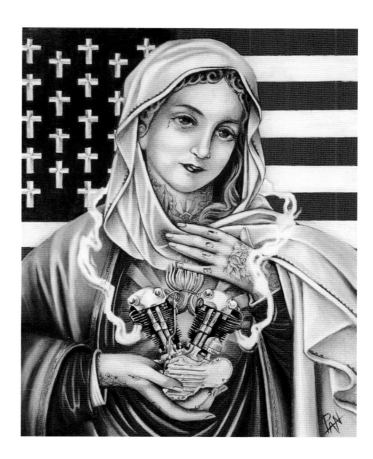

▲ Here's more work from Richie Pan. I can't say much about it except that it's gorgeous.

◀ Dark Star Tattoos in New Jersey is the home of well-known biker tattoo artist Richie Pan.

back—hence the name, Richie Pan. I have been riding for close to 30 years, and been tattooing for over 20 years. Danny gave me my roots, and the Piperato Brothers gave me my first job."

The Piperato Tattoo shops were hardcore biker tattoo shops back in the day. "These guys had shops like what I think every shop should be, the kind you would be afraid to walk into. And not like today's 'hipster' shops that sell panties, pocketbooks, and tattoos. Tattoo shops were a place where you *lost* your panties and pocketbook. Man, has this business gotten soft! I worked for different shops in New Jersey, right up until 11 years ago when I opened my own place: Dark Star Tattoo, in Toms River, New Jersey. And no, we don't sell panties, and we're not that *hip!*"

Biker tattooists don't get any more real than Richie Pan. He lives the life, and has put in the hours over the years to earn the respect and credit he deserves. You have to love how he remembers the guys that who such a strong influence over him when he was young. The impressions these guys made helped mold him into the amazing artist he is today, and you can't help but respect someone who knows where his roots are.

Willie Jones
Willie's Tropical Tattoo
Ormond Beach, Florida

When talking about bikers and tattoos, there's one name that could never be overlooked: Willy Jones, owner and operator of Willie's Tropical Tattoo in Ormond Beach, Florida. Not only is Willie's a great place to get a quality tattoo, but it's an iconic destination of Bike Week and Biketoberfest in Daytona. With so much to talk about, it made sense to start at the beginning, so Willie filled us in on how it all went down.

I was born in Daytona and grew up in Fort Pierce. I lived close to a bike shop and was interested in bikes ever since. We moved back to Daytona, and I bought a Harley Sportster when I was 15 years old. And I couldn't even legally own the bike, but I have been with a bike ever since. I spent some time selling auto parts and got to hanging out with the mechanics I sold parts to. All of these guys had bikes, and of course being from Daytona, we had plenty to do around bikes.

I've seen the changes during Bike Week over the years, and it continues to change. When I was younger, I met a guy named Mo. He was a mechanic over at the bike shop on Beach Street, and he was the biggest influence on me. Mo took me under his wing, taught me lots about bikes and tattoos. He was covered with tattoos, and started to tattoo himself. He taught me almost everything I know. Mo never got to be a big-time tattooist, but he meant lots to me.

◄ Snow is something not to worry about at Willie's Tropical Tattoo near Ormond Beach, Florida.

▼ Ohio Bike Week is a busy time for tattoo artists.

In the 1980s, I owned a bike shop with three other guys. We mostly worked on older bikes like pans and shovels, and we stayed busy. My goal was to open a tattoo shop, and around the early 1990s, the opportunity came up, and I bought the shop. Willie's Tropical Tattoo was one of the only shops in Florida at the time, and was the most sought-after tattoo shop in the southeast. That was until the TV shows came along, and Miami Ink made its mark. During the 1990s, tattoos were still taboo, and we had a hell of a time keeping the shop open. I had to hire lawyers and fight to keep from being outlawed.

We asked Willie to tell us about his Chopper Time show, the bike show held on Thursday during Bike Week, right in the parking lot of the tattoo shop. It's been a tradition for more than 13 years.

Basically I started doing the show because of all of the guys working for me. I would have like 15 guys working at the shop during Bike Week, and they would get mad that they had to miss out on all of [the] Bike Week happenings. Working the hours we were putting in, we'd be tattooing till like six in the morning. So I thought we'd bring some of Bike Week to the shop. And besides this, guys were already starting to meet up at my shop on Thursdays anyway, so it just made sense.

From traveling around to other rallies and meeting other bikers, whenever these guys rolled into town for Bike Week they would swing by the shop to say hi. A tradition kind of started with me, Jeff Cochran, Donny Loos, and Adam Chandler. They would roll up to the shop on Wednesday afternoon and we

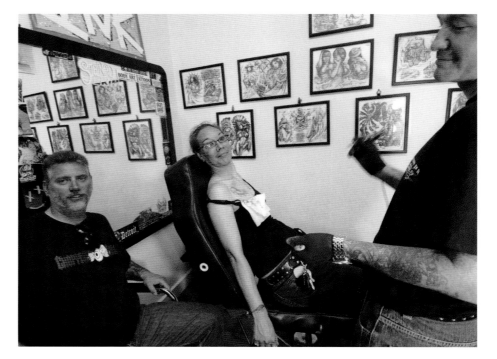

would all take a ride to Lollipops. Next thing you know, they would all swing by on Thursday just to hang out.

At this point I met this cat named Roadside Marty, and asked him to man the mic, and to make the announcements of the winners for the show. Marty told me he didn't know anything about doing something like that, but man he's perfect at it, and has been doing it ever since. I always ask builders to make some cool trophies for the prizes, and the show has become kind of a place to meet, to get inspired, and check out some amazing bikes. Now everyone knows that this is the place to be on Thursday during Bike Week.

We also asked Willie to tell us just how busy the shop gets during Bike Week.

Willie Jones and Darren McKeag are two amazing tattoo shop proprietors.

You know, it's different these days. Bike Week is different, and the people getting tattooed are different. We used to get a ton of walk-ins who just wanted flash art tattoos that would take a few hours. They would pick something out off the wall. But today, more and more people want custom-created artwork that takes time. You can't just walk in and get a custom-created tattoo in 30 minutes like you see on TV. So these days, people come in and make appointments, meet with the artists, and get the project rolling.

I have about 10 guys working for me now. DC came to work here in the 1990s. He likes to travel around to other shops and is always riding. He's got a reputation with bikers, and is always at the bike events. One of my other artists, Joe Delbuono—I actually sold him a bike when he first came to town, and he has been working for me ever since. He rides all over as well, and hits up the other bike events too. Got some great guys working for me. Like Clay. He is my right-hand man, rides a panhead, and I've never seen him in a car. Just on that old bike. We have been friends since the 1970s.

We could have kept the conversation going and going indefinitely, and I love the stories from back in the day, but we decided to end by asking Willie about his thoughts on the tattoo reality TV shows—"I hate them. Reality shows are a lot like politics: full of shit."

If you haven't been to Willie's Tropical Tattoo, make sure you stop by and tell them Lemme and Sara sent ya. They are amazing people and have a really cool shop.

Jim Frizzell,
Some-fucking-where, USA

In the early morning hours, facing a bout of insomnia-induced boredom, I focused my attention to the important task of examining the Book of Faces; to the bewilderment of my prying eyes, I stumbled across an amazing and terrifying thing: the existence of one James Frizzell, brother of the infamous white-trash icon and original American motherfucker, George the Painter. And I remember thinking, "Mother of God! There's *two* of these fuckin' guys?!"

Curiosity mixed with fear. Then I caught a glimpse of a passing photo bearing some type of mutant teddy bear octopus thing slithering its way across a plain white T-shirt. I scrolled back. What I saw was disturbing and amazing all at once. So I asked George if it was in fact his brother, and my suspicions were confirmed.

Luckily, George sleeps the same hours I do, which consist of little more then a short nap right before the sun comes up. He told me about the numerous T-shirts while I looked through them. They were all one-off, hand-drawn designs, created on the fly, and he did them all with a fucking ballpoint pen. Saying that these things were amazing is an understatement. I've never seen such dimension, or depth, or whatever these crazy artists call it.

In an extremely intelligent conversation with George, I learned that his brother Jim is also a tattoo artist. Well, paint my ass blue! The fact that I knew absolutely nothing about him seemed to be an issue. All I could write about him was his name. I'd never talked to him before. I didn't even know what he looked like.

So, on yet another shitty, sleepless night, I called up George and asked him if he would be willing to write about his brother for me. And he complied. And I was scared—if you've ever read the things George writes down, you'd understand where I'm coming from. I can't imagine what's rolling around in that guy's head that he won't write down. It's a frightening prospect.

But, George got me in touch with Jim, and wrote a bit about him for your reading pleasure or discontent, depending on who you are. And without further ridicule, I present to you, through the words of George the Painter, Jimmy Frizzell.

—Chad Lemme

George the Painter on his brother, Jimmy:

There is a hidden state of discontent burrowed and hidden from prying eyes [so] as to fit in with the nine-to-five working stiffs, hiding behind groomed lawns and perfect houses, sheltering what is presumed to be the American dream. Here lies the omnipotent agenda that all good citizens are expected to strive for: the white picket fence; the nice, safe minivans; and the obligatory nod to the neighbor you spend your life trying not to offend. The pathetic life of your average good American; the proper stereotype, the good neighbor, the upstanding citizen.

Sometimes, however, you meet someone who just doesn't give a fuck and wouldn't put out a burning infant without taking pictures first. A day without someone darting out of his way as he intentionally (and with great natural finesse) creates or preforms disturbances, just for the sake of waking the lulled masses out of their comas.

Dangerous cars, loud bands, and images not designed to rest comfortably on the pallet if ingested by health-conscious, "safety-first" modern Americana. Random acts of chaos just for the sake of cheap thrills and big noises, some of it even able to be viewed rather than endured. Art for art's sake, or at least a mess for the fuck of it all.

I can't really say much about the artwork of Jim Frizzell in that it speaks for itself; his detail work is unbelievable.

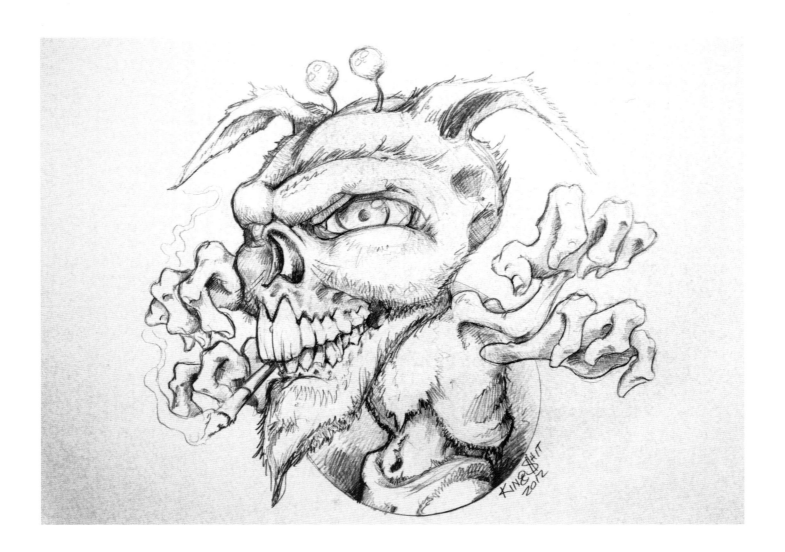

Jimmy "King Shit" Frizzell has been steppin' on toes and screamin' in the face of all things acceptable since he has been old enough to barf at the dinner table.

Whether he is planting his six-foot-nine frame in front of a microphone heading another doomed band, racing his motorized deathtraps headlong into disasters unforeseen, or leaving his vision on scraps of paper or rattle-canned onto anything that happens to be within the reach of his unstable need to create the unsettling—art for art's sake, or just making a mess, it's as satisfying to him as a junkie's long-anticipated pinprick. Nothing goes unmodified.

Good or bad, no project goes unnoticed. Through all his exploits into the creative, particularly regarding his ability to wield a ballpoint pen or Sharpie, his sketches have continued unwavering,

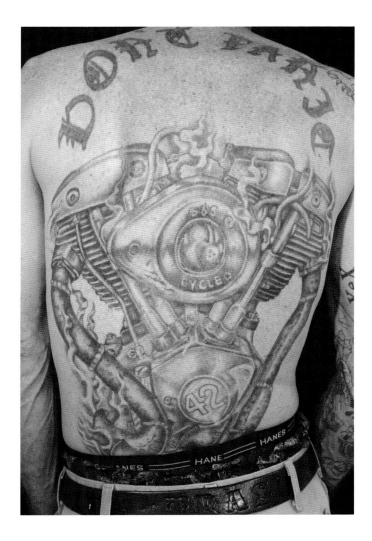

seems to be just a bit too catchy to describe what he does—falls short, if you absolutely have to put a label on it. Labeling what he does would be a fruitless endeavor. From the start, he has turned his back on convention, and convention would be the only reason to pigeonhole what he does as second nature.

Unrestricted creativity has come from a lack of any urge to become a "professional" artist. Without the need to be accepted, or bask in unending accolades, he has been able to do whatever the fuck he wants for as long as he has been doing it.

Recently, he has been causing a bit of a dustup as he has started to show a bit of what he has been doing for years. Seemingly an overnight sensation, he has continued with his nine-to-five, refusing to put any pressure on something he does simply as a relief valve, rather then something considered important.

But, with no urge to make any kind of a statement, or wade through the horseshit that makes up the structured art world, he just continues doing what he has always done: perfecting the art of the ludicrous, annoying the straights, and making his neighbor's lawn die. Just doin' his thing and smellin' like a fish. King Shit is still King Shit!

usually unnerving the viewer or unsuspecting passerby. Stacks upon stacks of past sketches and finished drawings litter the confines of his less-than-humble abode, most with no actual intent or destination. It's just something he is driven to do even if he has no idea why or any reason to figure it out.

Being categorized is a bullet that King Shit has been lucky enough to dodge. Lowbrow— a term that

Tattoo Artwork

It's no secret what our society has turned into: disgustingly disposable. Everything is disposable. No one fixes anything anymore. If something is down, the norm has become to simply throw it out and purchase a new one—cars, lawn mowers, televisions, appliances, and so on. Hell, look at how we consume beverages, all in throwaway cups. Trash is always filled with paper or plastic cups. God forbid people use mugs and bring them home and wash them to use again. Nothing is kept forever anymore.

One thing that is kept forever, though, is a tattoo. Sure, laser tattoo removal can take it away, but it's very expensive, very painful, and most people don't usually go through this procedure unless it's a huge mistake they need erased from their skin sketchbook. The process of deciding on artwork can be more painful than the act of getting tattooed itself. It takes a very disciplined person who knows exactly who they are, and what they stand for, to make a sound decision on what will be there for a lifetime. Many factors come into play in this process. For the well disciplined, it's not a hard process at all. These people are at a different place in life. They have a certain confidence about themselves and know what they want to experience every day. But for those lacking self-discipline, the decision process can be rather lengthy. There are many things to consider:

- Will this artwork reflect you personally?
- Will this artwork impose problems on your social life, career, or family?
- Where will you put this artwork on your body?
- Is this something that you are OK with having for the rest of your life?

Good tattoo artists try to steer clients in the right direction. They avoid the drunk, "We're in love, let's tattoo each other's names on our asses" type of clients. This can be one of the most challenging aspects of being a tattoo artist: trying to do right by your client, to help them with such a big personal decision, and to provide them with the artwork that will make them happy every day without regret.

Tattoo artwork is usually broken down into three categories.

1. Original art drawn by the artist
2. Flash
3. Custom art from the customer

Flash art is usually displayed on poster-sized boards hanging on the walls of tattoo shops. Not all tattoo shops

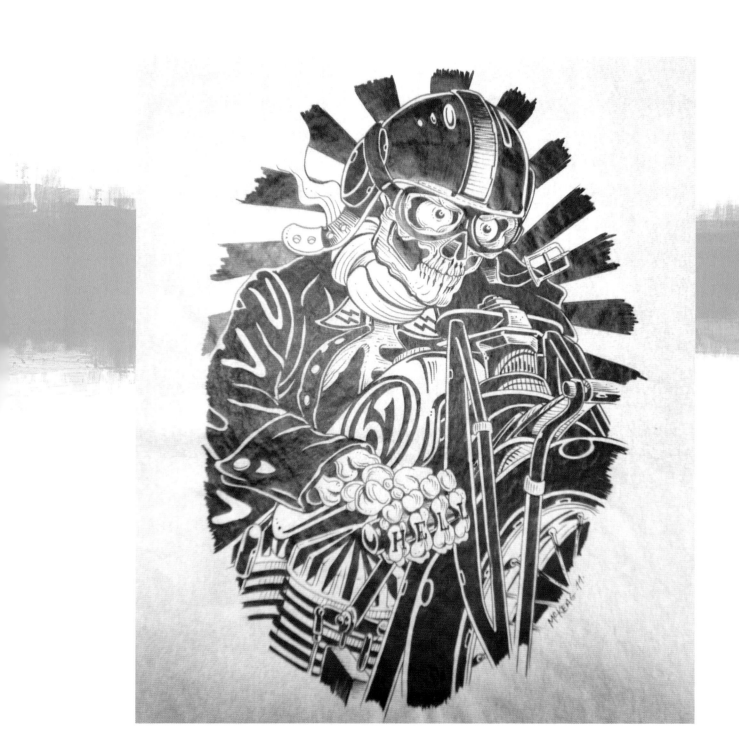

display flash, however. The true and talented custom artists usually don't like to offer premade tattoo designs. They prefer to create their own designs, or take direction from the client and create something very specific and unique. These shops specialize in original artwork. Most of the shops we visited had tattoo artists who create their own art and stay clear of flash. The artists we spent time with all enjoy the challenge of compiling client ideas and assembling them into a one-of-a-kind masterpiece.

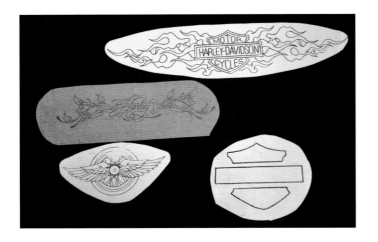

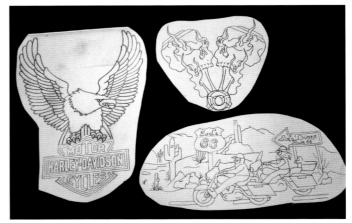

▲ Stencils for biker tattoos. Many designs stem from the clients, and it is up to the artists to turn them into artwork. These are by Long Jon, of Sacred Skin Tattoo, in Payson, Arizona.

▲ Above right: Here are more designs based on ideas from clients by Long Jon—a classic eagle and H-D logo, V-twin skulls, and a biker crew cruising Route 66.

▶ Some clients bring inspiring photos or illustrations from their favorite magazines. It is up to the tattoo artist to tweak it.

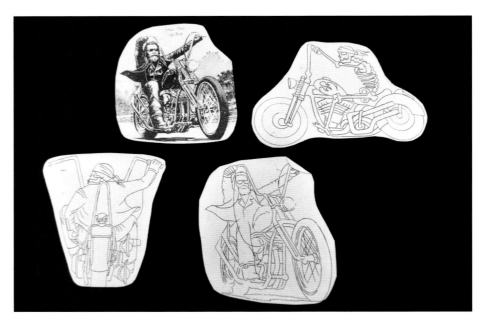

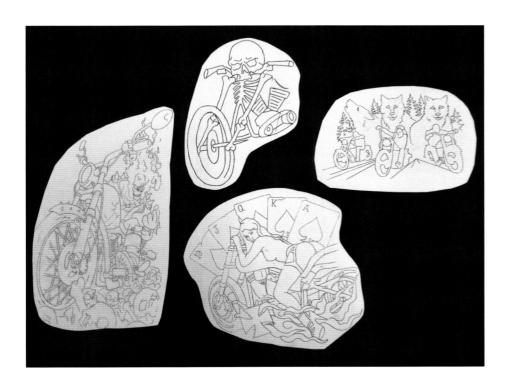

◀ Some artists are more prone to certain ideas or images than others. No matter the detail—wolves, women, or wargs—Long Jon puts a bike in 'em all.

▼ What would you call this? A V-twin she-devil? A motor mistress?

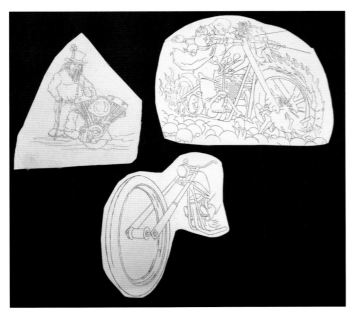

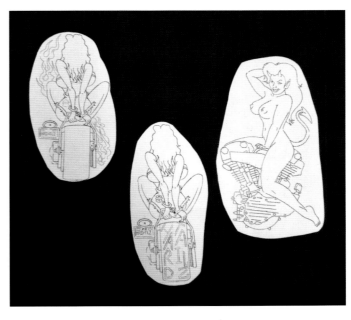

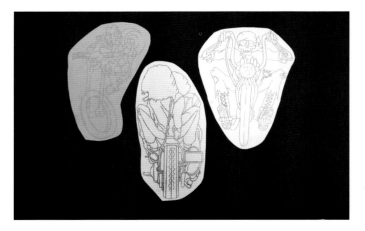

▲ You can't be a tattoo artist without an arsenal of motorcycles in your repertoire.

▲ The famous "Question Everything" logo is the trademark of Indian Larry, and almost every biker tattoo artist has drawn this up for a client.

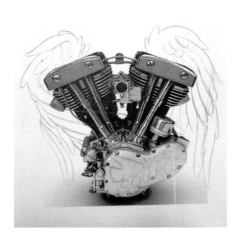

▲ Occasionally artists take a photo from a client and work in what the client wants added to the image.

▶ Betty Boop can ride! Skeletons too. It's fun to mix and match different styles and eras.

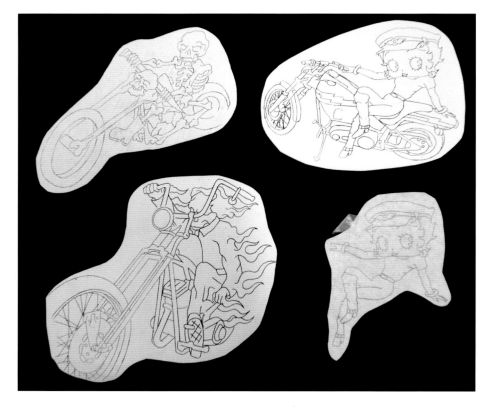

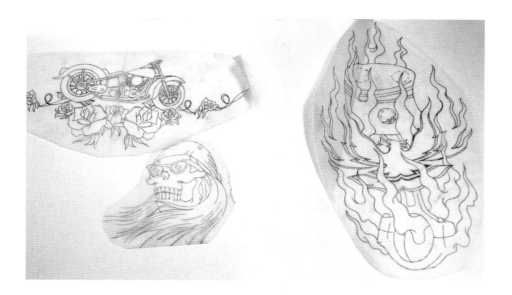

Skulls are probably the most tattooed image—they became popular from the counterculture of the mid-twentieth century and fit just about anywhere around a bike.

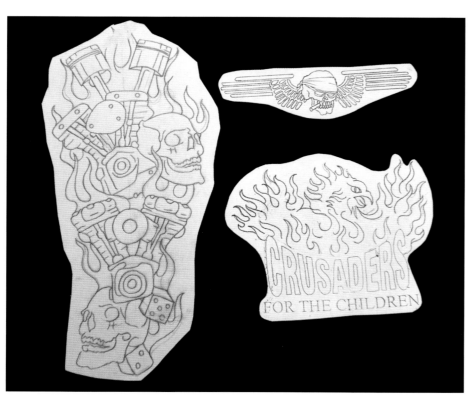

CRUSADERS

FOR THE CHILDREN

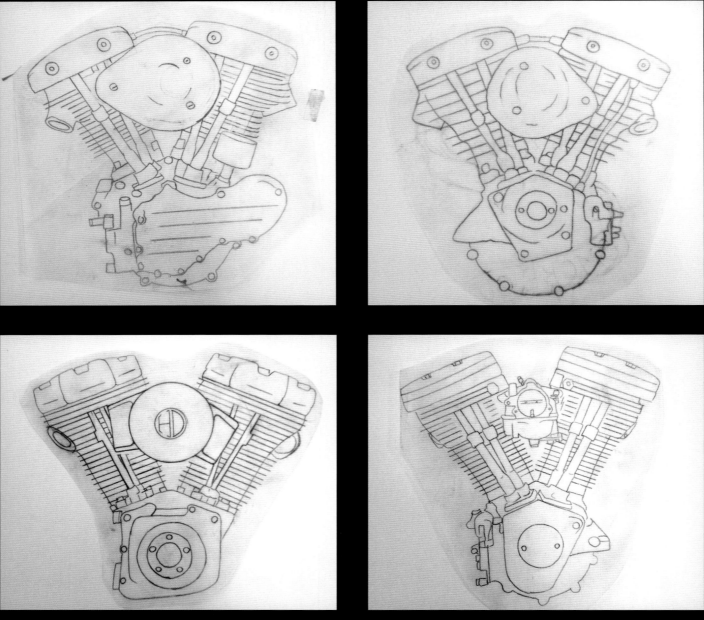

Many gearheads have an engine tattooed on them *somewhere*. Some guys are diehards when it comes to certain types of engine.

Of all the brand logos available, Harley-Davidson is hands-down the most popular. All tattoos by Long Jon of Sacred Skin Tattoo in Payson, Arizona.

The second most popular tattoo among bikers is just about anything with an eagle attached to it, wings spread and looking to the horizon. Nothing says "ride free" like an eagle. Artwork by Long Jon of Sacred Skin Tattoo in Payson, Arizona.

▲ There are endless variations on the popular H-D Bar & Shield tattoo.

▲ Tattoo artists often hang their original drawings at their stations for works in progress.

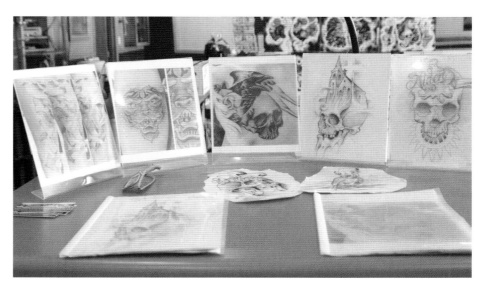

▲ Artists display recent work for you to flip through to help you decide which artist (and art) is the right one for you.

► Recently deceased tattoo artist Hank Bertka throws some ink on Jesus in this portrait.

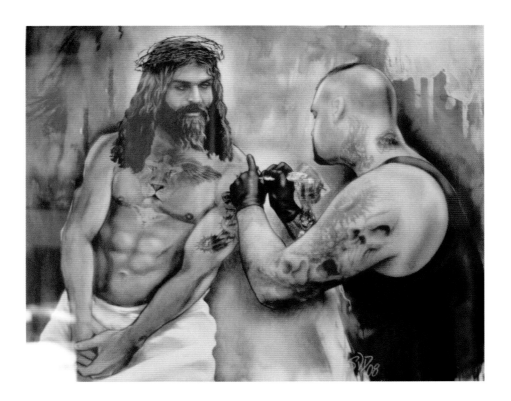

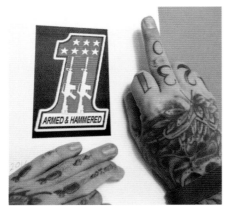

▲ Here, a common symbol is re-working and customized; number 1 gets a new meaning from the Wonder twin—Armed and Hammered!

► Some artists have professionally bound books to showcase their work. This book is filled with art from Alex Vance of Slingin' Ink.

► Many jokers twist a popular brand or logo to undermine its original meaning. This guy must have had a bad time on a Sportster.

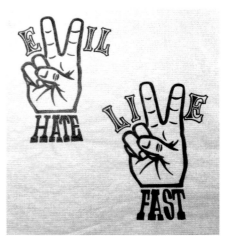

Darren McKeag creates all kinds of original artwork. Some are for tattoos, others for company logos, shirt designs, or stickers.

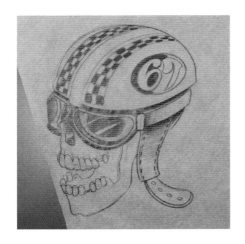

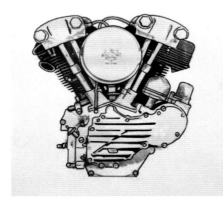

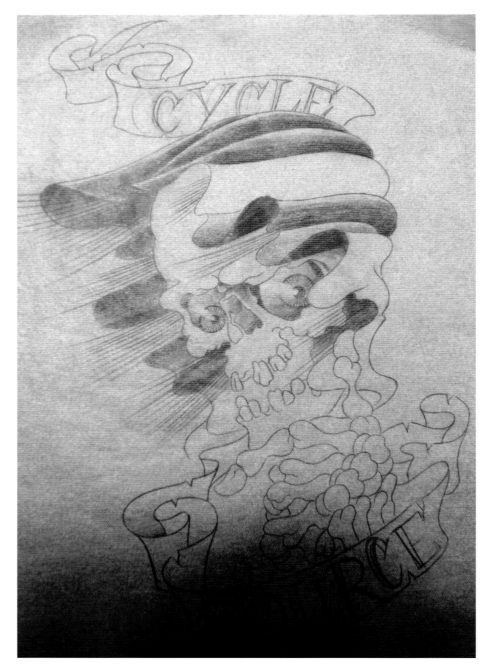

▲ Any artist who counts clients as bikers becomes quite good at drawing different types of engines, like this knucklehead by Darren McKeag.

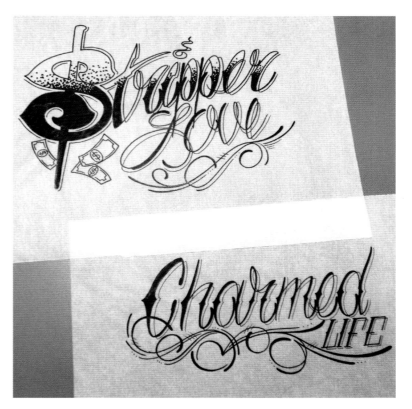

Lettering and scroll work are also important skills to have for any tattoo artist. Art by Darren McKeag.

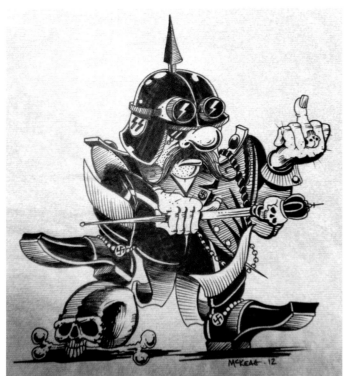

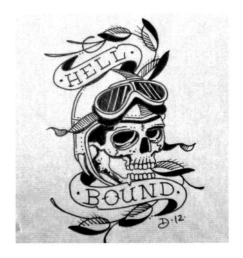

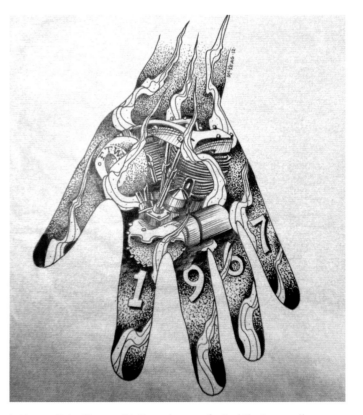

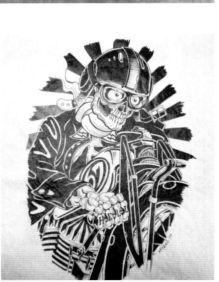

Animated characters are popular requests for tattoo artists. Darren McKeag has perfected that as well.

I can't get over the detail in this magneto by Darren McKeag.

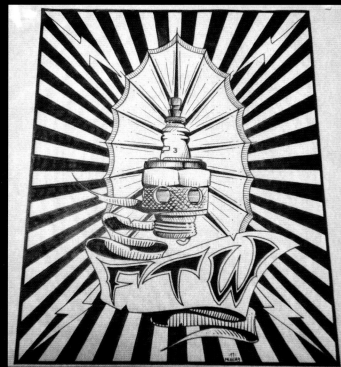

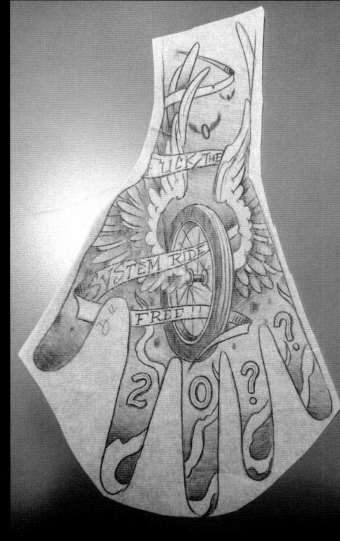

Darren McKeag's quick sketch of author
Chad Lemme, the other half of the

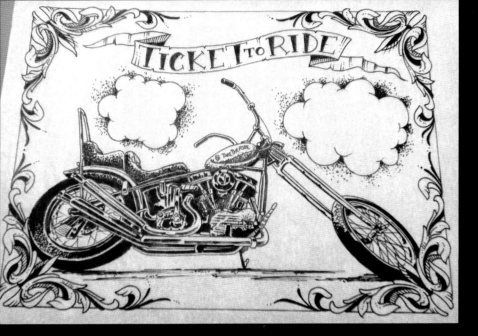

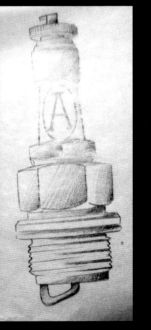

These sketches are all in various stages of design from Darren McKeag. Some are done in ink, others in red pencil, colored pencil, or standard pencil, some on tracing paper, others on Bristol board—like any other art, the vision often dictates the materials.

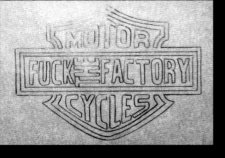

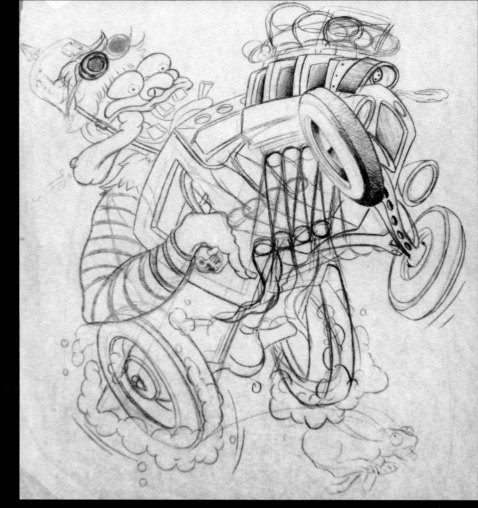

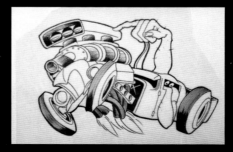

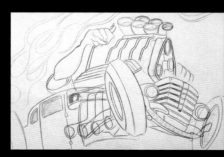

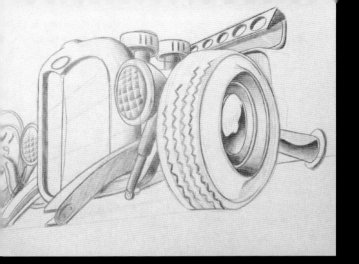

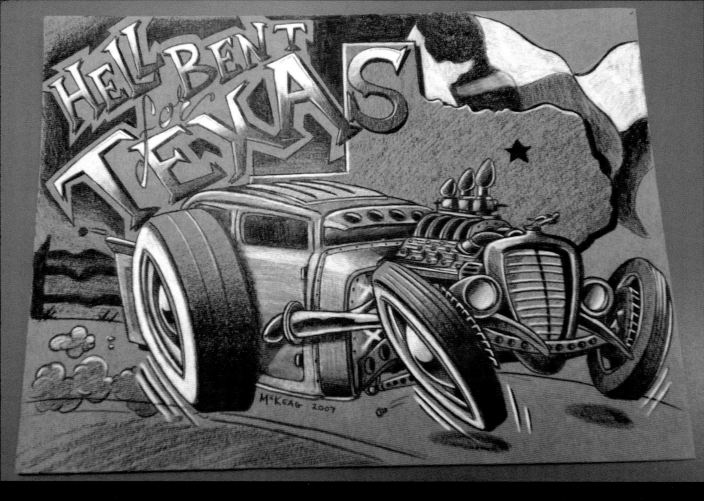

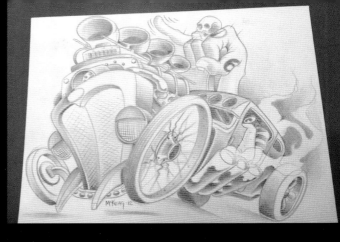

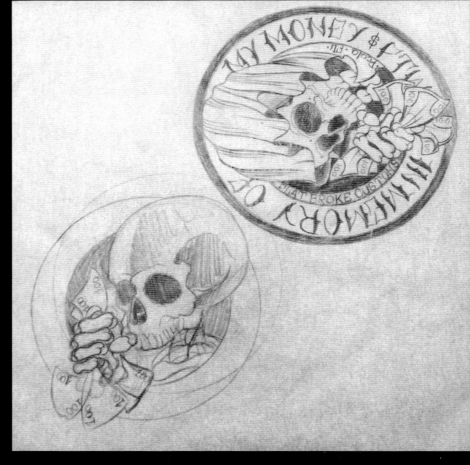

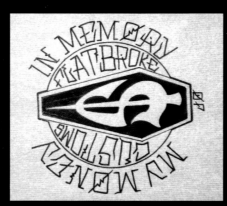

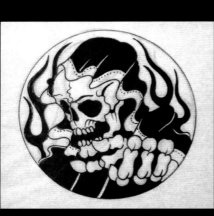

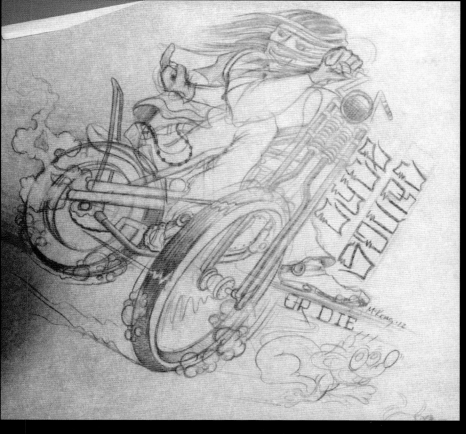

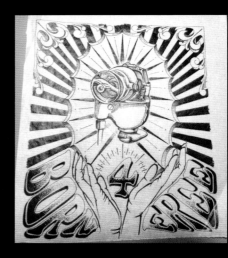

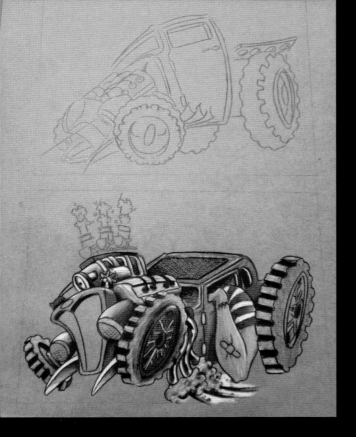

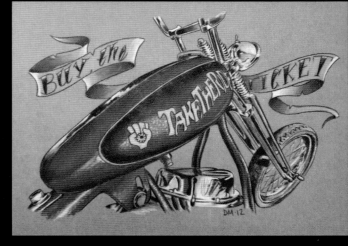

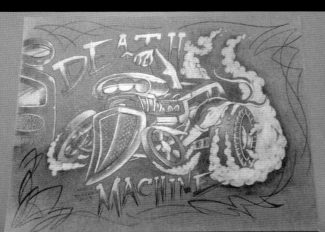

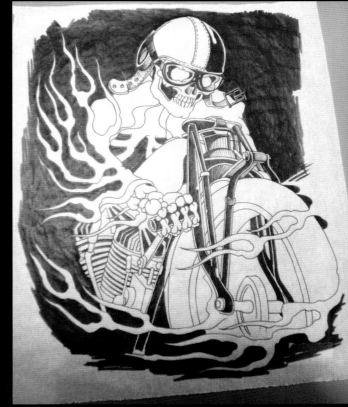

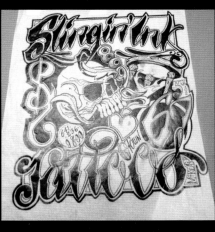

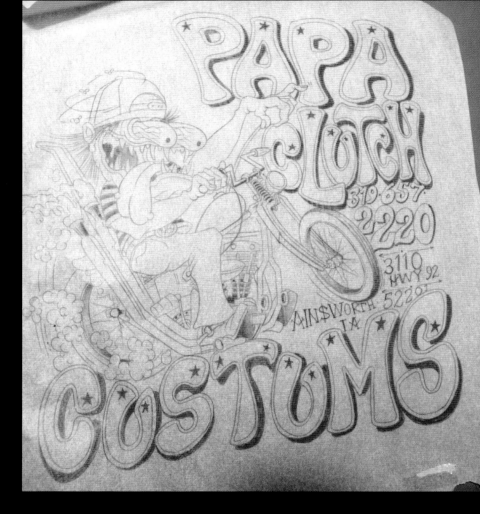

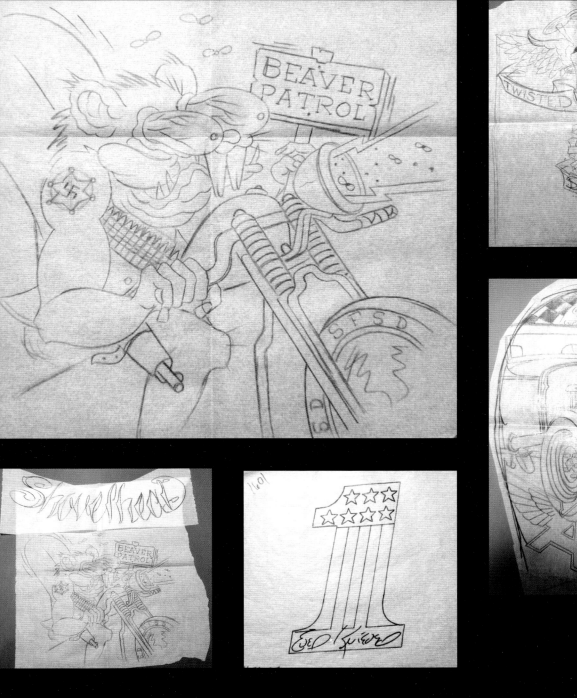

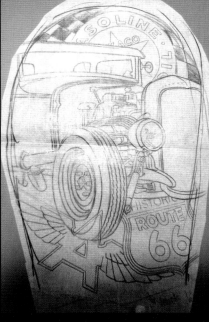

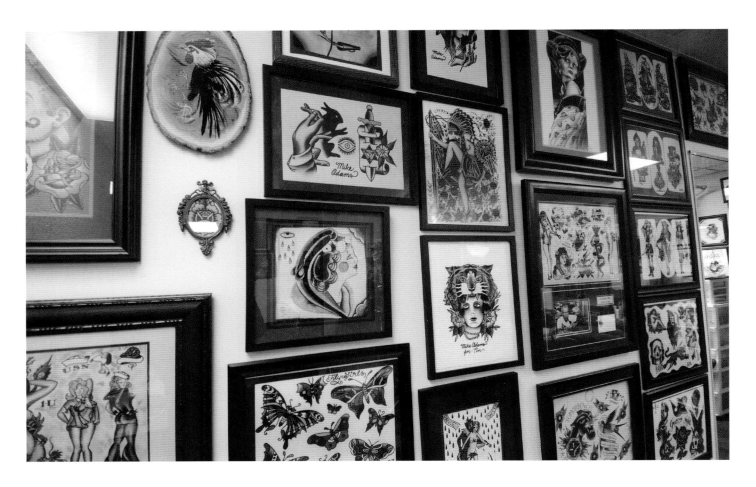

Ink & Iron (Sioux Falls, South Dakota) has a huge collection of vintage flash tattoo art.

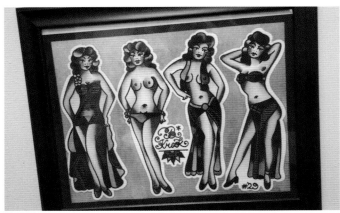

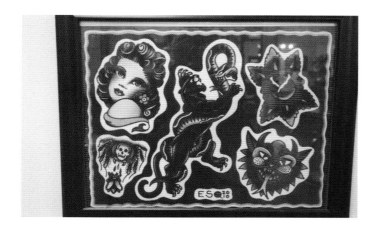

Vintage flash art is great to decorate the walls of a tattoo studio, to inspire tattoo artists, and also to ignite ideas in the minds of the clients.

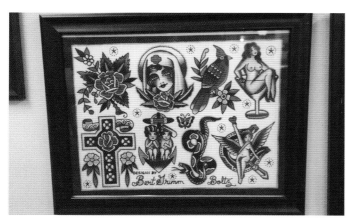

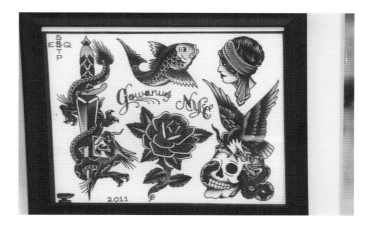

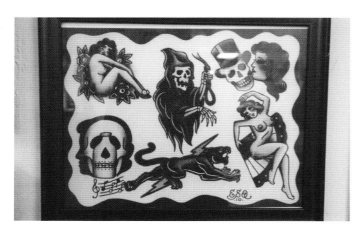

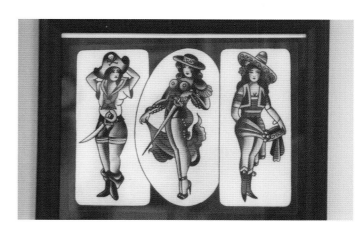

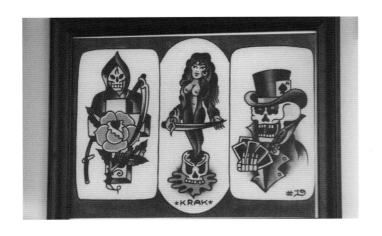

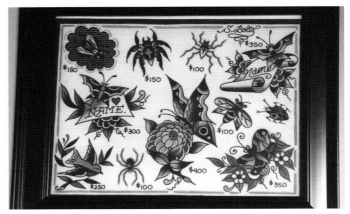

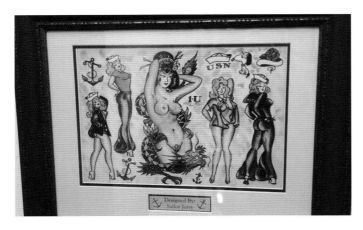

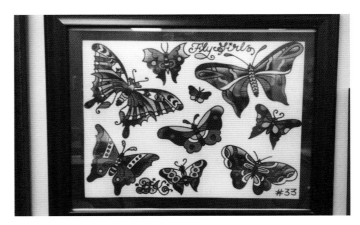

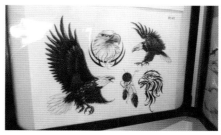

Modern tattoo flash racks can usually be found in tattoo parlors. Some clients prefer to flip through flash to find what they are looking for in a tattoo, while others use it as a starting point to spark their own ideas.

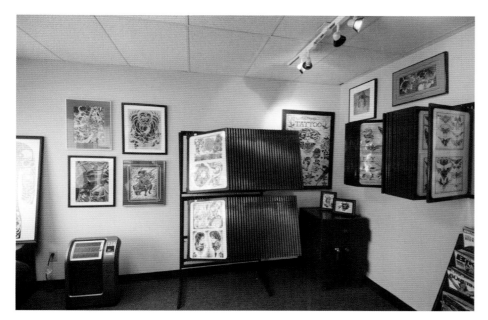

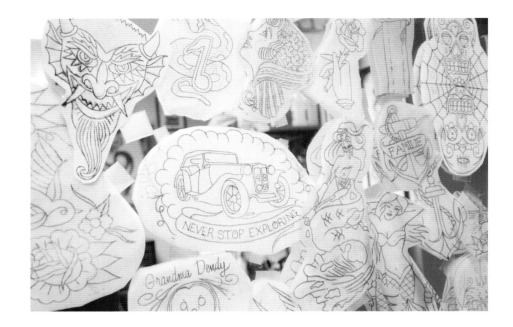

▶ This is a montage of original work from Tim Jewell of Ink & Iron Tattoo.

▲ Just the type of sign you want to see in a tattoo shop!

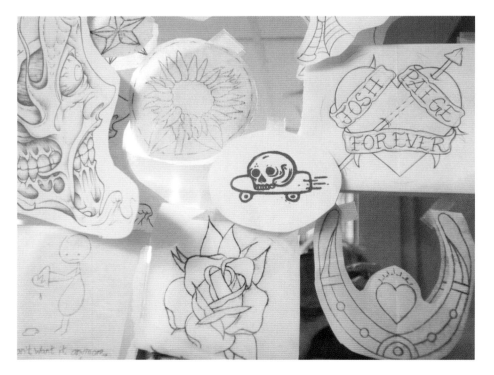

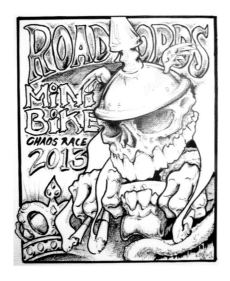

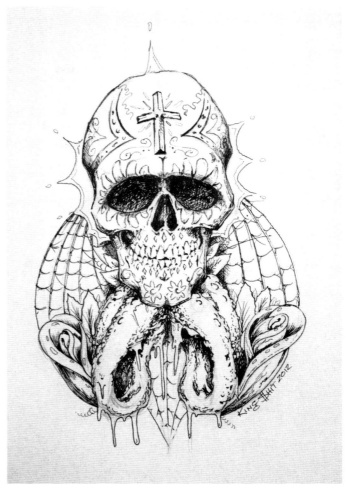

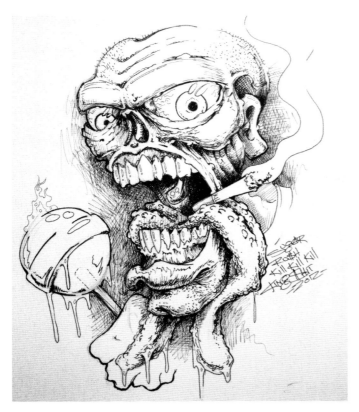

I can't really say much about the artwork of Jim Frizzell in that it speaks for itself; his detail work is unbelievable.

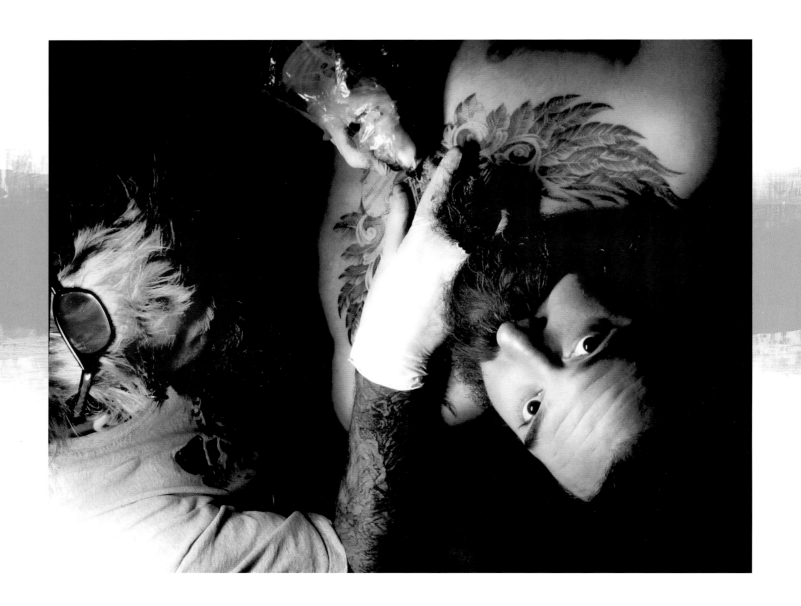

The Tattoo Process

"Did your tattoos hurt?" "Will this hurt?" "What does it feel like?"

The dreaded questions of the first-timers; it seemed that in every shop, talking with every artist, this topic came up more than once. Some of the responses were insanely funny. "No, this won't hurt a bit. It's just a little needle jammed into your skin at about 300 strokes per minute. And when we use a seven-liner, that's 2,100 holes hammered into your skin per minute. It's virtually unnoticeable."

Once the initial 50-question gauntlet has been run, and all the intellectual questions have been answered (as well as a decision on the artwork), the fun part begins. A few different methods can be performed to get the initial outline of the artwork onto the client. This serves a few purposes. First, it helps positioning, and ensures the client is happy with the location on the body. Second, it serves as a guide for the artist. Some of the more talented artists simply use a Sharpie marker and make up the outline sketches as they go along, but most artists make a carbon transfer—something like a photocopy of the design transferred onto the skin.

This is all done after the area has been shaved and wiped down with antiseptic to ensure a clean surface and to prevent potential sickness. The artist will already have his or her work area set up with the necessary tools. The color inks are laid out in cups next to a few cups of water for diluting ink, a glob of ointment, a stack of paper towels, needles of various size for lining and shading, and the most important part—latex gloves.

Recently, most tattoo equipment has shifted to one-time use rather than constant sterilization of a single piece of equipment. Not only is it much less of a headache, but it ensures the absence of spreading disease. In the past, multi-use equipment was kept sterile by means of an autoclave, a machine that pressurizes steam at incredible temperatures to kill bacteria, fungus, and other fun things of that nature. However, it is not entirely fail-proof. Disposable equipment eliminates the possibility of disease.

The client is kept comfortable—and by "comfortable," I mean *not* comfortable—in a regular chair, a reclining chair, or on a massage table, depending on where the tattoo is going on the body. The client is asked to sit or lay motionless, so as not to interrupt the artist or create movement and jeopardize the outcome of the artwork. Some tattoo artists will charge extra if you pick up your cell phone while in the seat.

Depending on the size of the design, you could sit for 10 minutes or eight hours. Also, the client's pain threshold will help dictate the amount of time in the chair. When finished for the day, the artist will wipe the tattoo down, maybe spread some ointment on the area, and cover it up with clear wrap to protect the area from germs. Air drying is recommended for follow-up care, along with ointment dressing for a few days.

▶ Once the artwork is transferred to the skin, it's time to take the gun in hand and start the inking process. *Darren McKeag*

▶▶ The design is transferred to skin and cleaned up for easy-to-see outlines for the artist to follow. *Darren McKeag*

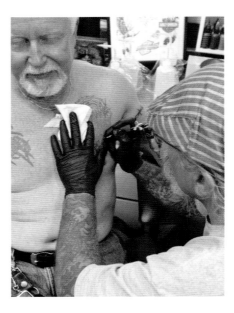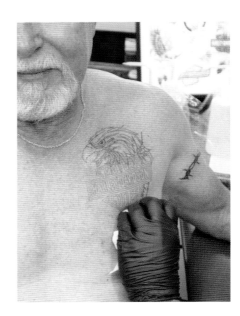

▶ After the artwork has been transferred to the skin, the client and artist can accurately measure location, angle, size, and more, before making it permanent. *Darren McKeag*

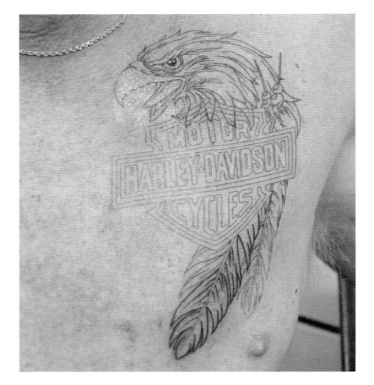

▲ Here, Pinky at Sacred Skin runs some artwork through the transfer machine.

▲ ▲ These custom designs must pass through the transfer machine in order to make the template for the skin.

▲ The artwork is turned into a transfer, allowing the client to check its placement before the art is permanent.

▶ After the transfer is applied to the client, the client gets a chance to check it in the mirror before giving the tattoo artist the official OK to proceed with making the art permanent.

▶ Pinky starts with the outlines and then colors in the marked or shaded areas.

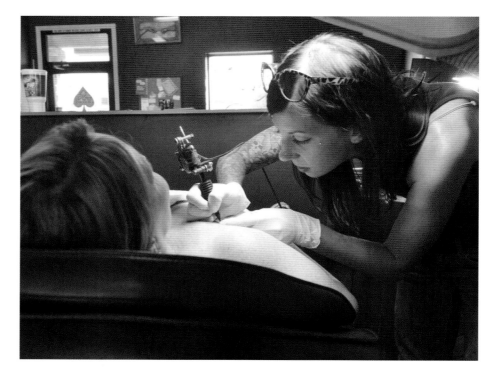

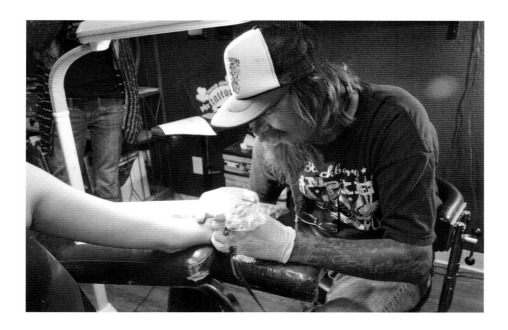

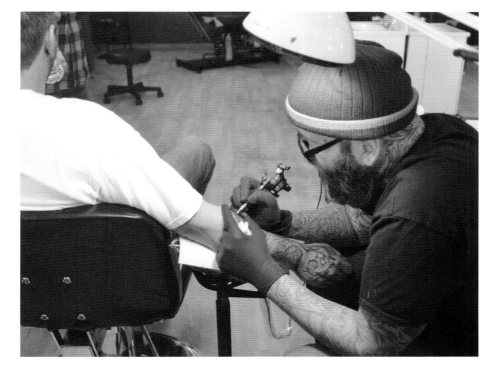

▲ Above right: Pinky's husband Long Jon lays down some ink on this client. A clean and sanitized workspace is the first indicator of a reputable tattoo parlor.

▲ An observer checks the progress of the new tattoo.

◀ Darren McKeag of Slingin' Ink goes to town. Different-sized needles are used for different areas of the work, and a well-lit workspace is key.

▲ Make sure you look around the tattoo shop before jumping in the chair. Look at the work of the artists, as well as any awards, trophies, or recognition of good work on the walls. Also look for magazines with write-ups featuring the shop or artist.

▶ Here's a good look at how an artist creates shades. Ink cups begin with the blackest of blacks, then black ink drops are added to water to create varying degrees of gray.

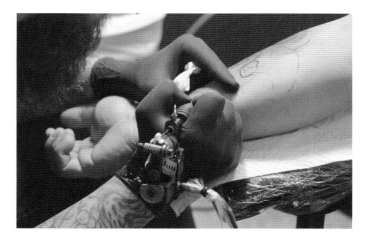

▲ Again, good lighting for the artist is important. Artists work with sterile gloves and a paper towel in hand to wipe away excess ink in order to see the outline.

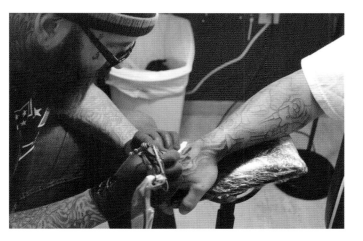

▲ The process always begins with any lines or major definite borders. Then the shading begins, working in either grays or colors.

▶ A cup of water is always handy to thin out your colors.

▶ The tattoo machine (absolutely not a gun—do not call it a tattoo gun) lays down the ink.

▼ Here, Darren mixes shades of gray as he begins to fill in the design.

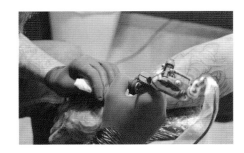

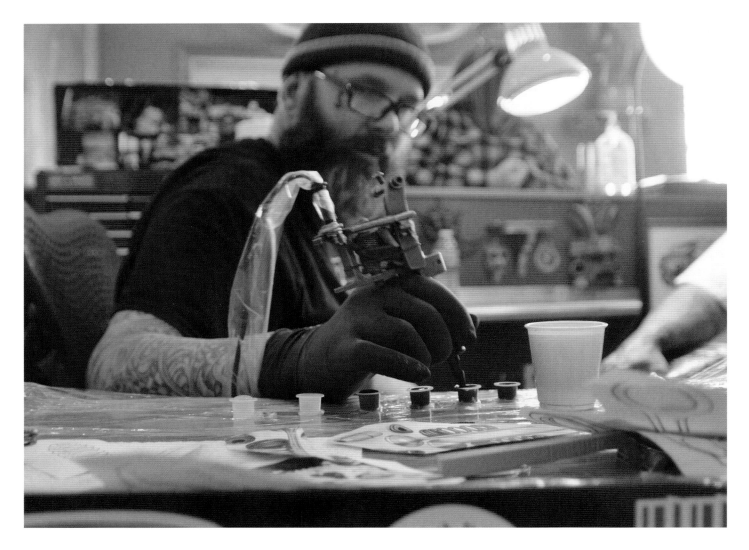

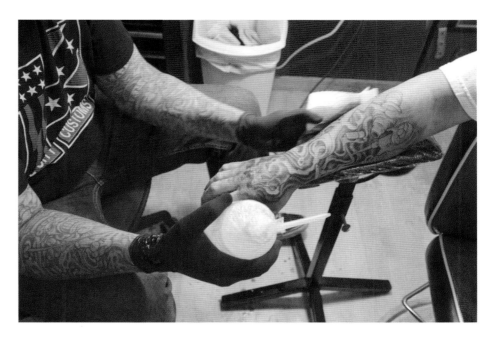

▲ Wiping down excess ink reveals all the work that's been done . . . and all there's left to do!

▶ Sometimes the best part of getting a tattoo is the moment when the ink has been cleared away, and the artwork seems to magically appear.

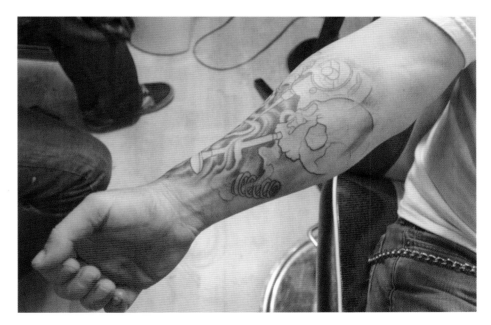

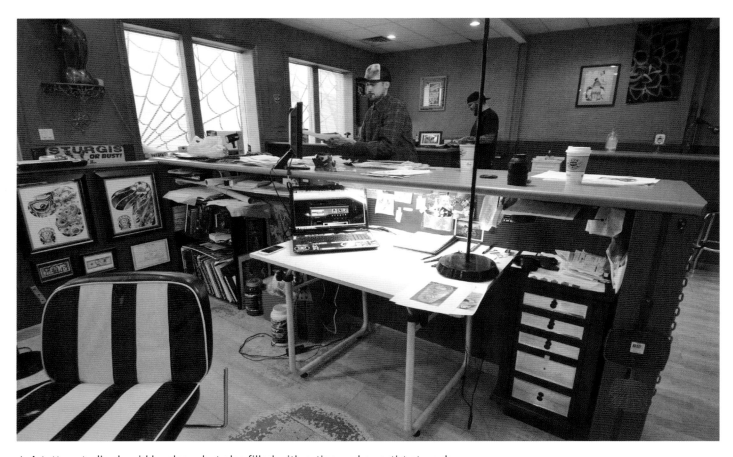

▲ A tattoo studio should be clean, but also filled with action and an artist at work.

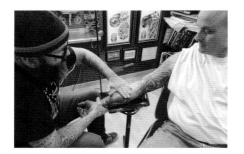

▲ The area to be inked gets a clean shave and wash with soap and water to ensure a clean canvas.

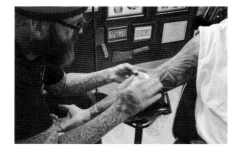

▲ If the location allows, the artist might tape the reference art above the area for easy reference.

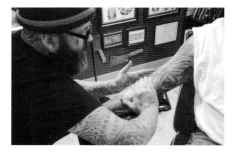

▲ If not working freehand, the artist will transfer a line drawing template onto the skin for reference lines to follow.

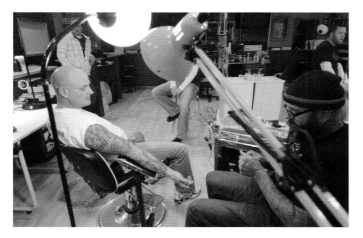

▲ Both artist and client look at the location to assess final approval before the inking starts.

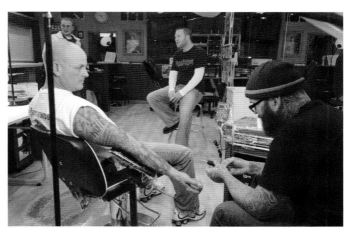

▲ Darren McKeag loads a needle in the tattoo machine to start this piece.

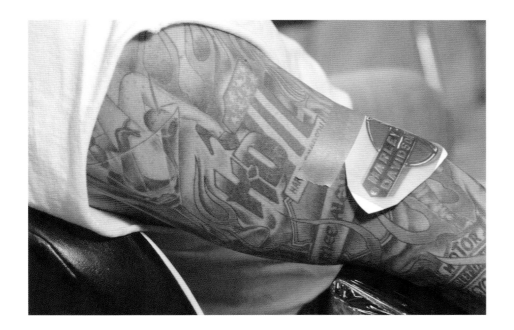

▲ The reference art is taped to the arm so Darren doesn't have to keep turning his head to look at it.

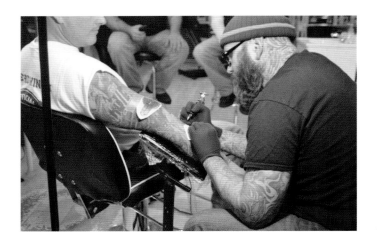

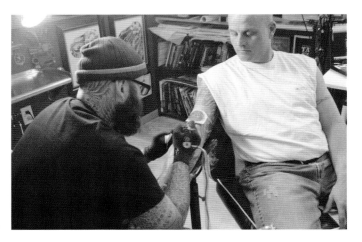

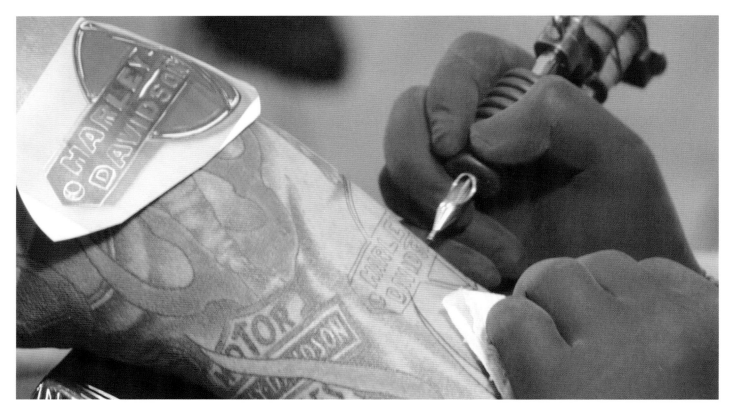

And the tattoo process begins! This is when people become the most nervous, especially if it is their first tattoo. They worry about how bad it will hurt and how it will look. This guy has had plenty of work done by Darren, so he know exactly what he is in store for.

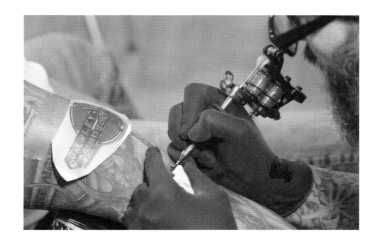

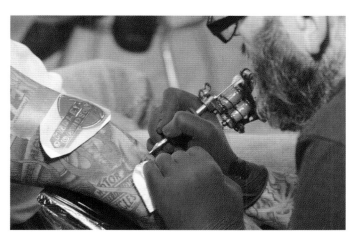

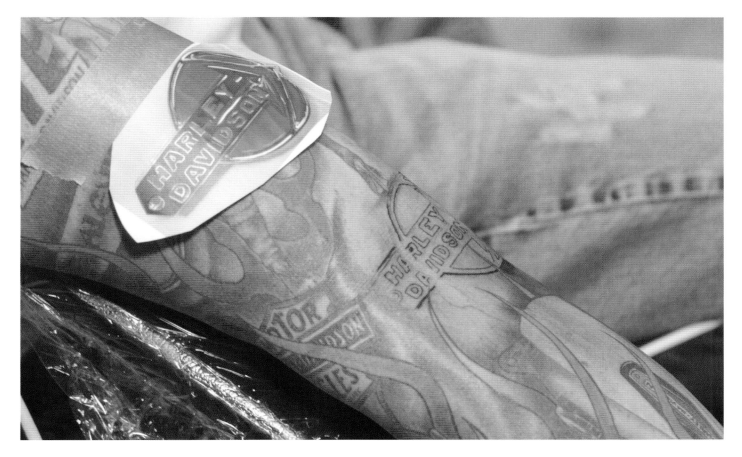

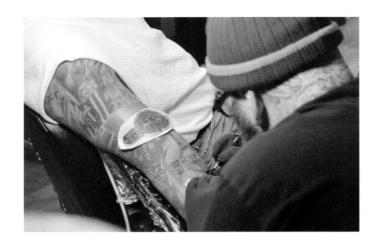

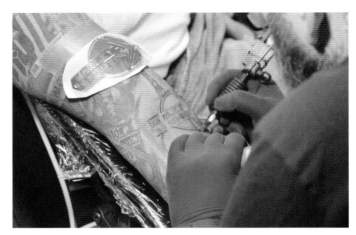

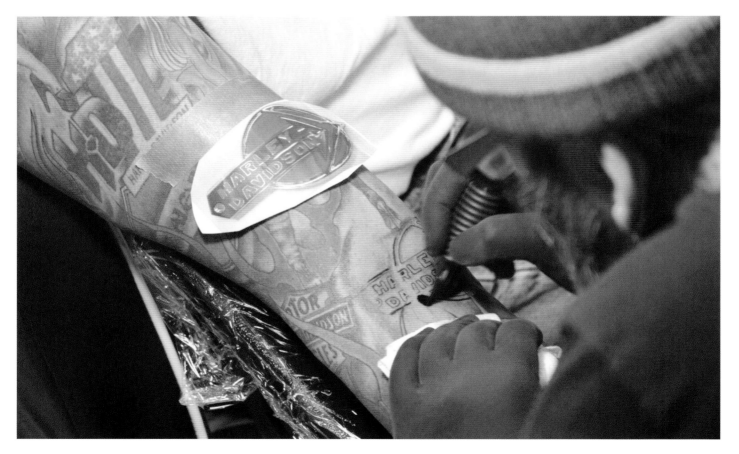

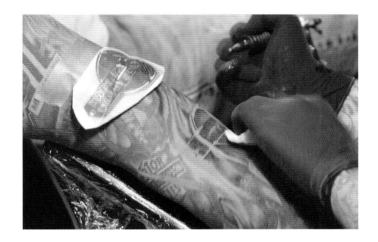

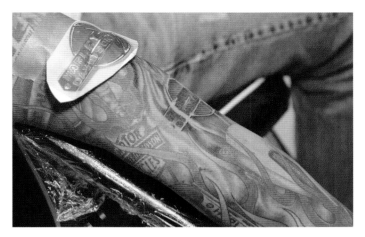

▲ Working with color is the same process as working with black ink—the area must be wiped once in a while to clear excess ink.

◄ The work is very clear after being wiped down.

▶ The sketch—step one—the client gives to the artist starts as an idea of what they would like, and it is up to the artist to interpret it.

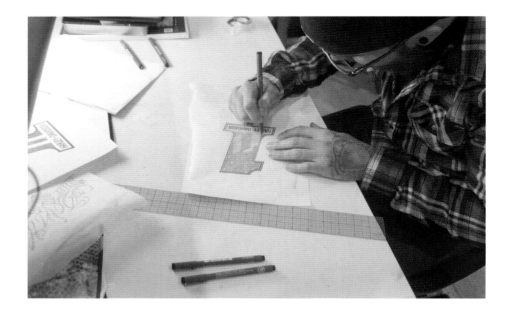

▶ Scottie B of Slingin' Ink places his artwork on a client's arm for location approval. Once the location is good, he will transfer the outlines and begin the process.

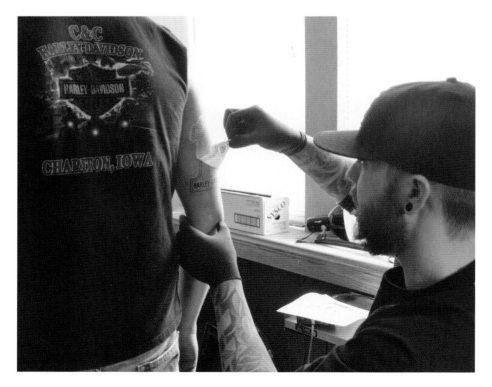

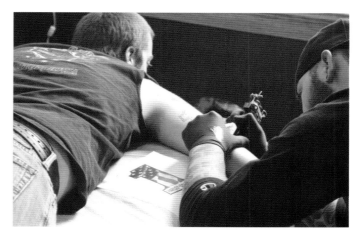

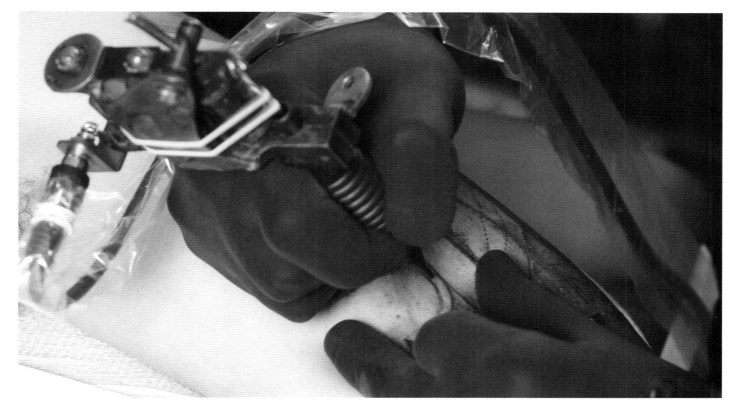

▲ ▲ As he sets up the work station, Scottie keeps the reference art close by.

▲ With the ink process underway, the client is encouraged to get comfortable and relax. The artist doesn't want (or need) any sudden movements while he is working.

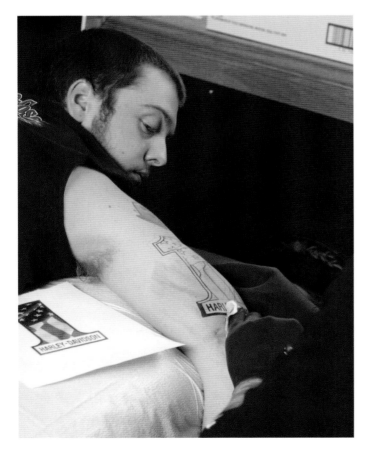

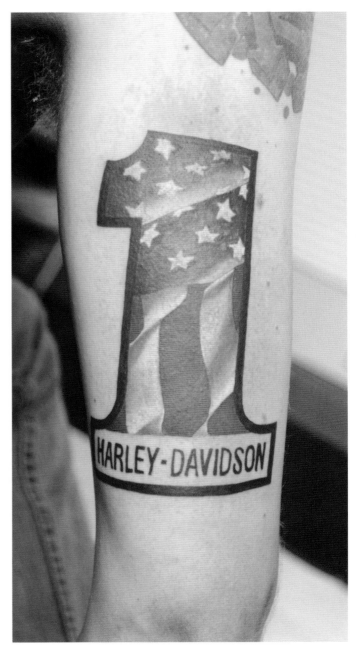

▲ At last, the final product and one very happy client is revealed! Kudos to Scottie B on a great job.

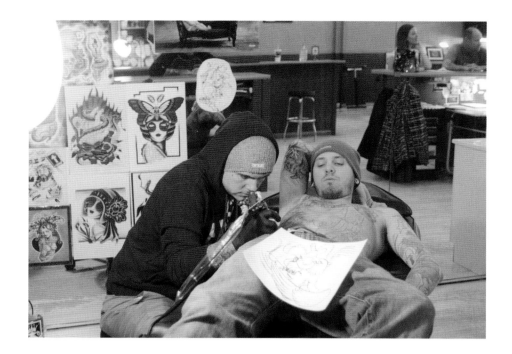

▲ Darren from Slingin' Ink starts another project for a client.

◀ Alex Vance from Slingin' Ink puts in hours upon hours on this huge stomach piece.

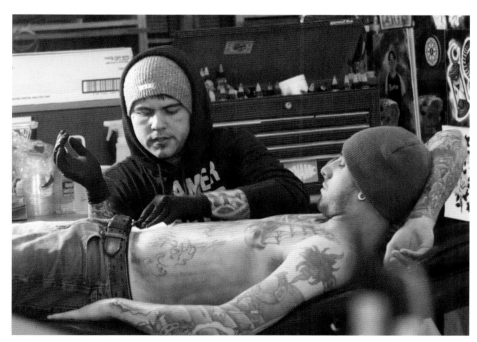

▲ Tim Jewell of Ink & Iron works on a chest piece.

▶ ▶Depending on what area gets tattooed, you may be sitting in a chair or reclining on a massage/dentist-type table.

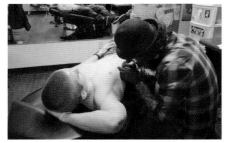

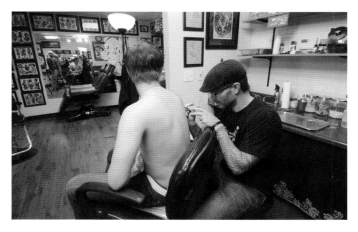

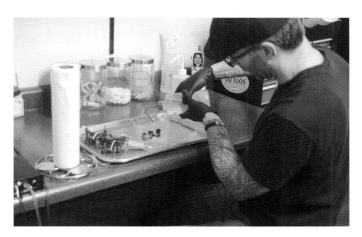

▲ ▲ Tattoo artists use many drawing tools to get their sketches just right—rulers, circle stencils, and a compass are a few they keep handy in their lineup.

▲ It's common to see tattoo artists use a tool box as the chest for tools, needles, and more.

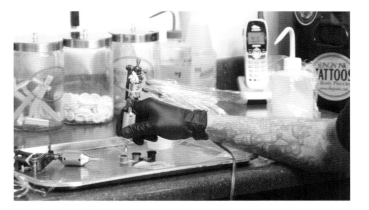

▲ ▲ After the artwork is transferred to the skin, the artist may make a few more prominent lines in marker.

▲ The pallet is set with ink and water.

◄ The tattoo machine is ready to dip into the first color for the artwork.

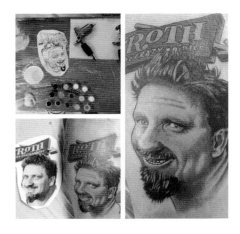

▲ Again, a clean, well-lit area is a good indication of a quality tattoo parlor. *Shutterstock*

▲ ▲ Here's a collage of work station, sketch, the art in progress, and the finished piece of this Ed Roth portrait by Darren McKeag.

▲ "Relax, get comfortable, this won't hurt a bit" are words every tattoo artist knows. Here, Darren McKeag works on a chest piece.

▶ Of course, another indication of a quality parlor is quality ink on the tattoo artist. It means his standards are as high as yours. *Shutterstock*

◄ This top-down view showcases a clean palette for a true artist. *Shutterstock*

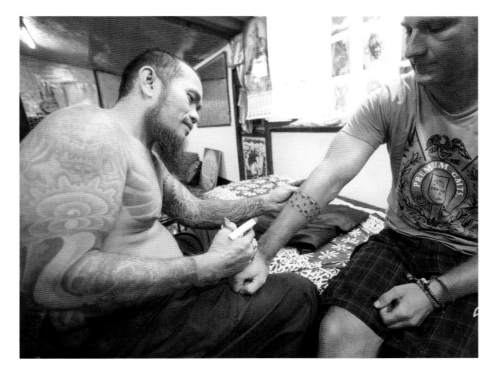

◄ Part of getting a tattoo is also is being comfortable with yourself—or in this case, with the giant, shirtless tattoo artist. *Shutterstock*

▲ Some shops are more creative than others. This one features a motorcycle as a table for the actual inking. *Shutterstock*

▶ Tattoos can hurt, but that sleeve speaks volumes about her past. *Shutterstock*

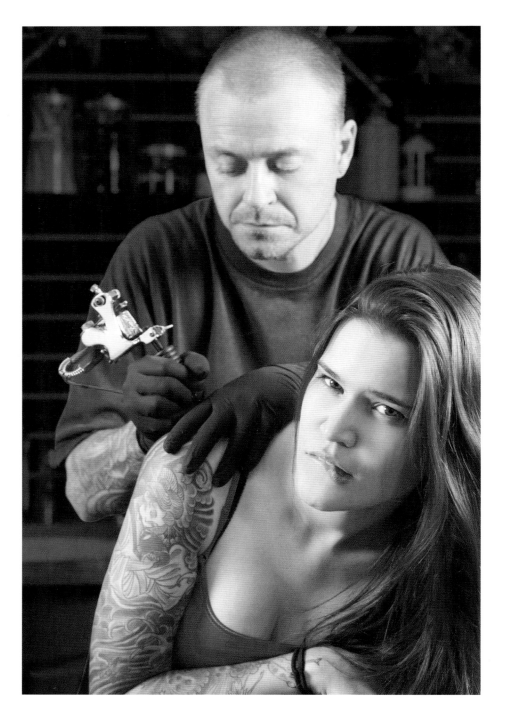

▲ An eagle's flaming wings can be seen on this woman's back as the tattoo artist continues to fill in the lines. *Shutterstock*

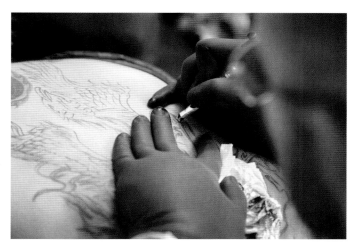

▲ Here's another view of the new flaming eagle tattoo. Notice how meticulous the work can be—the careful inking, the rubber gloves, the bloody wipe. The best tattoo artists and parlors will take every precaution to ensure a good experience. *Shutterstock*

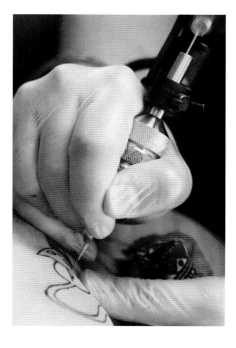

◀ Here's a close-up of an important aspect of a tattoo artist's work. A painter can't paint on a flimsy canvas any more than a tattoo artist can ink on flabby skin; here, the artist presses the skin tight with one hand while the other wields the tattoo machine. *Shutterstock*

Tools

Tattoos have been around since the time of the first humans. Throughout history, we've seen images of flesh etched by the crudest of tools. Some frightening examples range from old nails, to sharpened bamboo sticks, to shark or animal teeth. The ink could have been sugar cane juice mixed with burnt wood ash. Regardless of the method used to make the mark, the important part is the meaning of the tattoo.

Over the years, the tools have been improved upon immensely, and for the last one and a quarter centuries, the tattoo machine has been the trusted instrument of tattoo artists.

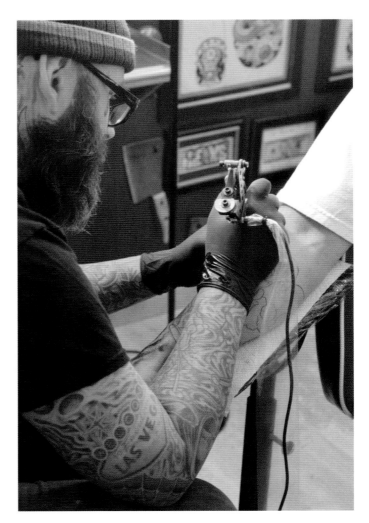

▲ A tool chest stacked full of tattoo ink and other various tools of the trade.

▲ Never call it a tattoo gun. It is not a gun. It is a machine. Call it a tattoo machine.

▲ Above left: A stainless steel tray is where many artists place their needles, water, ink, and Vaseline or A&D ointment.

▲ Every color under the sun is available.

◄ Here's another work station ready to go—it features the artwork, black ink cups, water, Sharpies, needles, and the tattoo machine.

▲ Different needle gauges are used in every machine—tattoo artists are meticulous about making sure the needle matches the art.

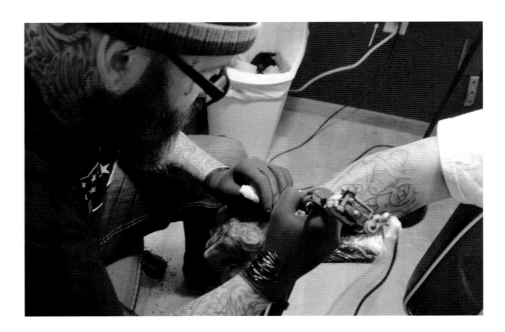

▲ Darren inks in the borderlines first.

▲ Everything is wrapped in plastic to keep the area clean. After each client, the plastic is removed and everything is sanitized and rewrapped with fresh plastic.

▲ Look how disposable (and more sanitary) the tattoo process has become—almost everything is one-time-use only.

▲ Darren shows the client how to place a needle inside a tube before the inking process starts.

▲ The work station light is one of the most important parts of a good station.

▶ Brilliant hues always win over dull ones in the land of colored tattoos.

▶ ▶ Various types and sizes of tattoo tubes hold the needle in the machine.

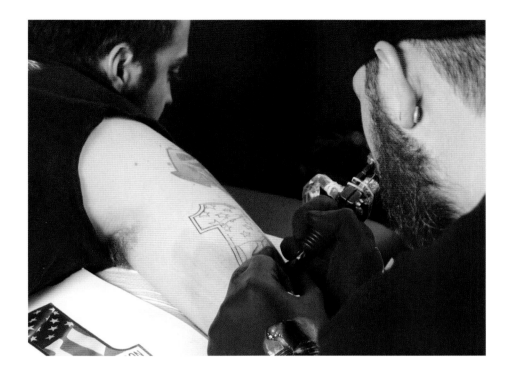

▲ ▲ ▲ A chest of tattoo machines, all laid out perfectly, some are chosen for certain jobs.

▲ ▲ Shop owners know how to protect themselves from would-be robbers.

▲ ▲ The tattoo machine continues to evolve from its humble roots.

▲ Well-loved and cared for machines becomes pieces of art in their own right.

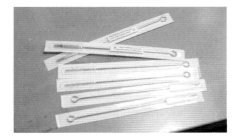

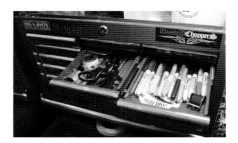

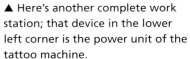 ▲ Here's another complete work station; that device in the lower left corner is the power unit of the tattoo machine.

▶ An extra supply of needles in every size is always necessary—you never know who (or what) might walk in!

▶ The larger needles are used for shading, and the finer ones used for fine line and detail work.

▶ Some artists just draw directly on the client, and when they do, they usually use Sharpies.

▶ Almost everything in the tattoo application process is disposable. Clients need not worry about infection at reputable shops.

▲ ▲ A supply of rubber gloves and plastic cups are always in stock at a professional tattoo shop.

▲ Elastic is used to keep the proper amount of tension on the needle.

▲ Each artist sets up his or her work station differently. There really is no right or wrong way in this business, as long as it's clean and it works.

▲ ▲ Above right: Is that an amp, or a power supply for a tattoo machine?

About the Authors

About Chad Lemme
By Sara Liberte

Never have I met such a multifaceted man; Chad is a true renaissance man, and I don't use that term loosely. Skilled in multiple fields and disciplines, he has an amazing broad base of knowledge, and I am thrilled and fortunate that he shares it with me. Chad's quest for knowledge started at an early age as he learned about farming, land, life, and religion from his family and grandfather in South Dakota. In his teens, he learned about the automotive industry, and soon gleaned all he could about woodworking from his father and medicine from his mother. In the army, he learned the cruel lesson of life, death, and war in combat. After returning home from war, he began studying history, philosophy, and geology. Before long he was perfecting engineering, design, fabrication, and motorcycle assembly. Hand-tooling leather was next, and perfection of that soon followed (I'm surprised he hasn't picked up a tattoo machine yet, and perfected that as well). I am continually in awe of his accomplishments as an artist, writer, and designer.

About Sara Liberte
By Chad Lemme

You know when you're evading rebel guerillas through the jungles of Nigeria to the border of Cameroon for exfiltration, and you have no coms, no night vision, no food or water, and you're beyond exhausted due to having been operating for the last one 123 consecutive hours?

Of course you do. We've all been there before, right?

That's what writing this book was like—a high-speed chase across the country and back again, in search of fantastic tattoo work, for better or worse. And we found plenty of tattoos, both beautiful and terrible in kind. And in the midst of the hundred-plus miles an hour lifestyle I've been living for the last several years, I met Sara, and we just kept running into each other at the motorbike events and wound up where we are now.

She's such a great chick, and I am *so* grateful for her. You can't take anything for granted, and she doesn't. She's passionate about everything in her life; I could fill an encyclopedia with the things I love about her. I'm certain there is no better woman in the world, so that makes me the luckiest guy in the world. I'm truly fortunate.

Sara and Chad doing a "self portrait" in the mirror at Slingin' Ink Tattoo.

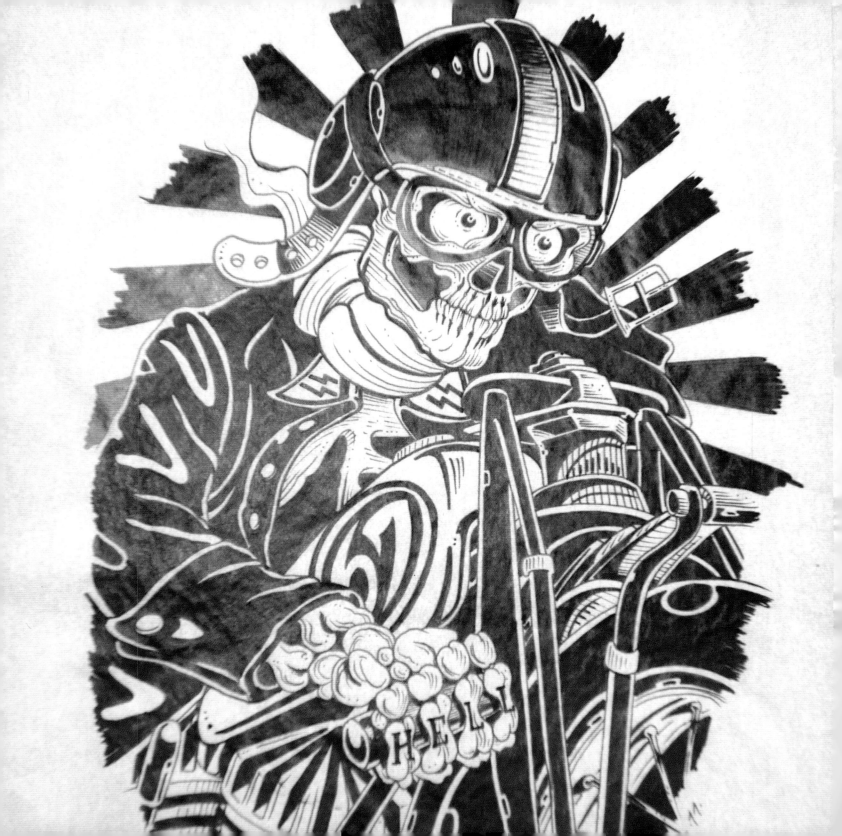